W9-DJE-681

St. Louis Community College

Forest Park
Florissant Valley
Meramec

Instructional Resources
St. Louis, Missouri

THE ARTIST
AND HIS MODEL

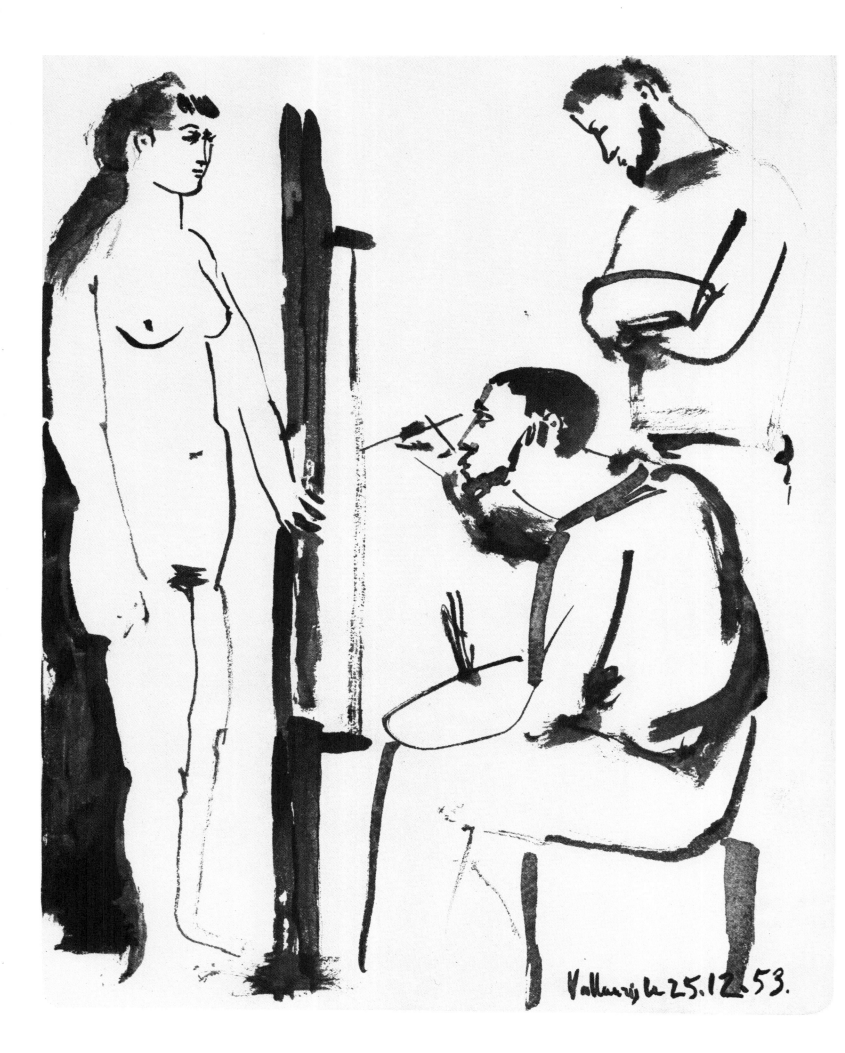

Vallauris le 25.12.53.

THE ARTIST AND HIS MODEL

180 Drawings

Pablo Picasso

DOVER PUBLICATIONS, INC.
NEW YORK

COPYRIGHT

Copyright © 1994 by Dover Publications, Inc.
All rights reserved under Pan American and International Copyright Conventions.

BIBLIOGRAPHICAL NOTE

The Artist and His Model: 180 Drawings, first published by Dover Publications, Inc., in 1994, is a republication of the drawings originally published by Harcourt, Brace and Company, New York, in 1954 under the title *A Suite of 180 Drawings by Picasso*. The text of that edition is here omitted. A new Publisher's Note has been written specially for the Dover edition. The drawings on pp. 2, 15 and 165–177, originally in color, are here reproduced in black and white; the ordering of plates has also been adjusted to reflect a more accurate chronology.

LIBRARY OF CONGRESS CATALOGING-IN-PUBLICATION DATA

Picasso, Pablo, 1881–1973.
 The artist and his model : 180 drawings / by Pablo Picasso.
 p. cm.
 "An unabridged republication of the drawings originally published by Harcourt, Brace, and Company, New York, 1954" — T.p. verso.
 ISBN 0-486-27877-8
 1. Picasso, Pablo, 1881–1973. 2. Artists and models in art. I. Title.
NC248.P5A4 1993
741.944—dc20 93-37470
 CIP

Manufactured in the United States of America
Dover Publications, Inc., 31 East 2nd Street, Mineola, N.Y. 11501

Publisher's Note

In September 1953, Françoise Gilot left Pablo Picasso, with whom she had lived since 1946, taking with her their two children, Claude and Paloma. Although the relationship had been strained for a while, the blow was nevertheless considerable for Picasso, who was abruptly brought face to face, at 72, with the realities of old age and mortality.

On November 28, at Vallauris on the Côte d'Azur, where he had shared a villa with Françoise, Picasso began a series of 180 virtuoso drawings, the central theme being the painter and his model. (In the 1930s, for the Vollard Suite, he had observed the sculptor and his model.) The Vallauris drawings, completed February 3, 1954, constitute, in effect, Picasso's evaluation of his life and work.

In a Felliniesque parade, marked by subtly graduated transformations and sometimes jarring combinations, we see the artist (as a young man, an old man, as Picasso himself, as a baboon, as a woman) and the model—beautiful, serene, remote. (But even she is unable, ultimately, to escape the toll exacted by time: On pages 105, 108, 109, 115, 122 and 124, in treatments reminiscent of Rembrandt, she is revealed in middle and old age.)

Picasso uses the potent motif of the mask to explore further the symbiosis existing between artist and model. Through masks, the two are able to exchange identities or assume totally new personae (pages 149–178). In one of the most corrosive drawings of the series (page 161) Picasso depicts himself as a clownlike figure, the model as ever-so-slightly fly-blown. Through the artist–model relationship they are able to see themselves as the masks they hold up to each other. He becomes the young, vibrant creator; she the Classical beauty. In another series of drawings devoted to the mask, a Cupid holds a mask (which frequently bears a grotesque likeness of Picasso) as he flies around the model (pages 61–78). But Cupid unmasks (page 76). It is all a joke.

Turning his barbs to the artist's public—friends, critics and collectors—Picasso examines the paradoxes of art. On pages 126–130, the model lies in a pristine state, somnolent and exuding an easy sexuality, while the painter and his entourage, oblivious to the living being, turn their backs on her as they examine the canvas—a dead thing, the flat, painted surface of which Picasso indicates with a few scrawls.

Figures from Picasso's earlier repertoire are also in evidence: circus performers, equestrian subjects, neoclassical figures, the owl and the dove (the artist having designed his famous Peace Dove in 1949). A close examination of the drawings reveals that, despite the superficial brio with which they are executed, there is a richness of allusion and a depth of content that enables the series, taken as a whole, to offer substantial insights into the complex mind of Picasso, who went on to enjoy another 19 years of extraordinarily creative activity.

THE ARTIST
AND HIS MODEL

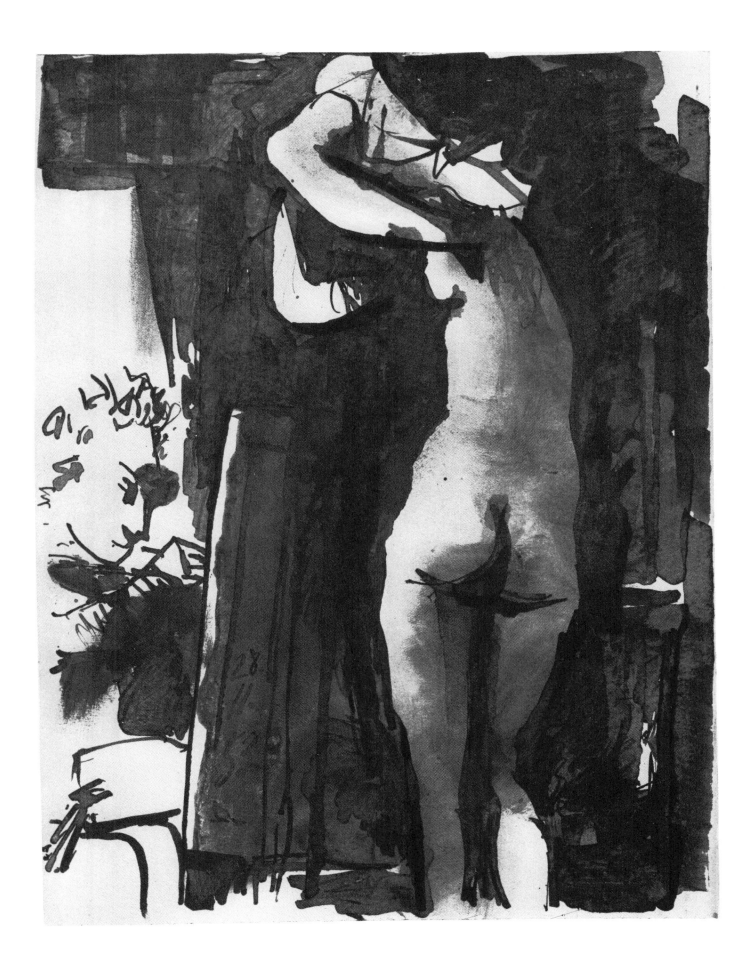

1

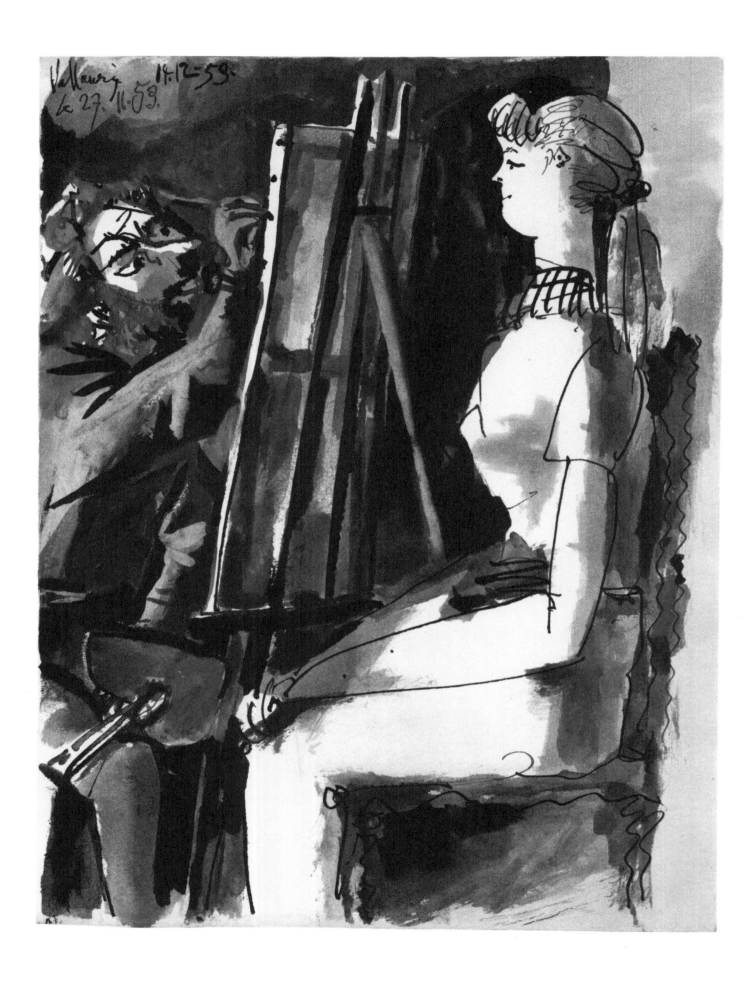

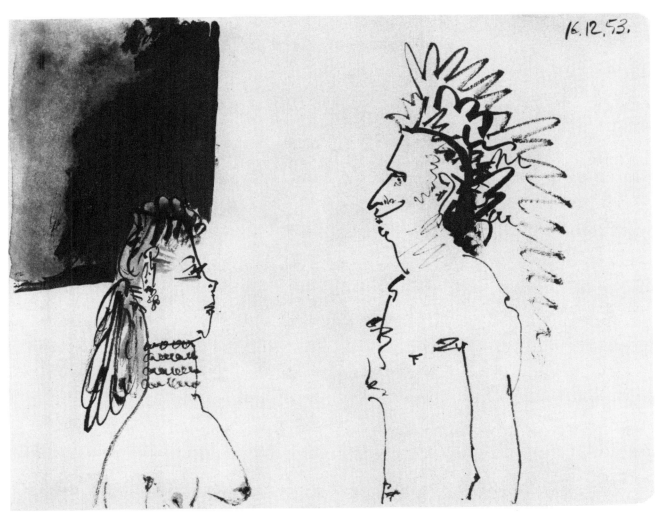

16.12.53.

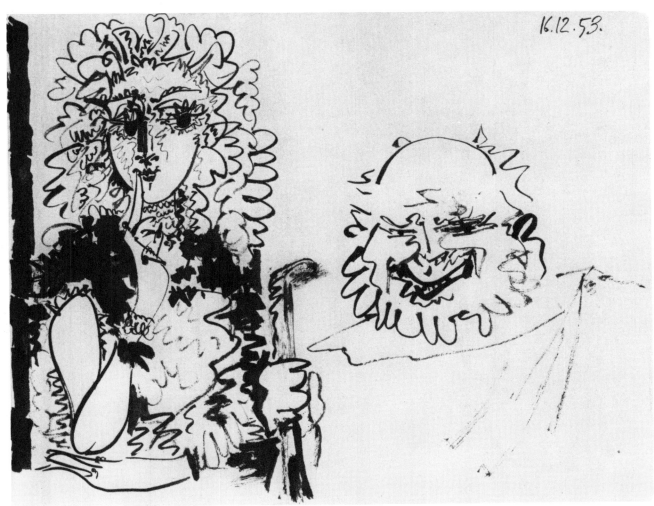

16.12.53.

3

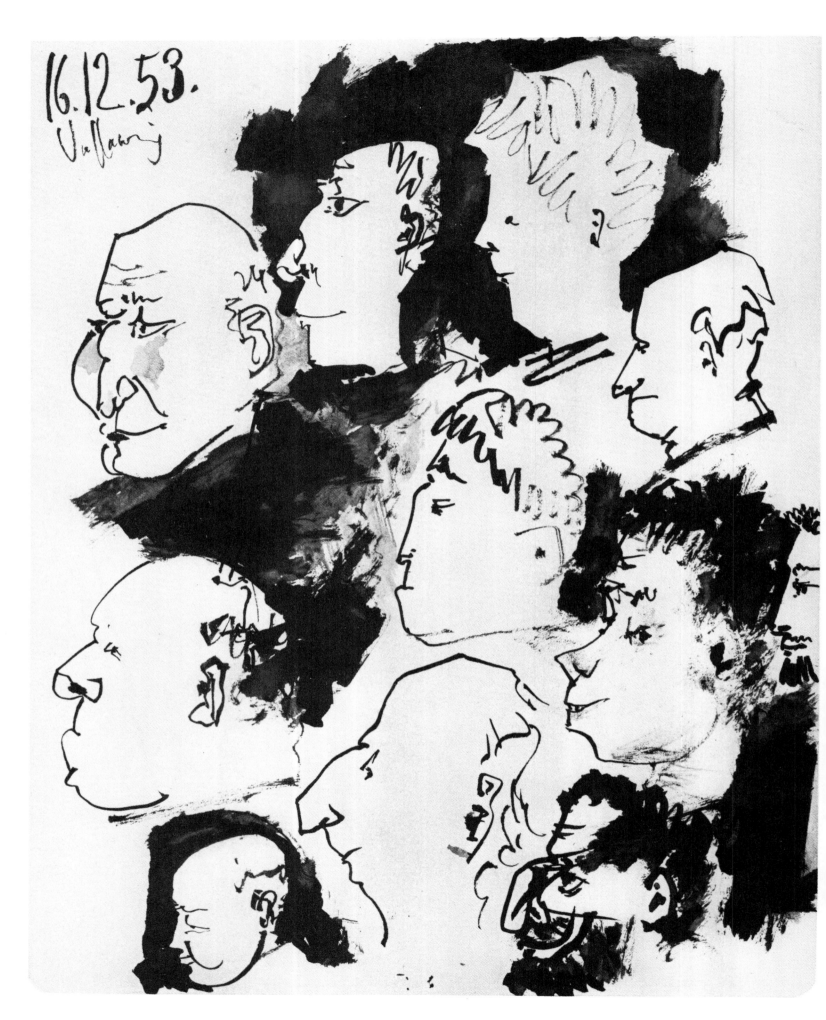

16.12.53.
Vallauris

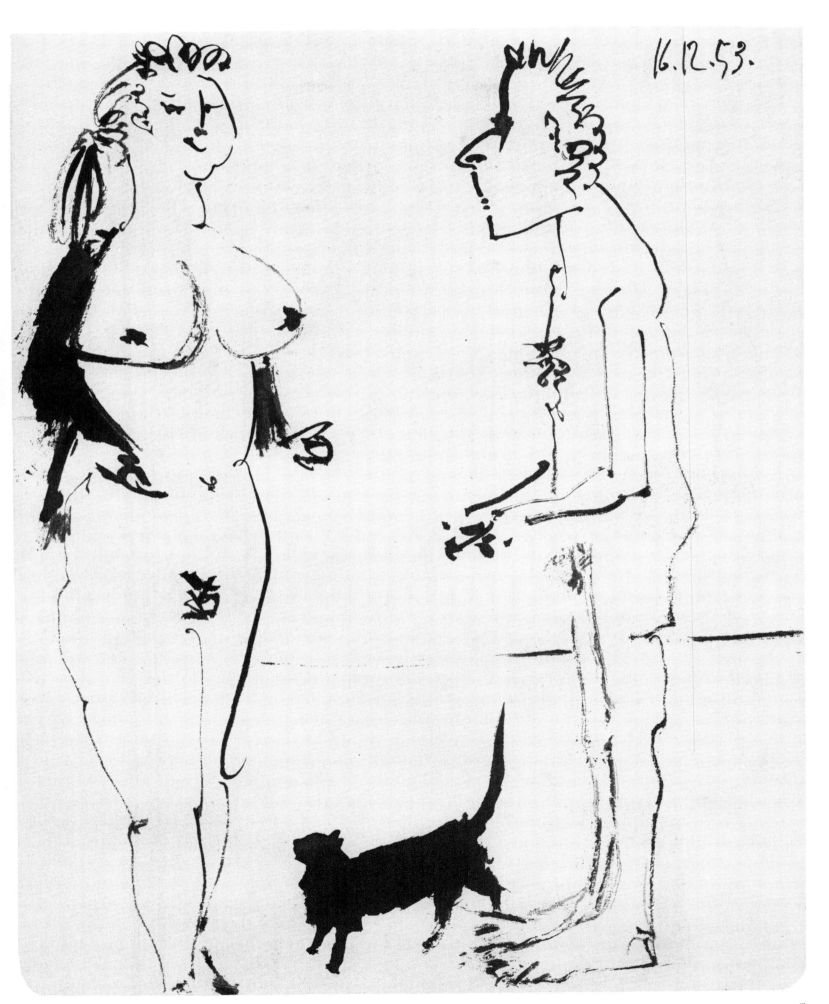

16.12.53.

5

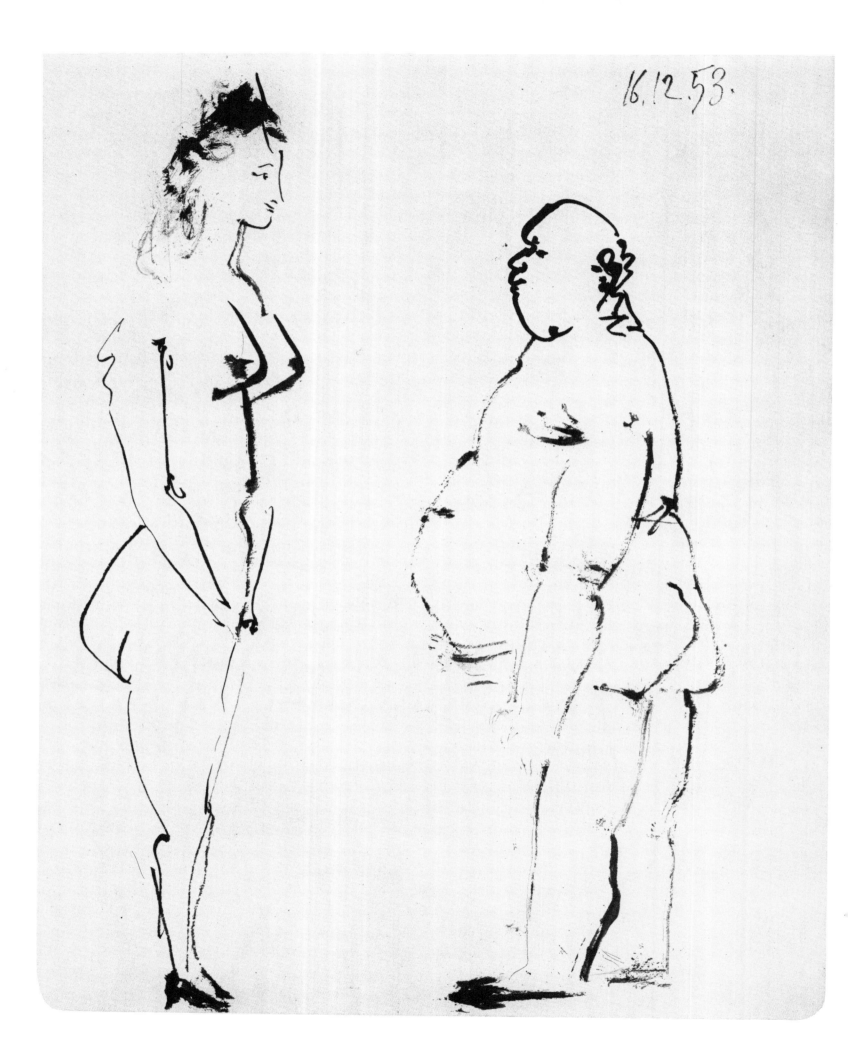

16.12.53.

6

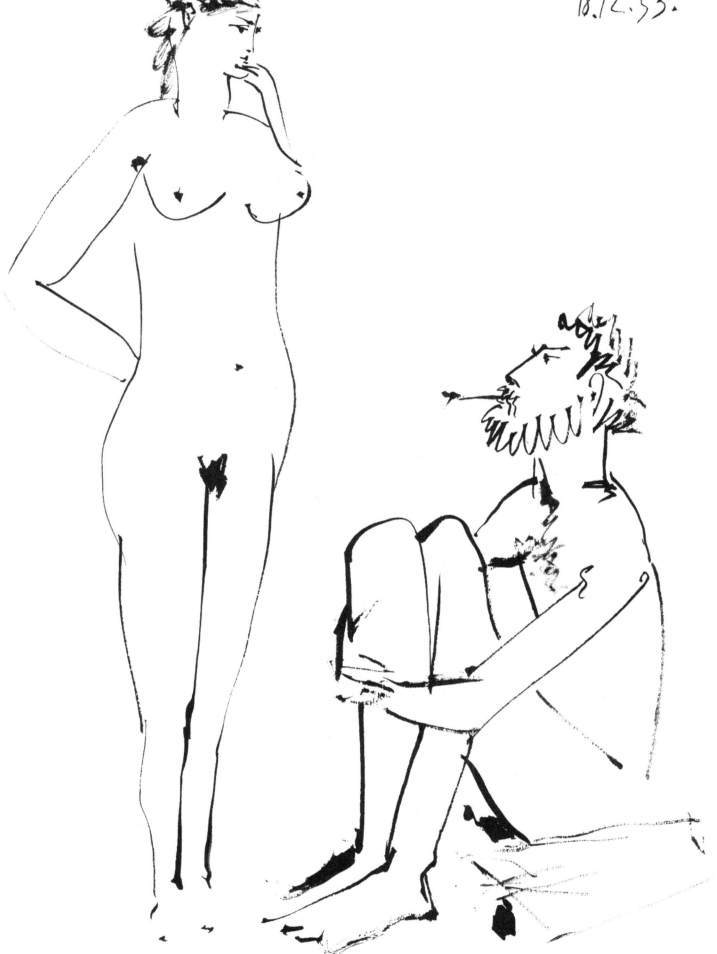

18.12.53.

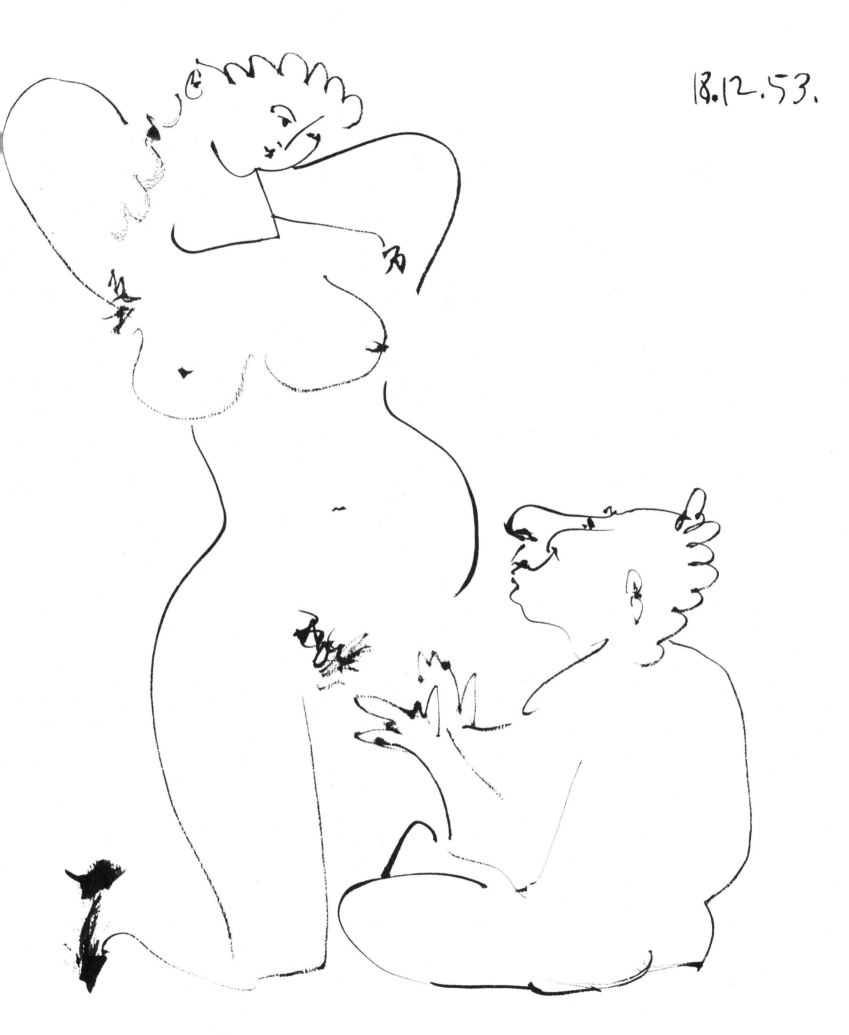

18.12.53.

9

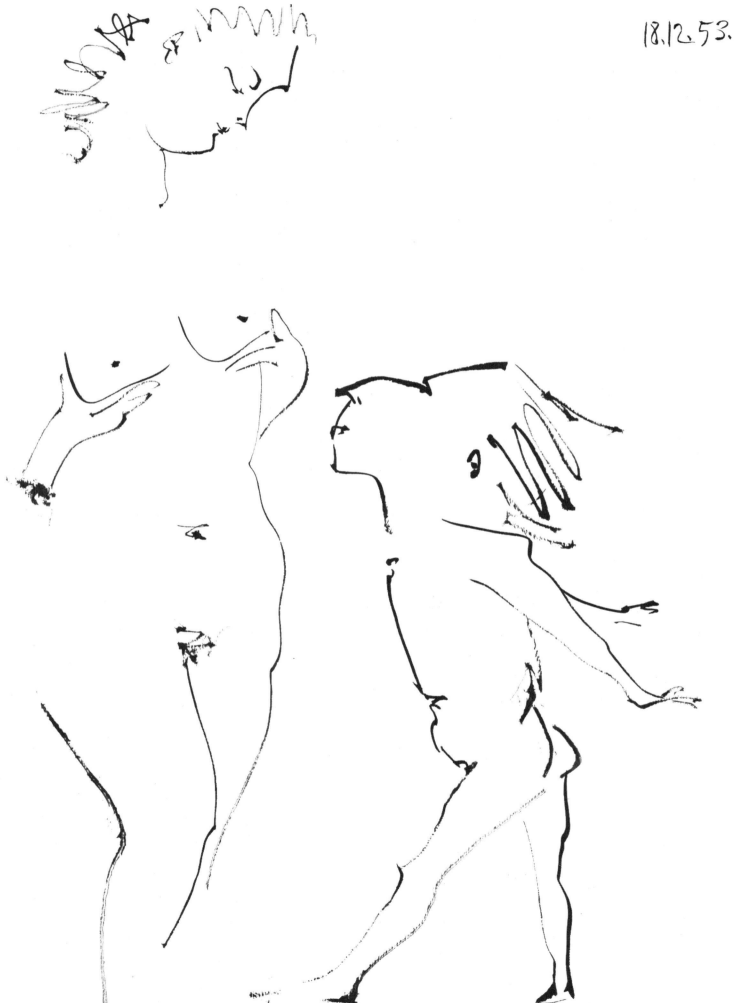

18.12.53.

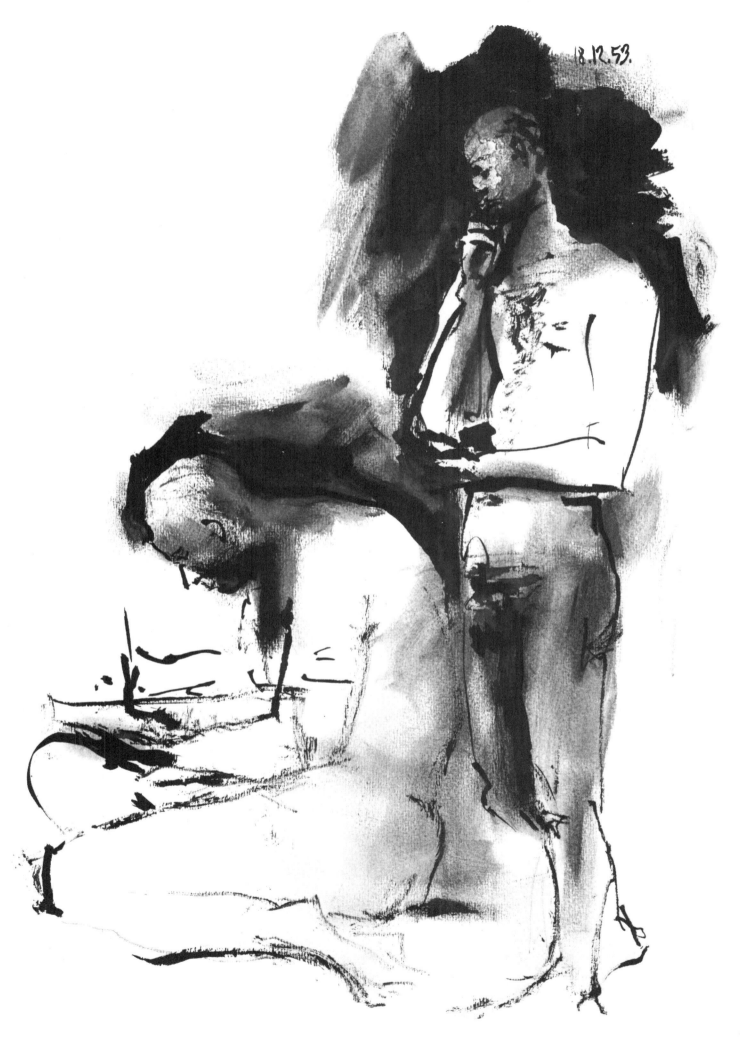

11

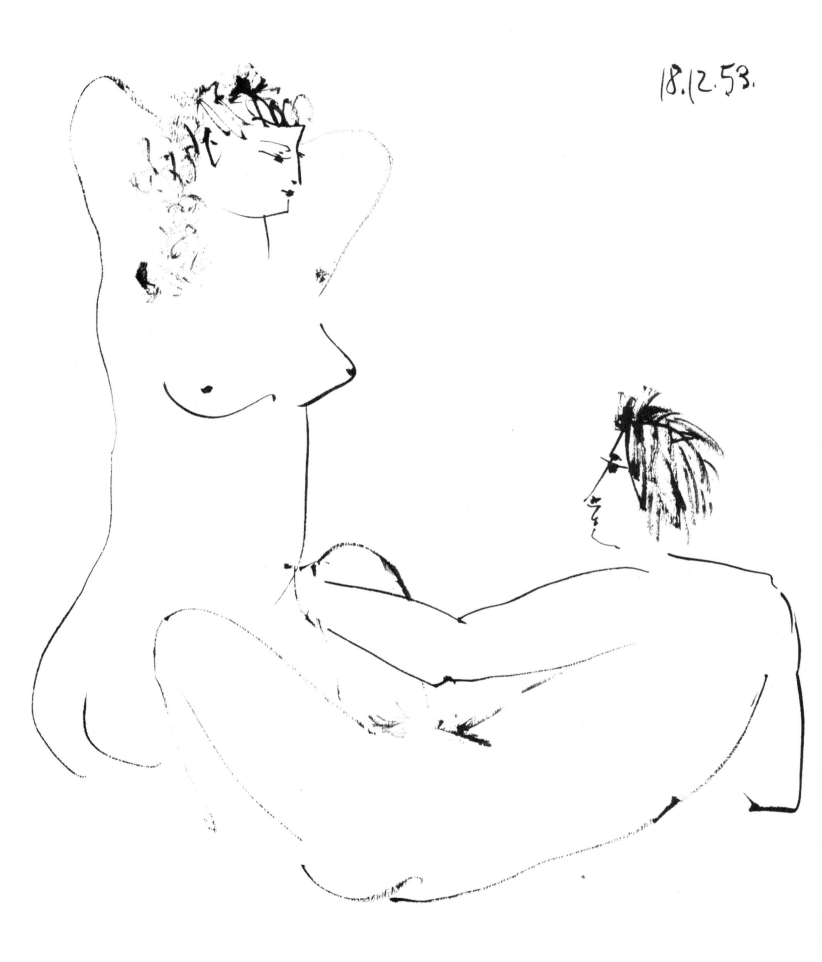

18.12.53.

12

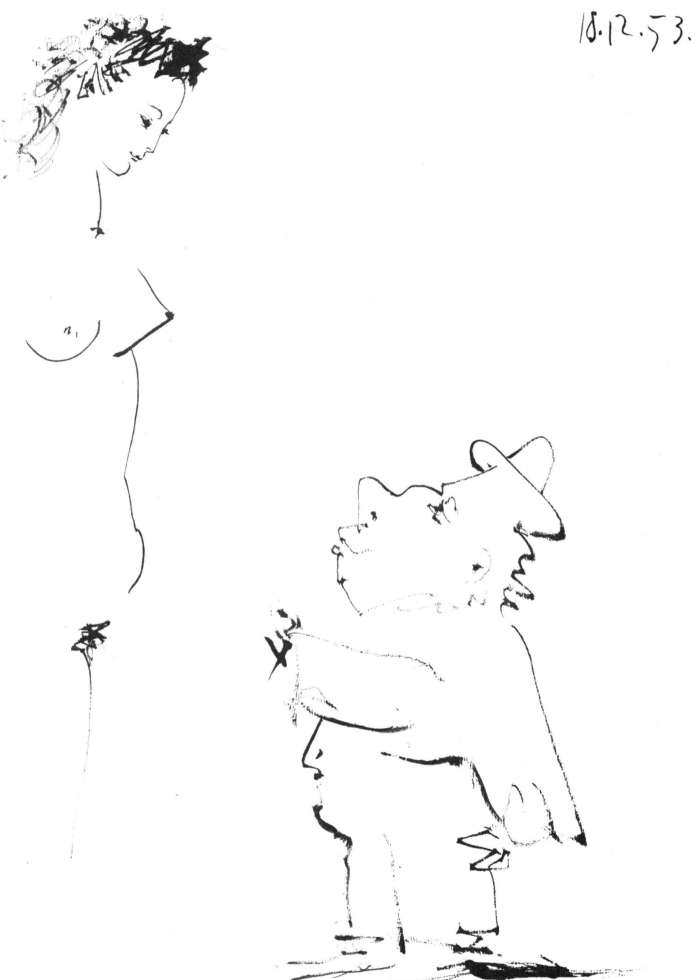

18.12.53.

13

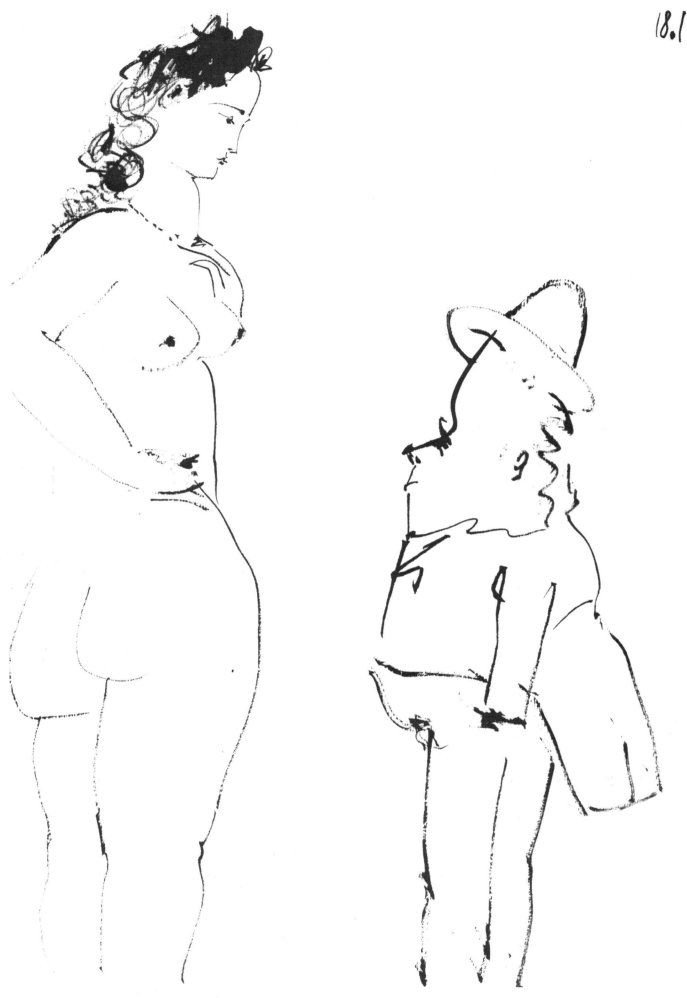

18.12.53.

14

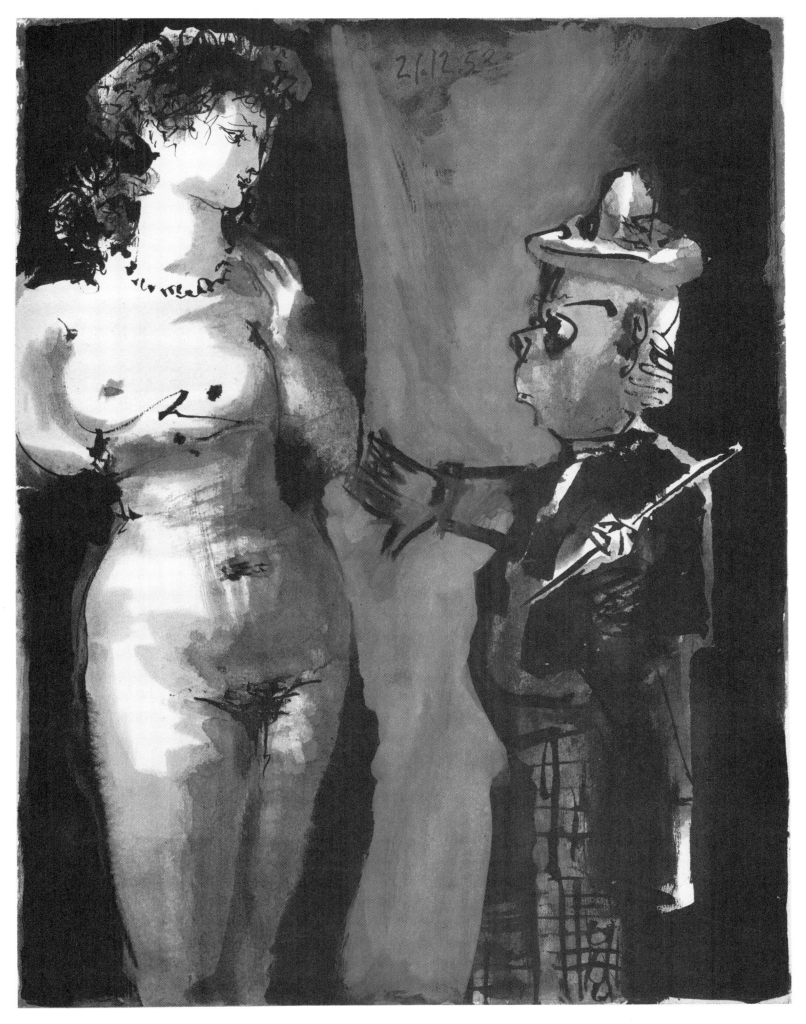

15

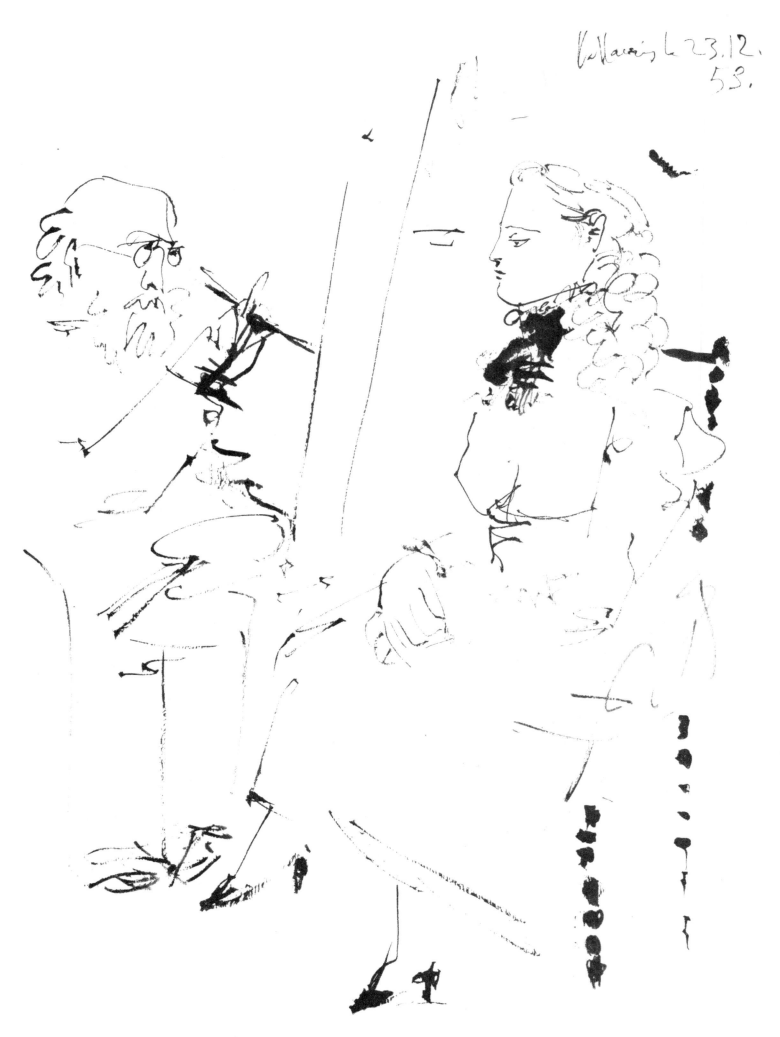

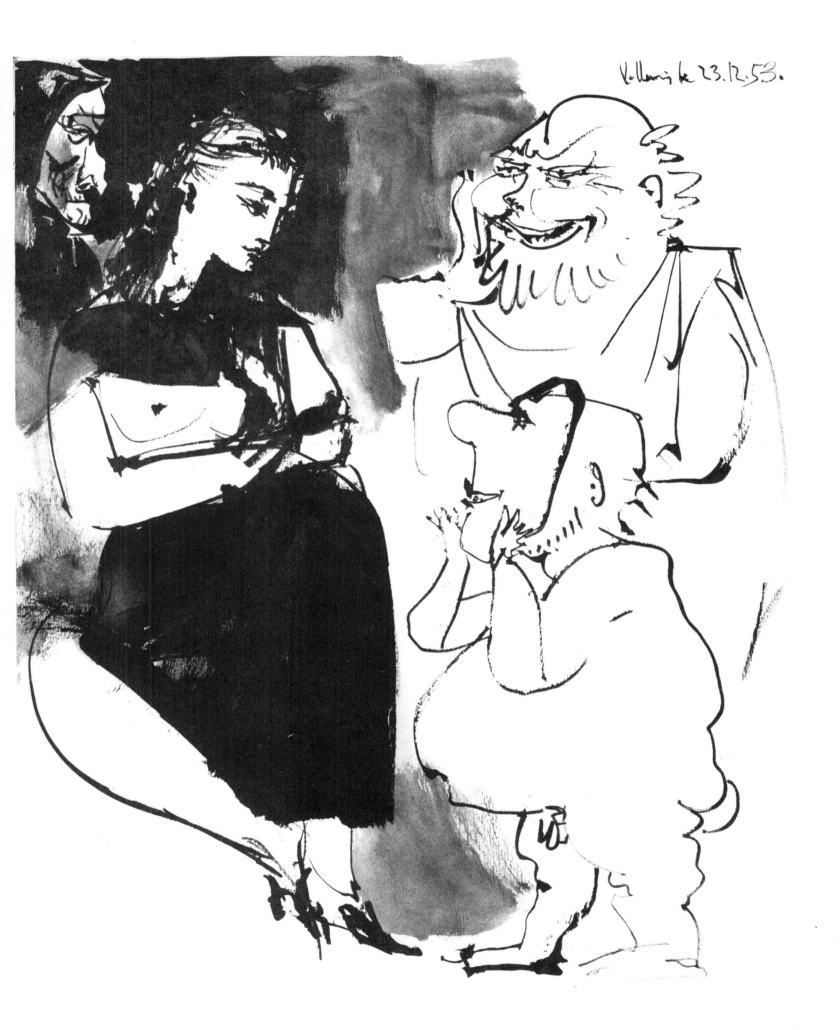

Vallauris le 23.12.53.

17

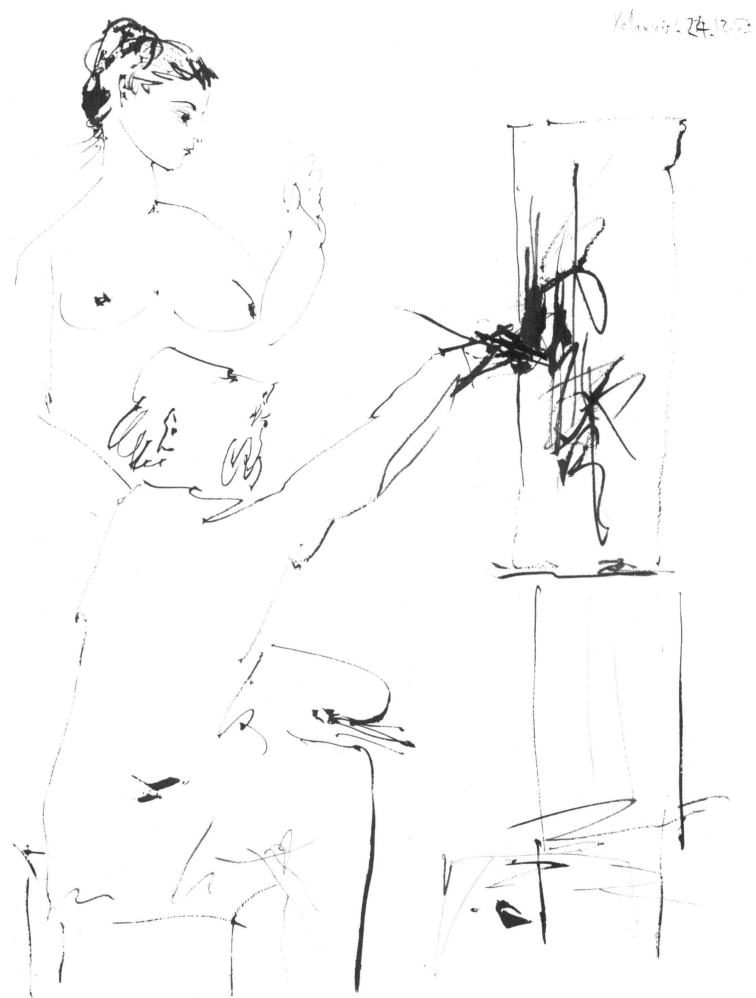

18

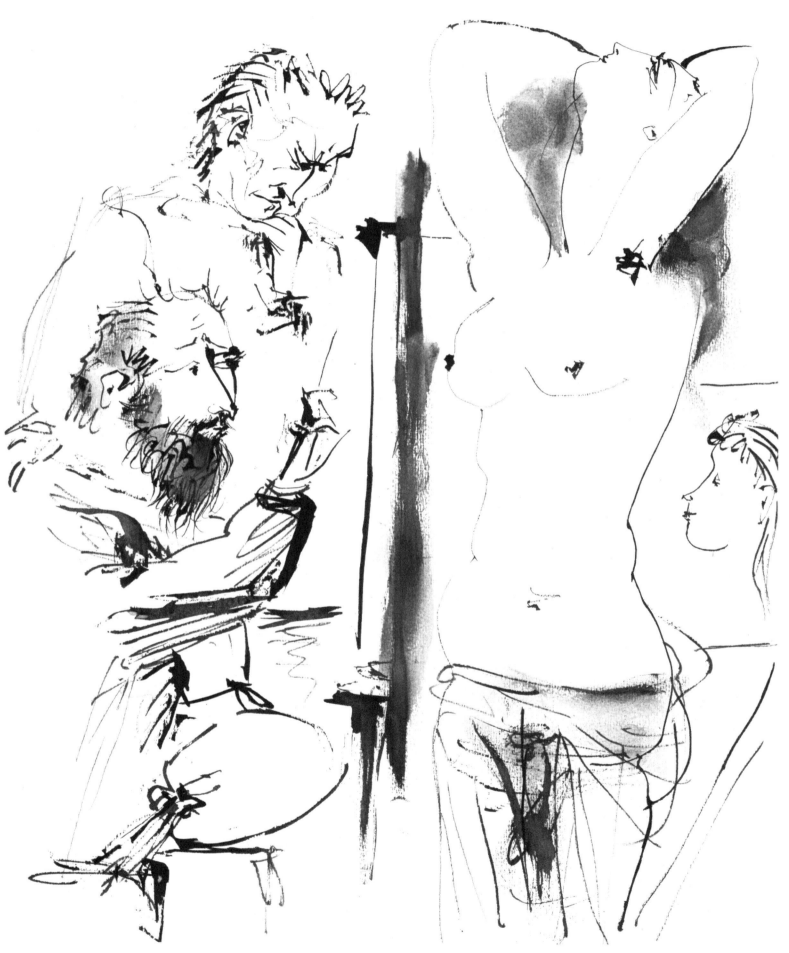

24.12.53.

19

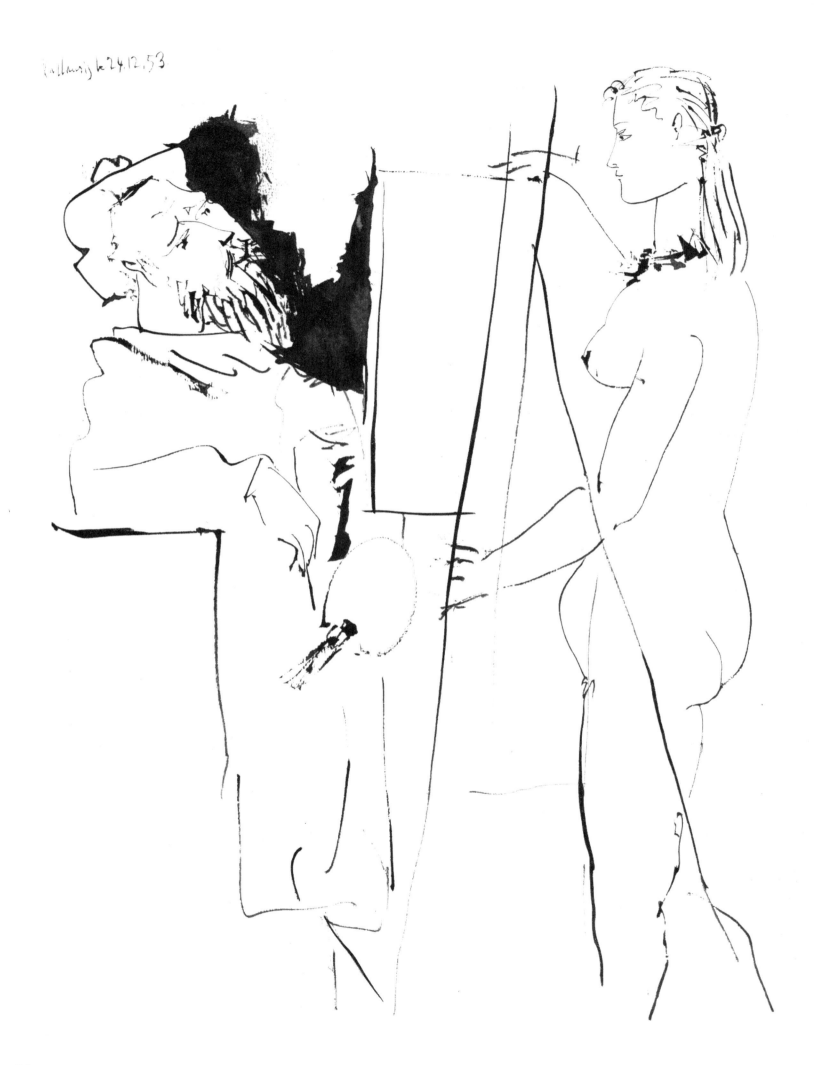

Vallauris le 24.12.53

20

Vallauris le 24.12.53.

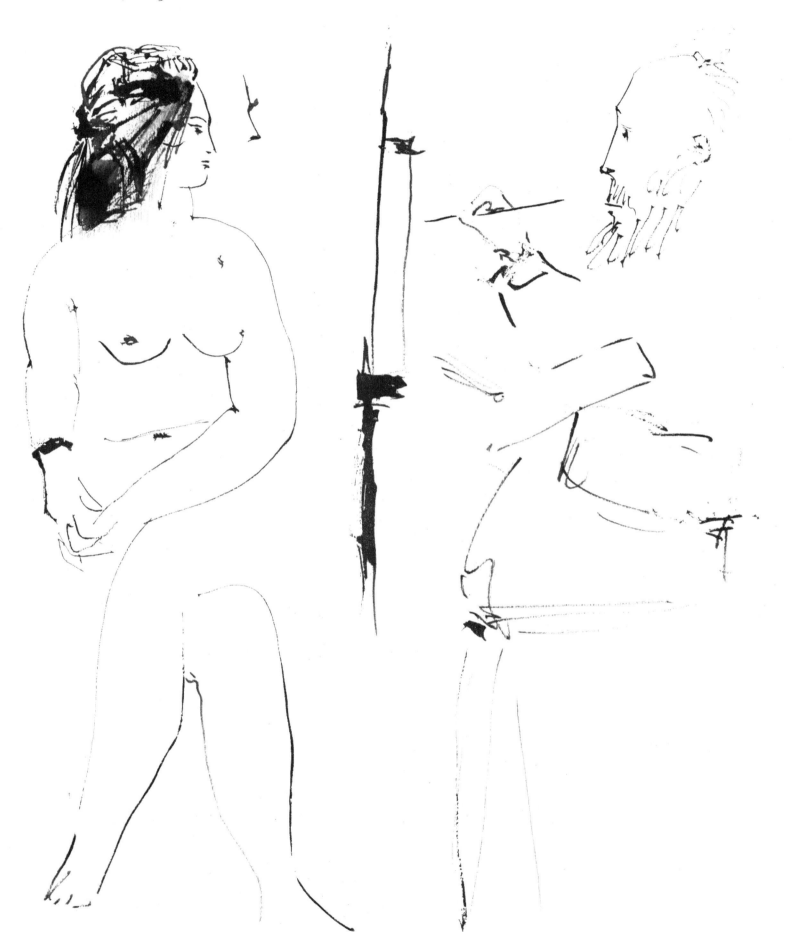

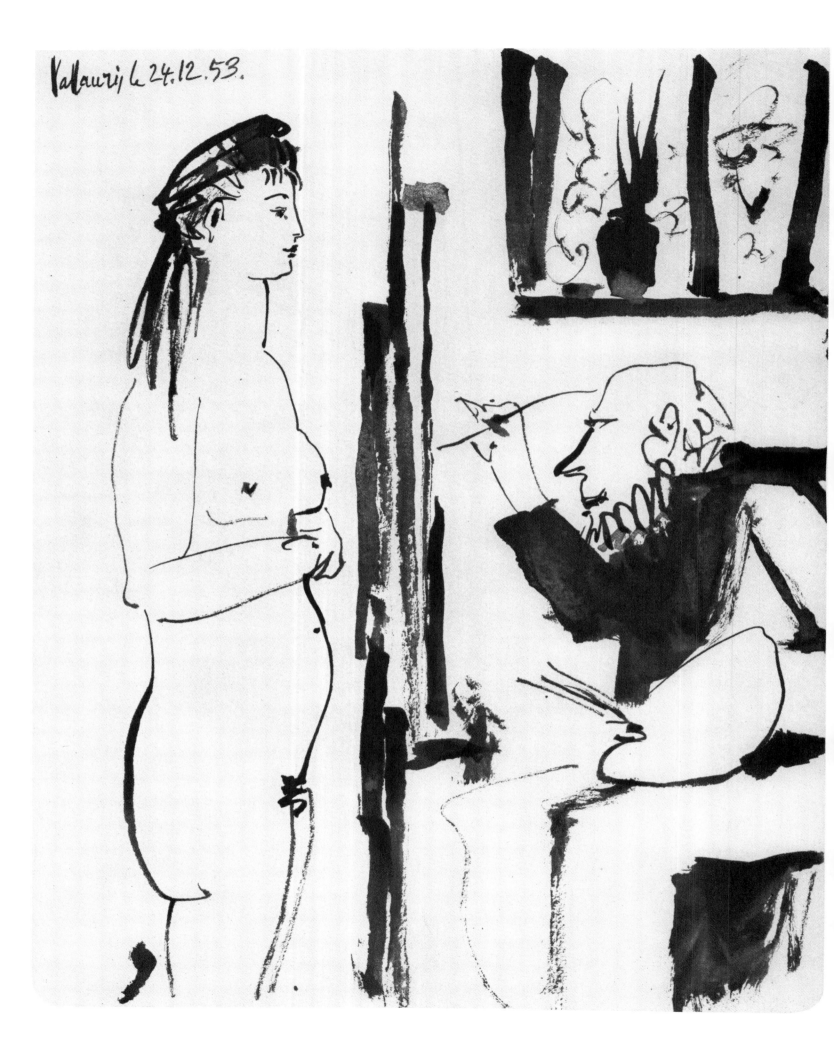

Vallauris le 24.12.53.

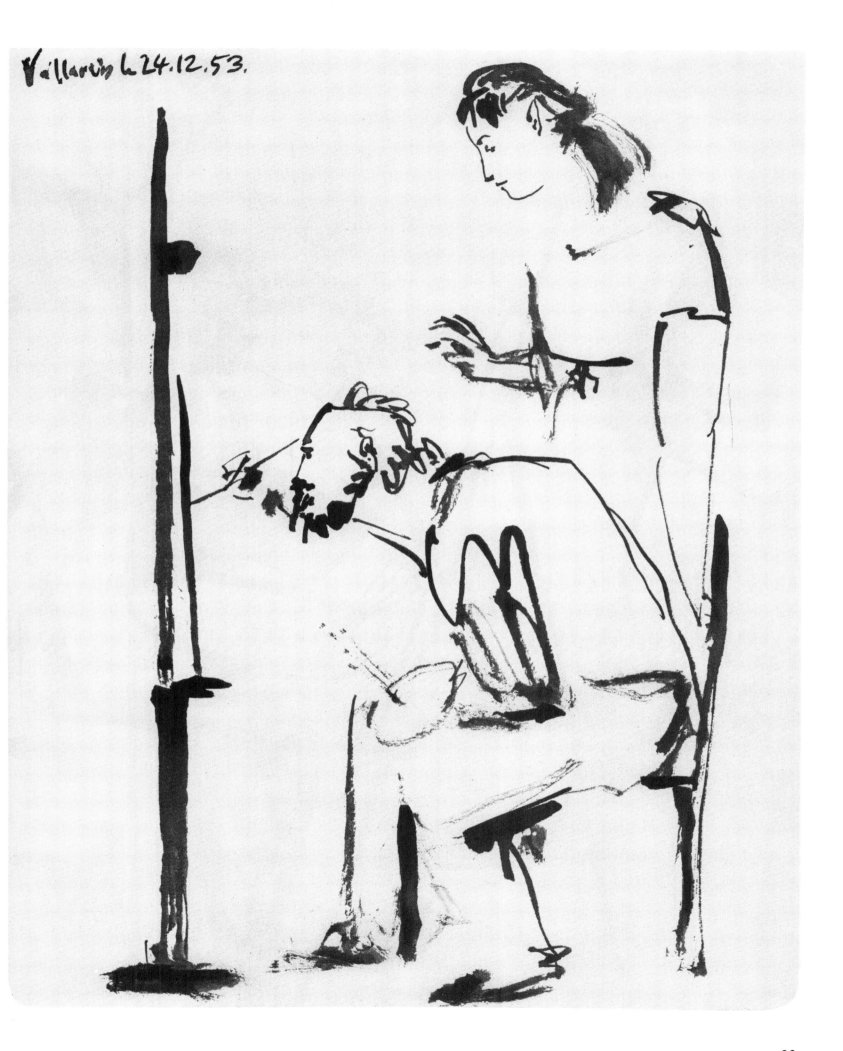

Vallauris le 24.12.53.

23

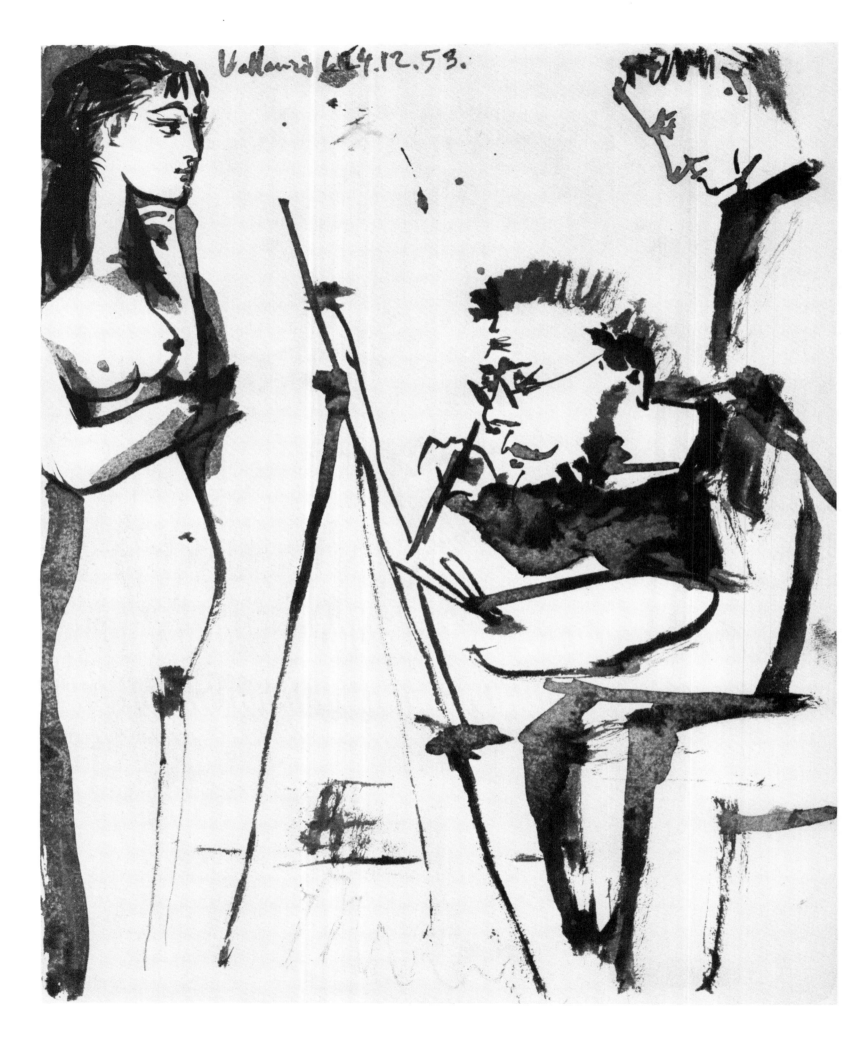

Vallauris 4.12.53.

24

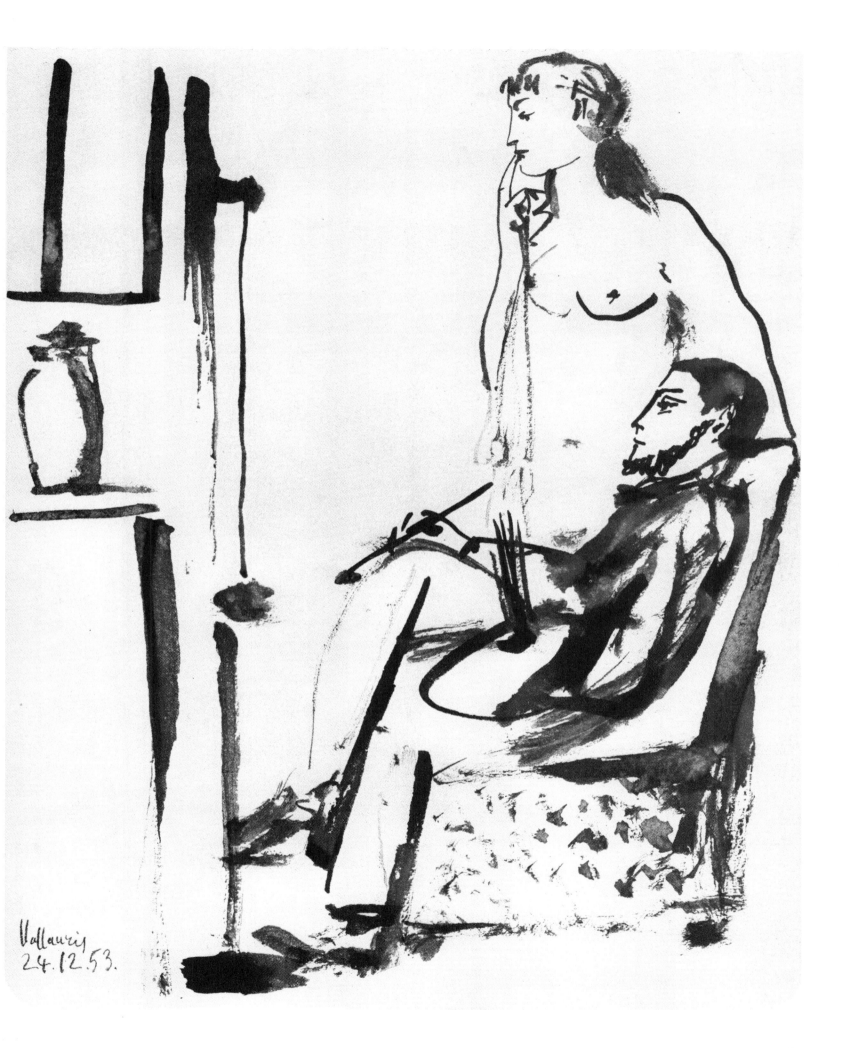

Vallauris
24.12.53.

25

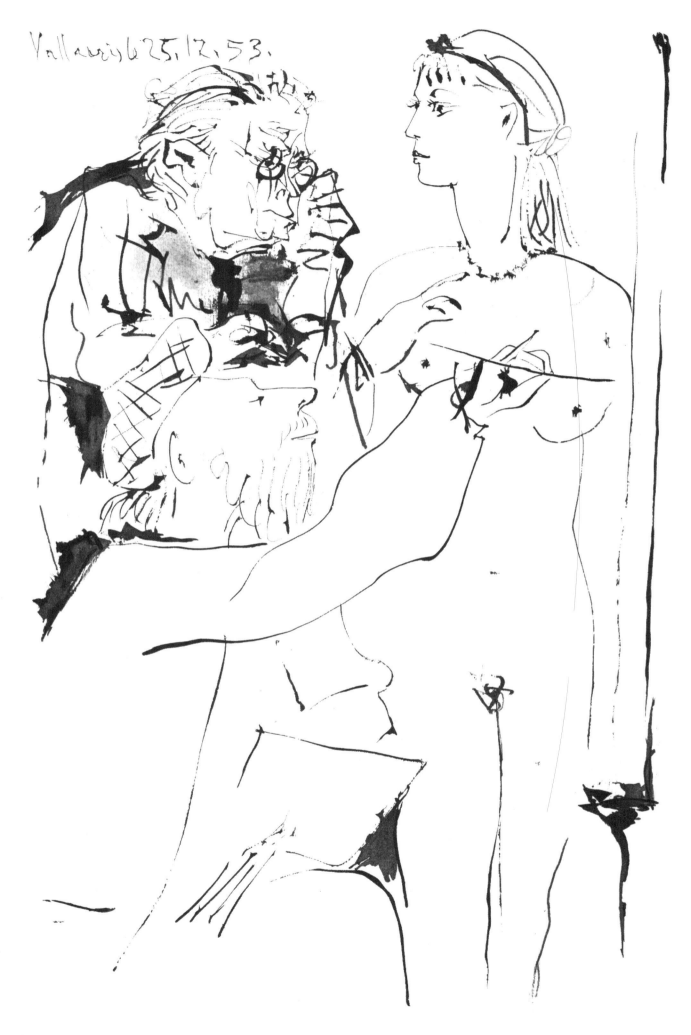

Vallauris 25.12.53.

26

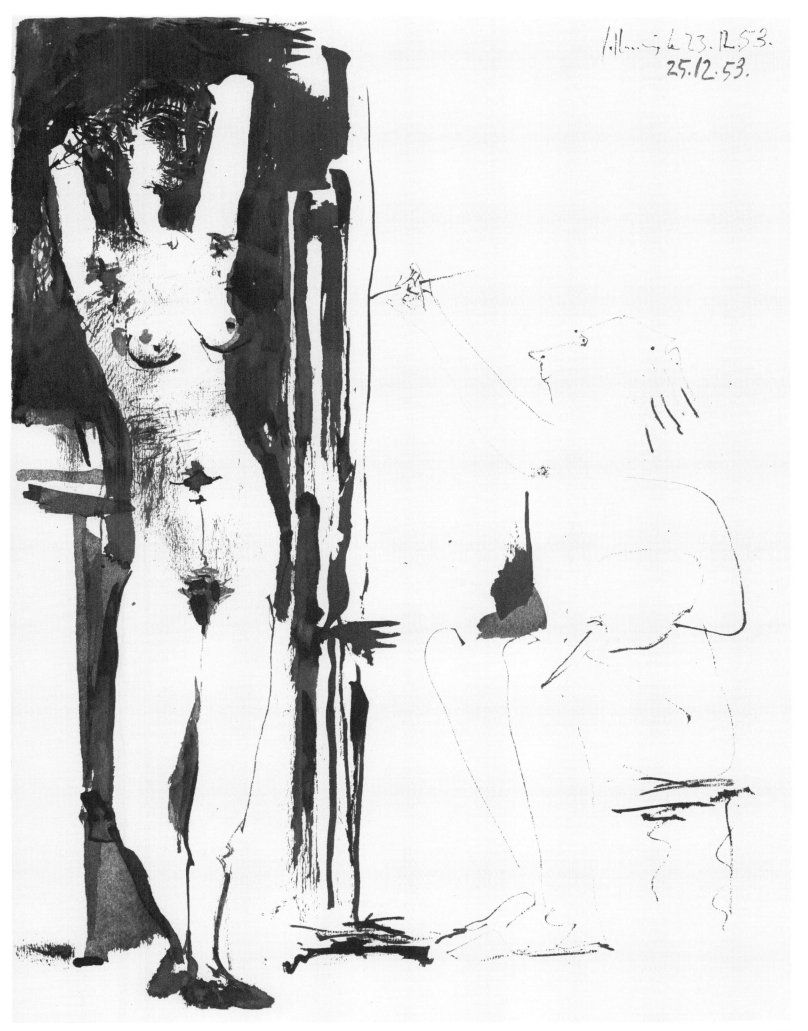

25.12.53.

27

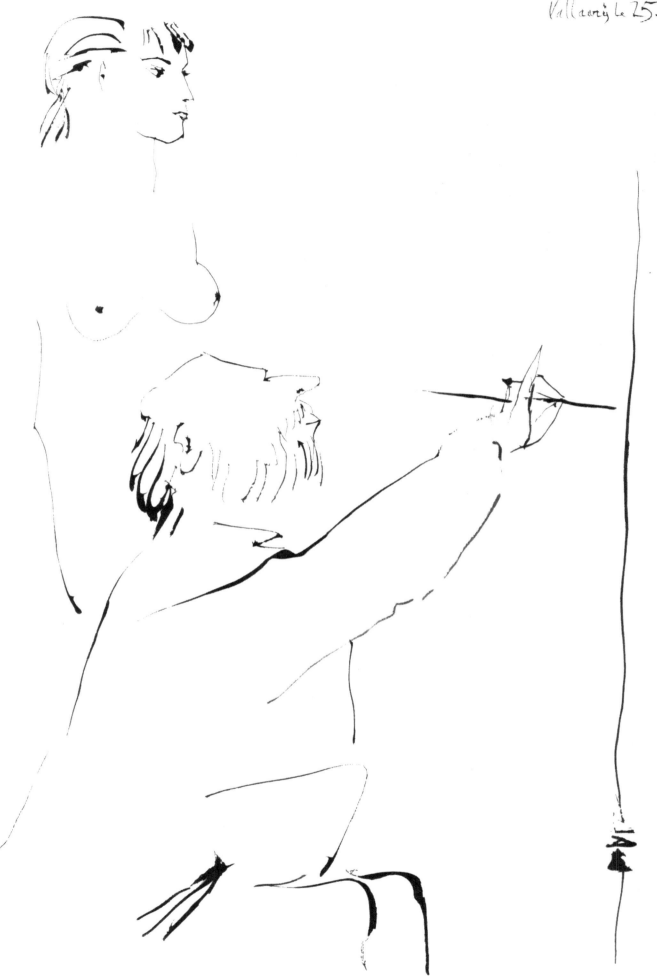

Vallauris le 25.12.53.

28

Vallauris le 25.12.53.

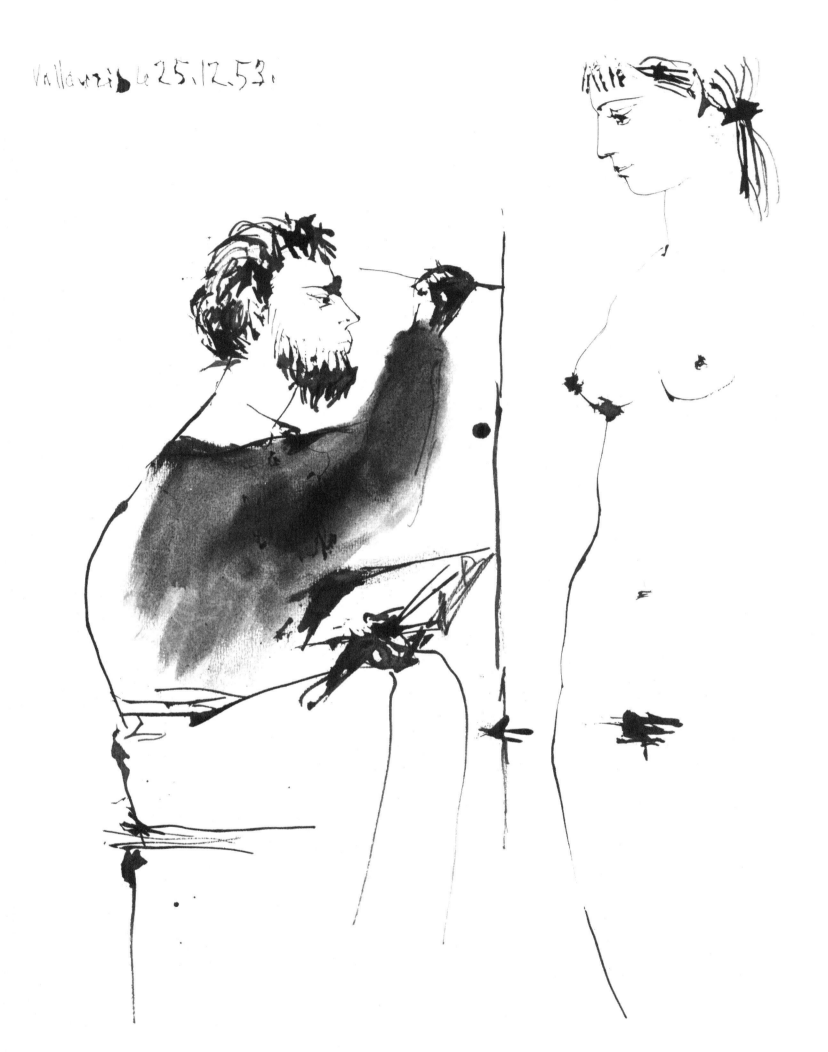

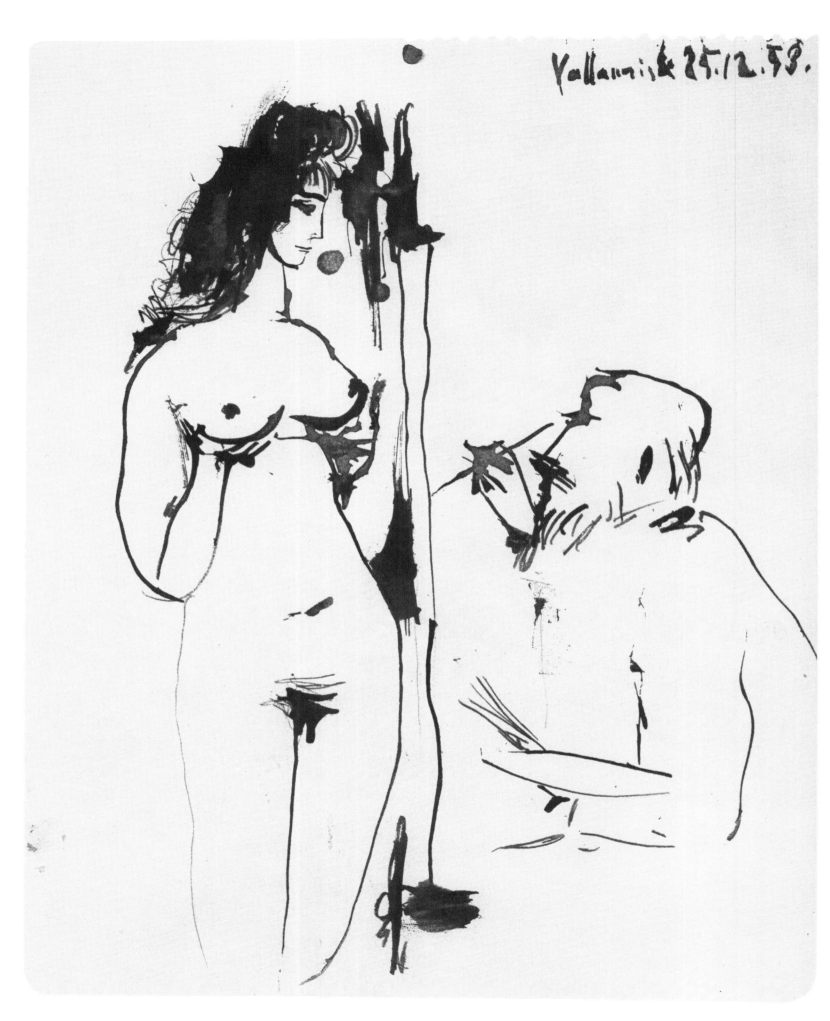

Vallauris 25.12.53.

30

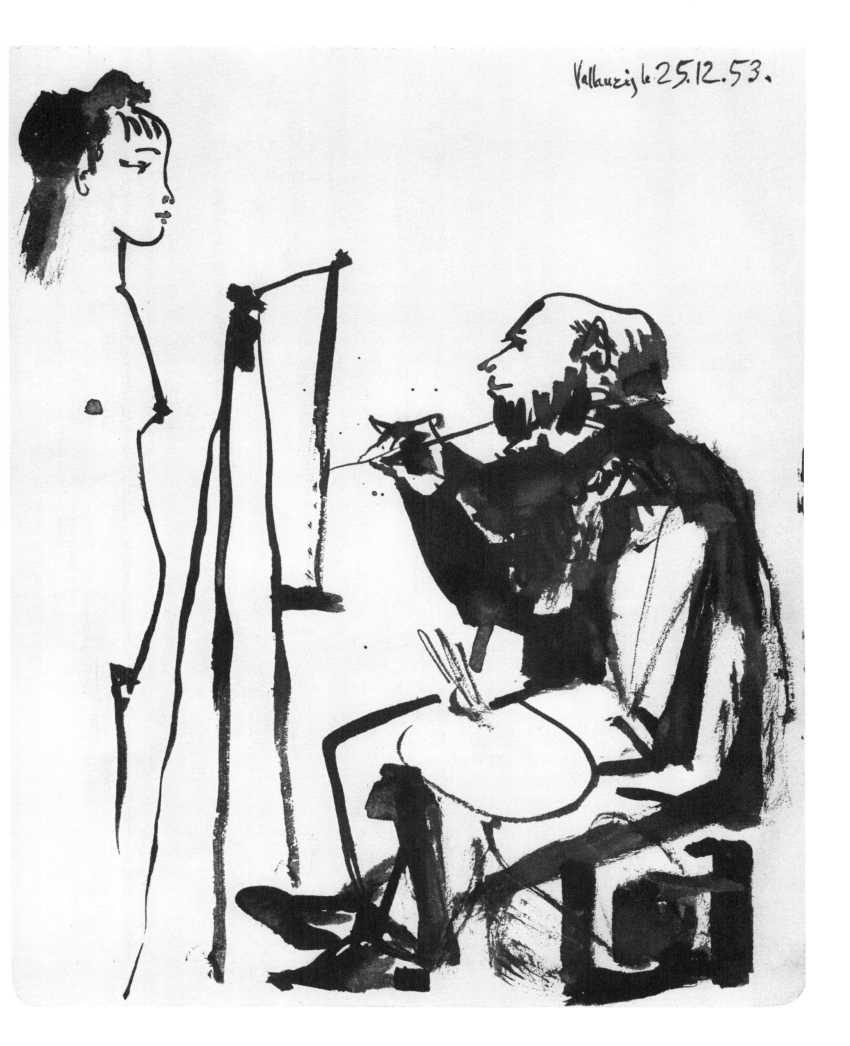

Vallauris le 25.12.53.

31

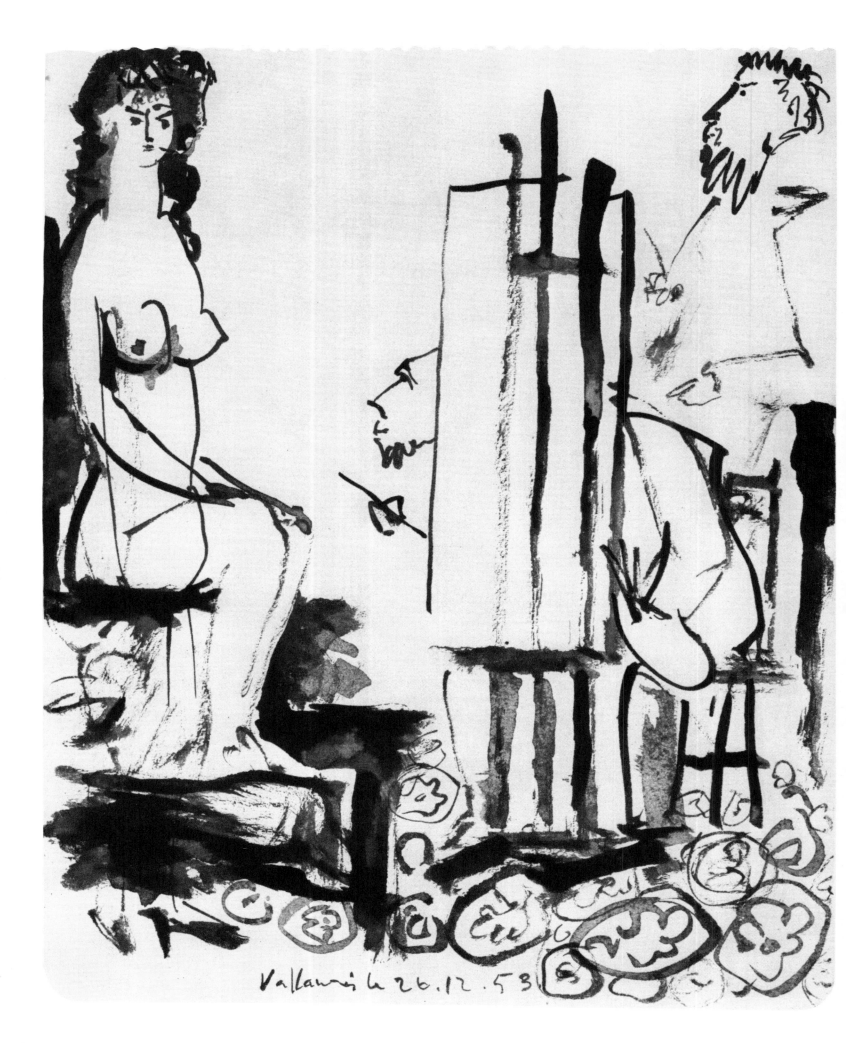

Vallauris le 26.12.53

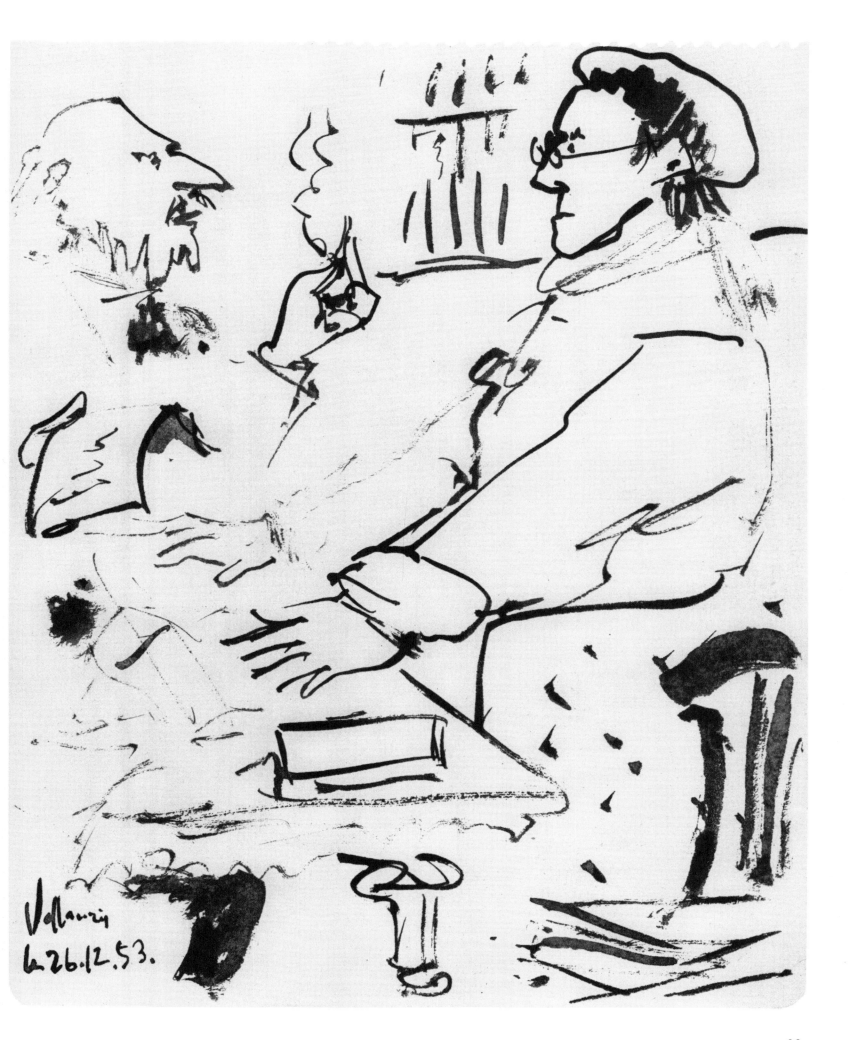

Vallauris
le 26.12.53.

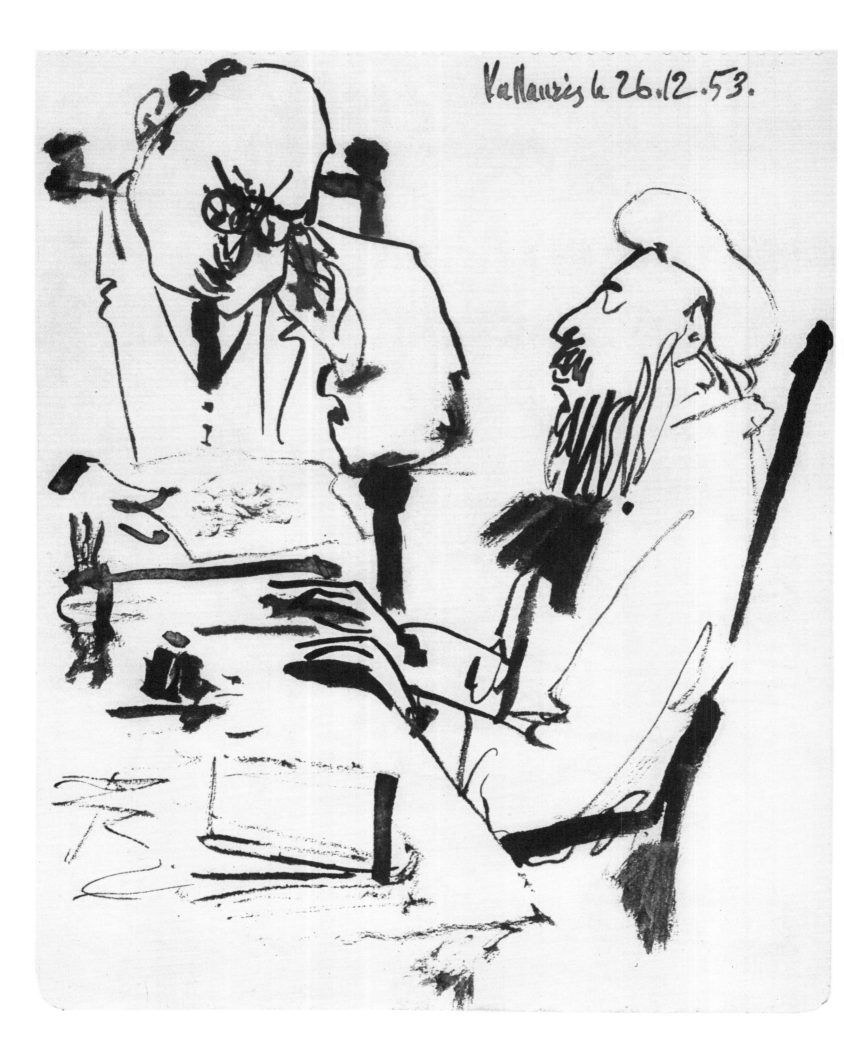

Vallauris le 26.12.53.

34

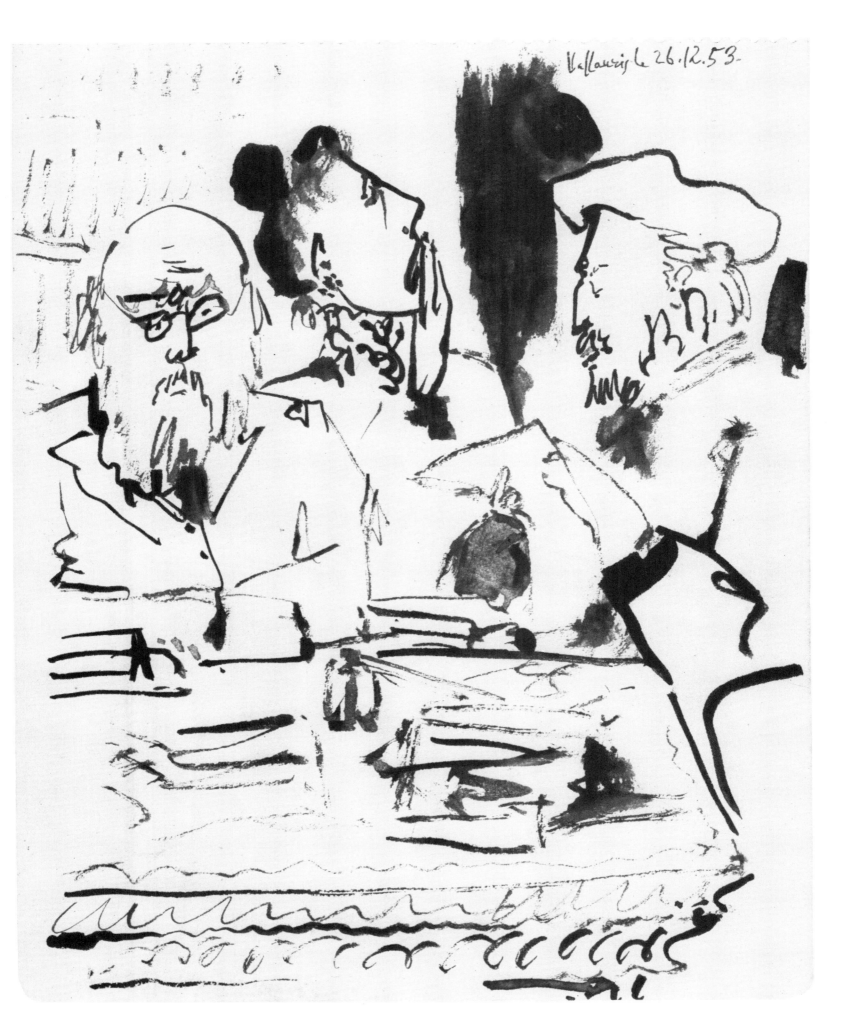

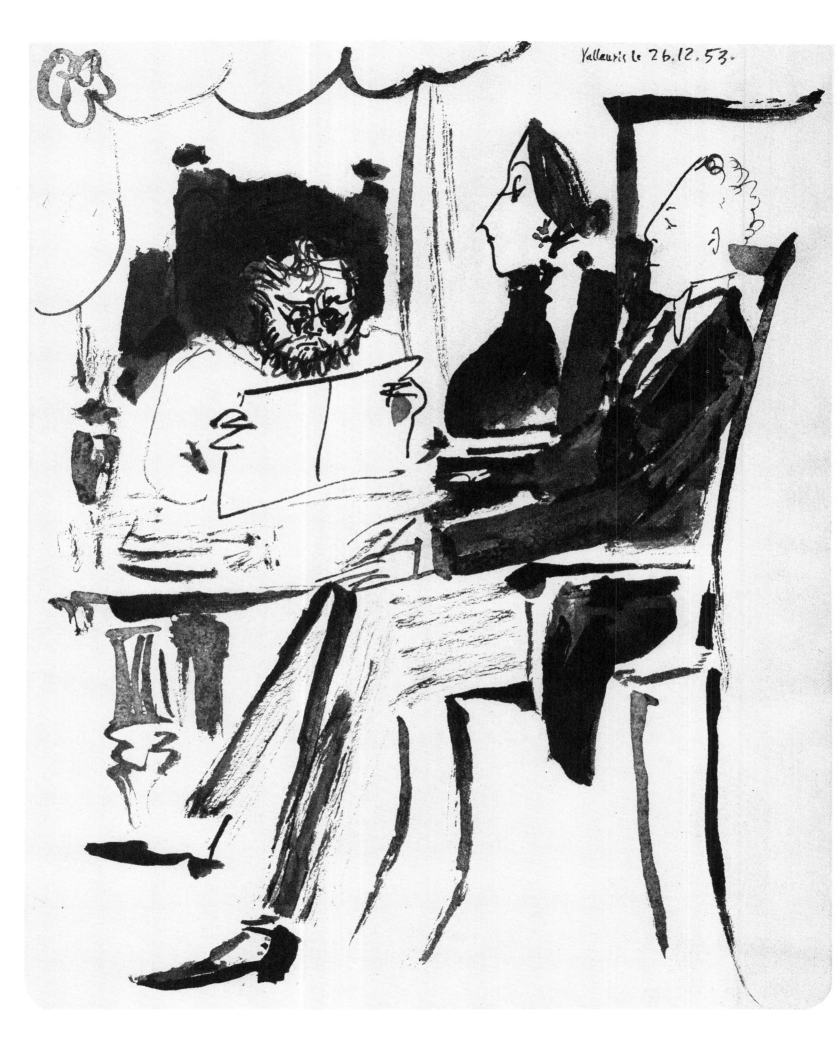

Vallauris le 26.12.53.

36

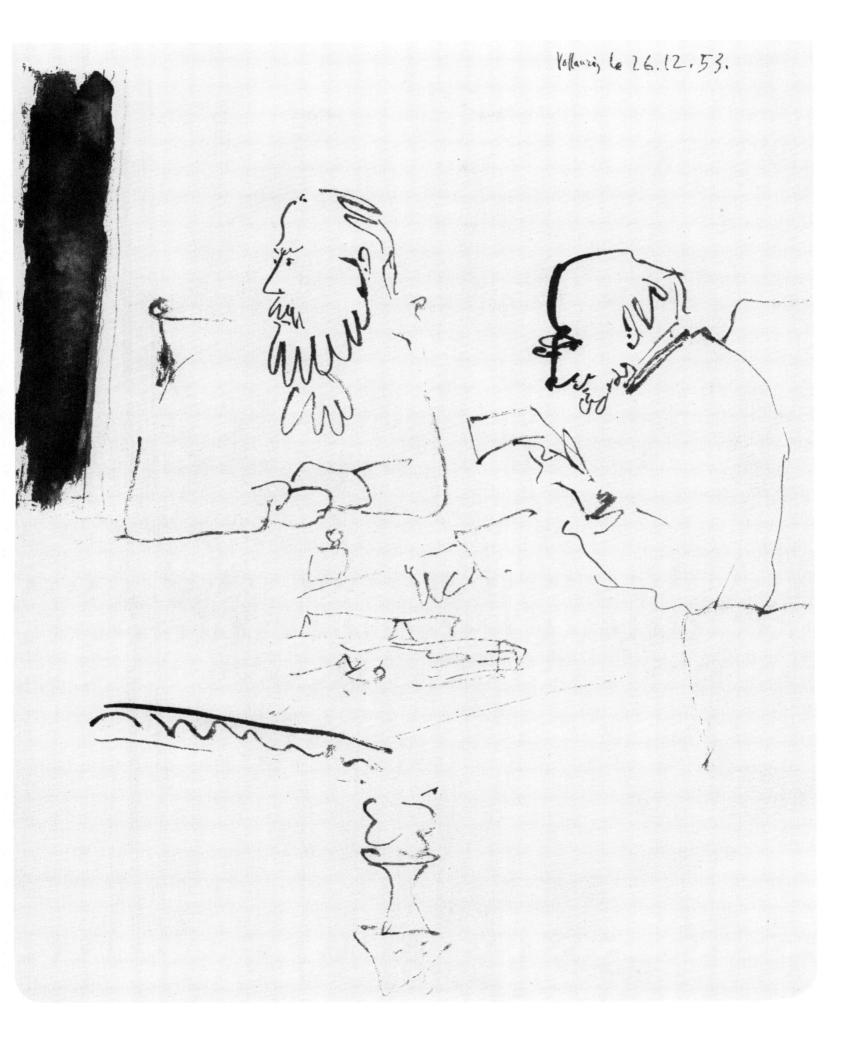

Vallauris le 26.12.53.

37

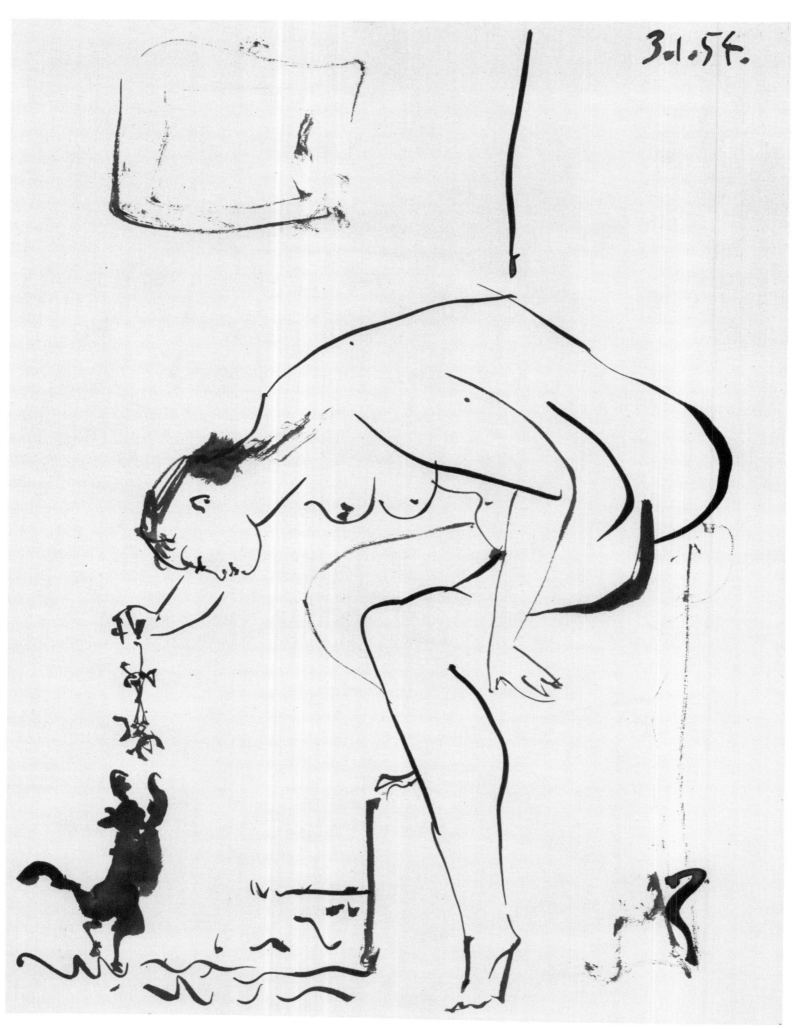

38

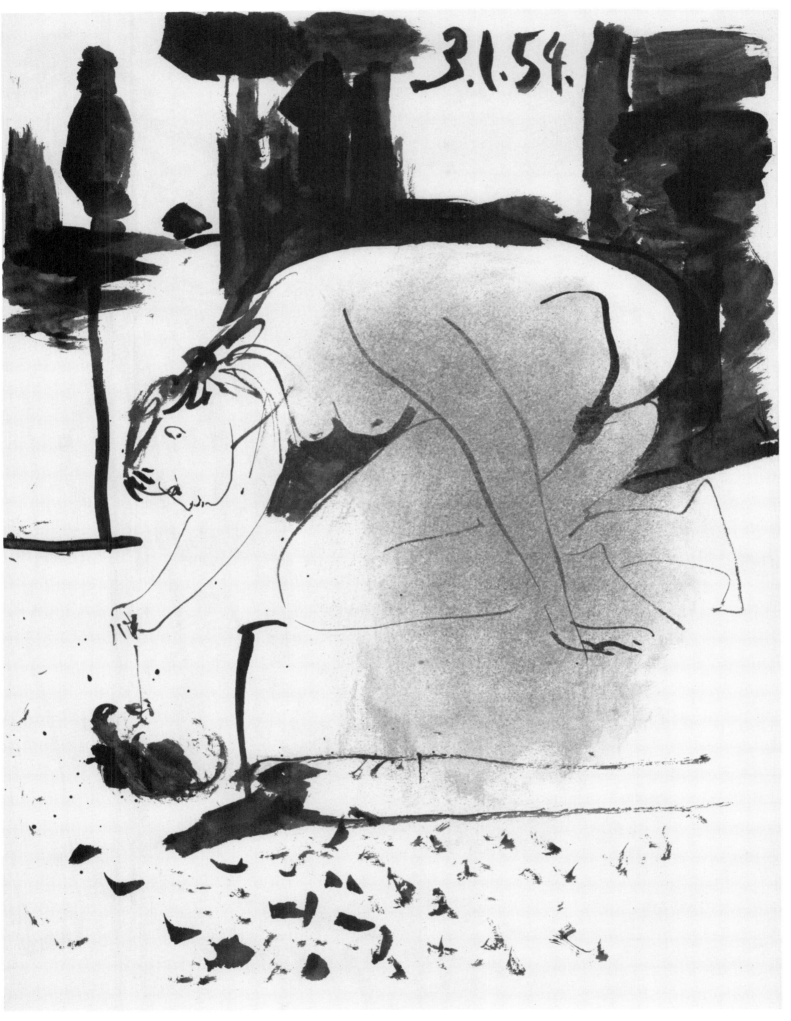

3.1.54.

39

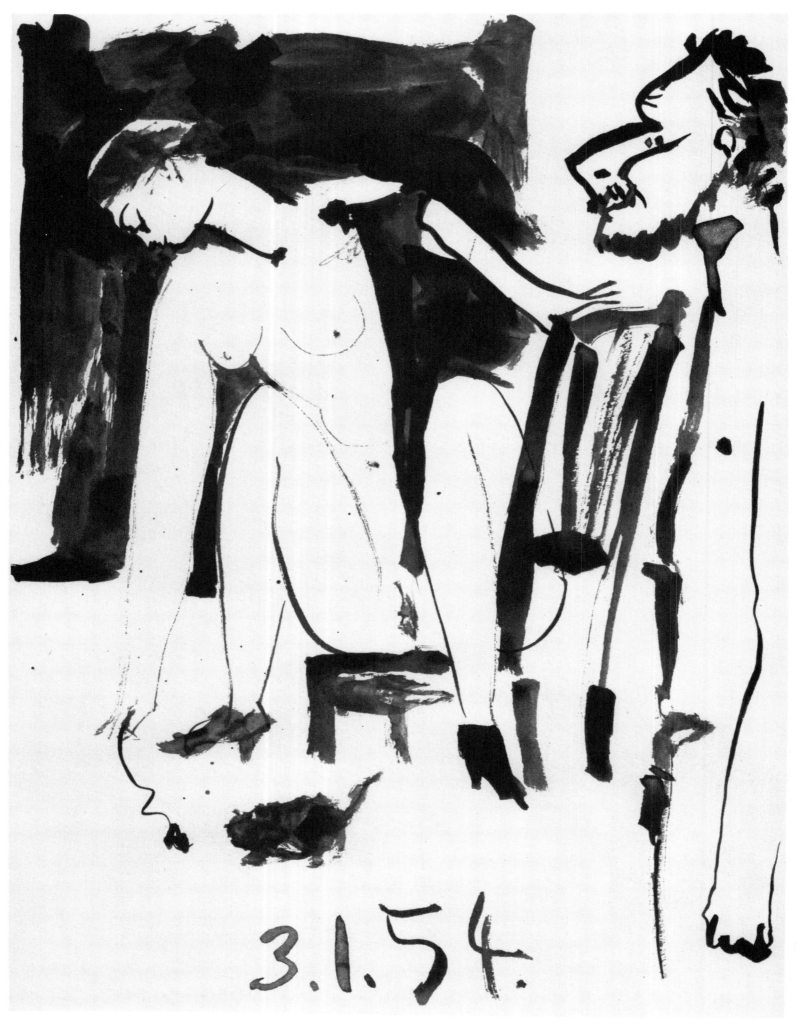

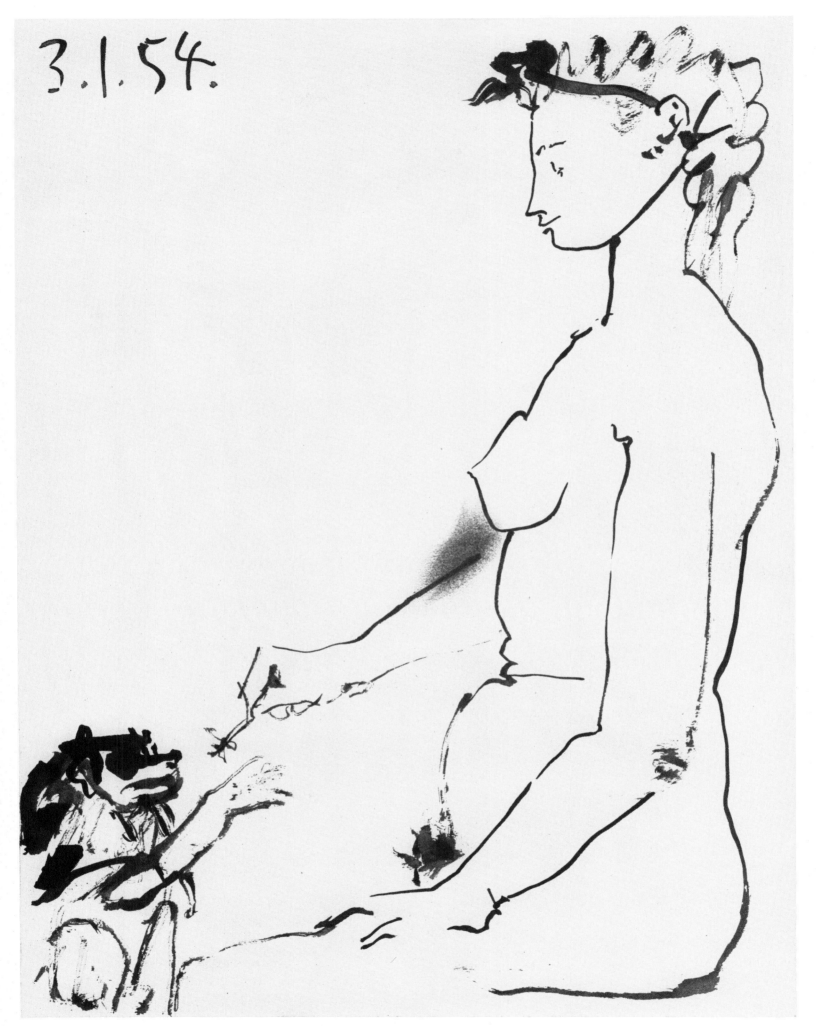

3.1.54.

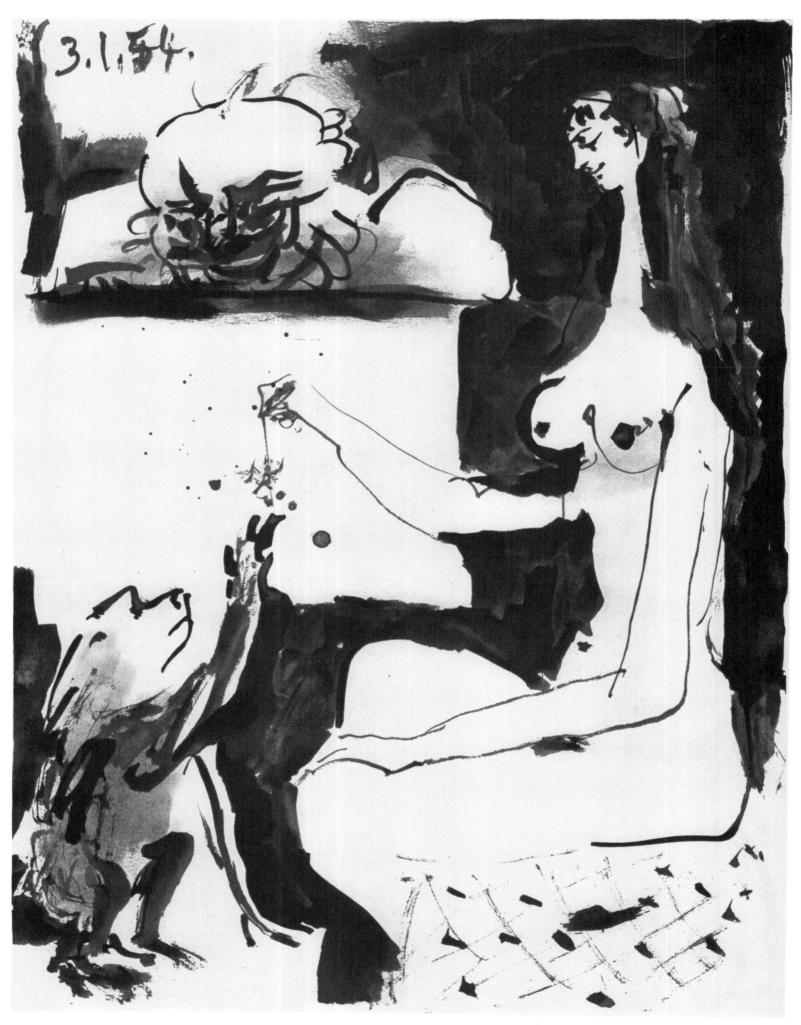

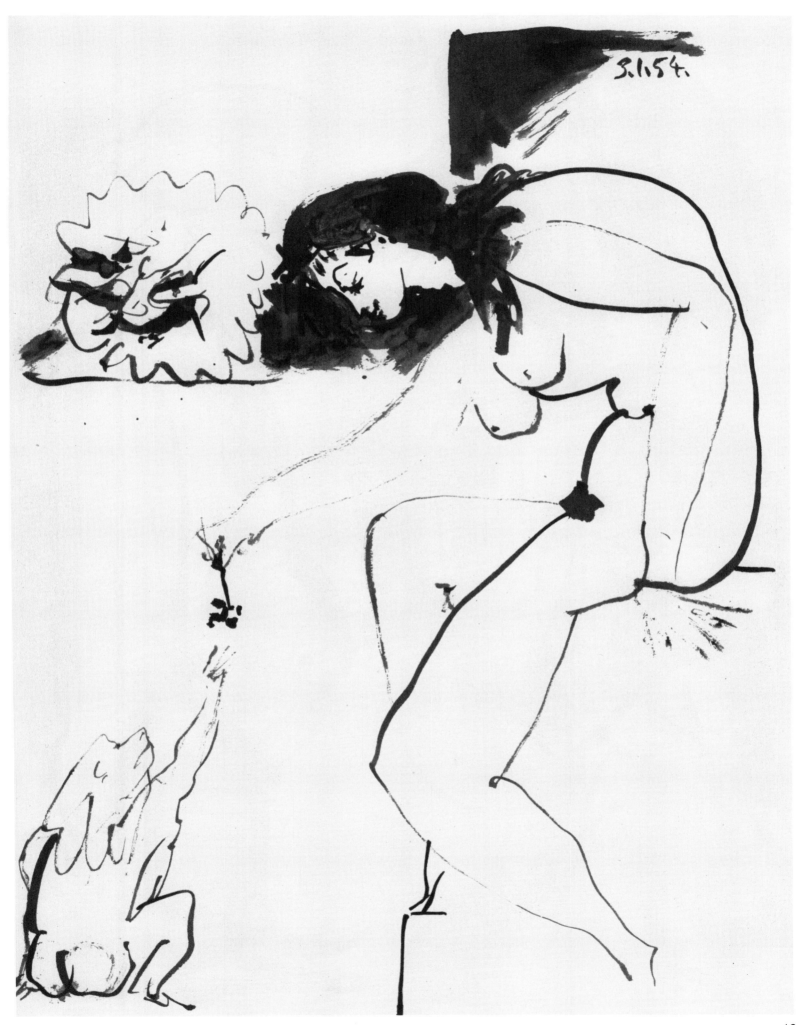

43

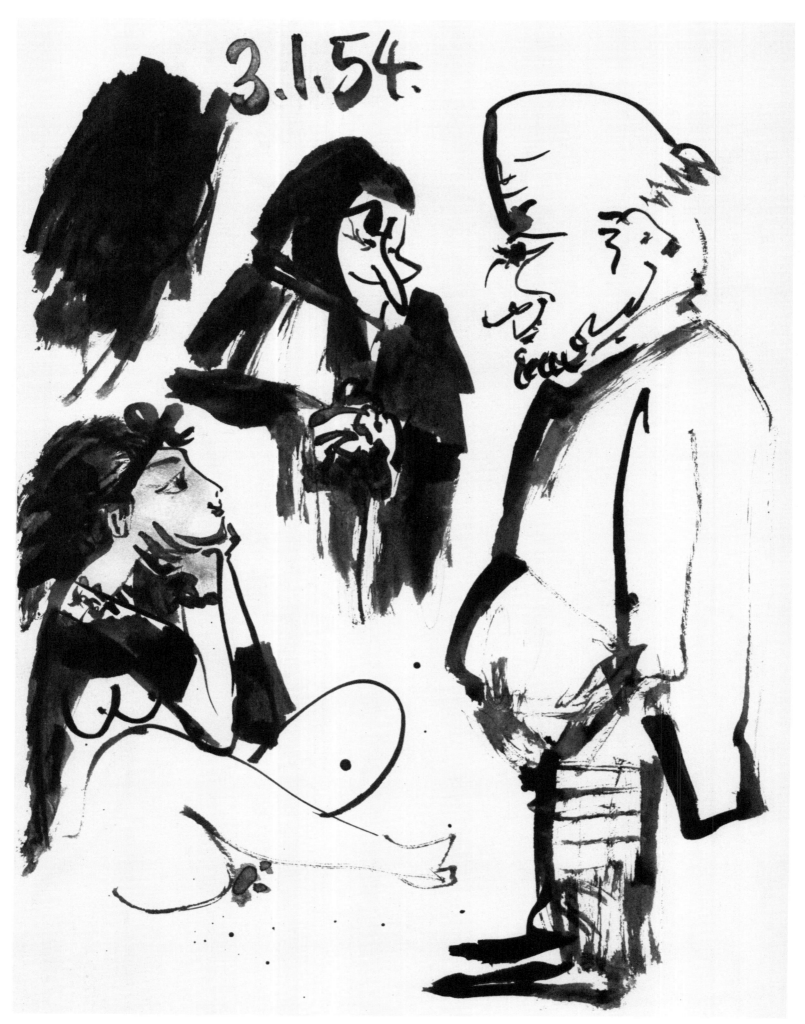

44

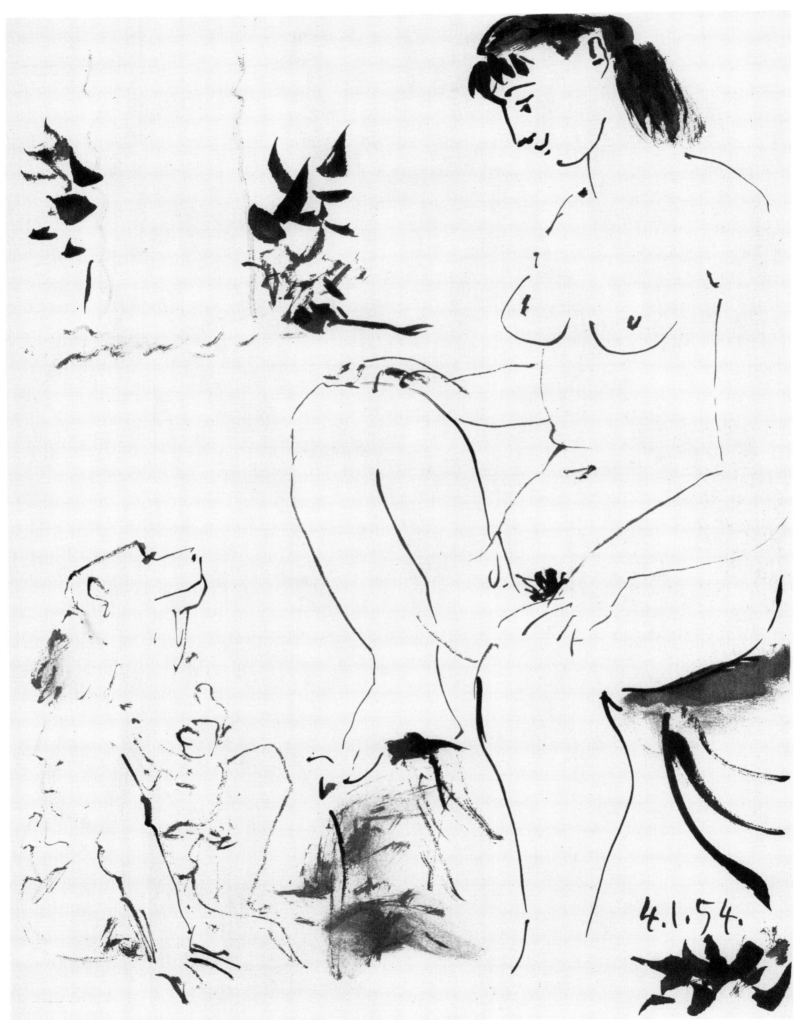

4.1.54.

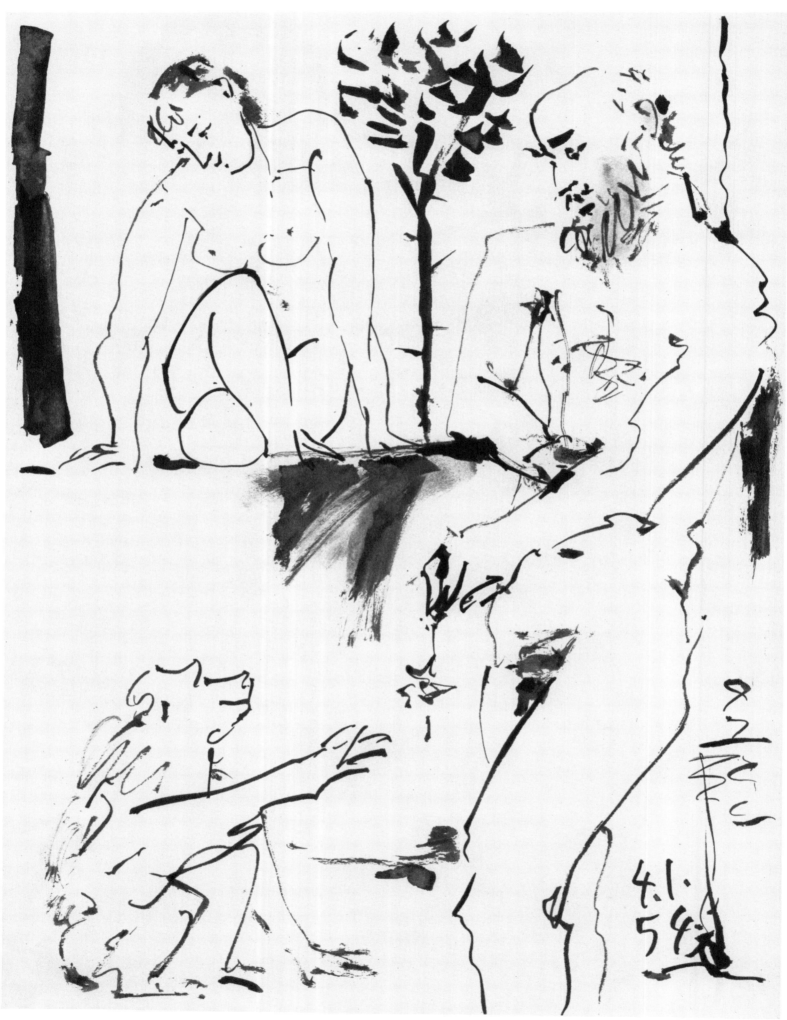

46

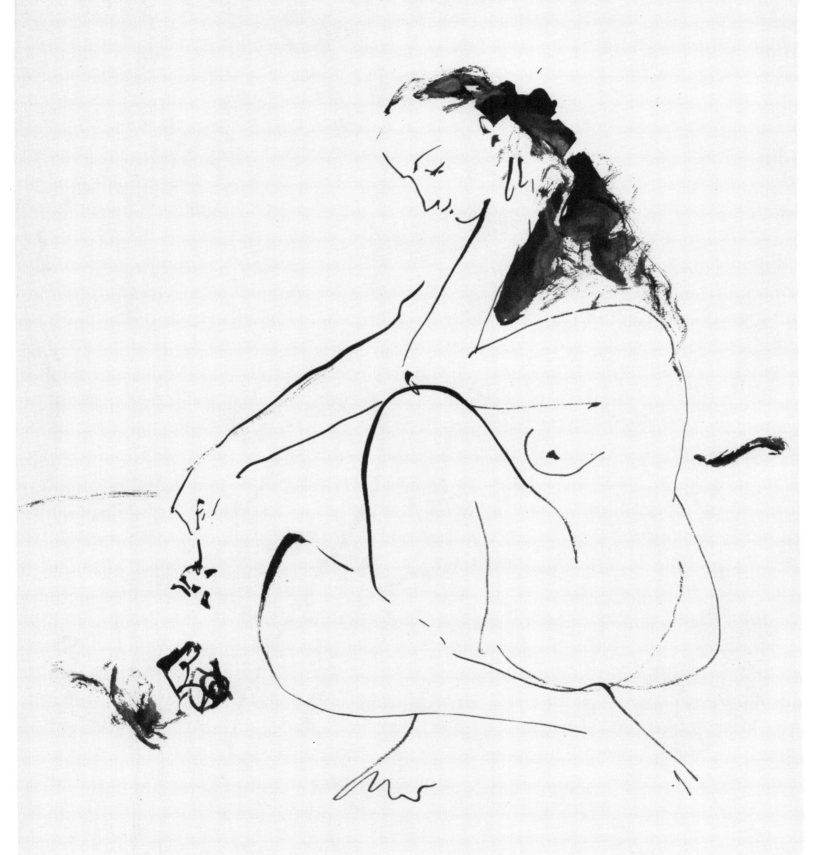

4-1.54.

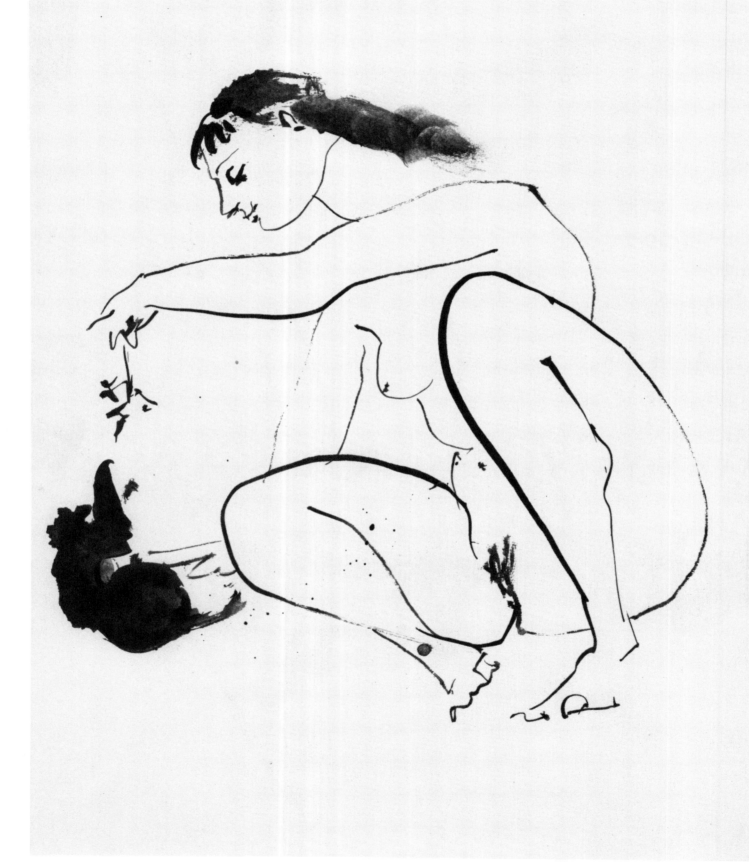

4.1.54.

48

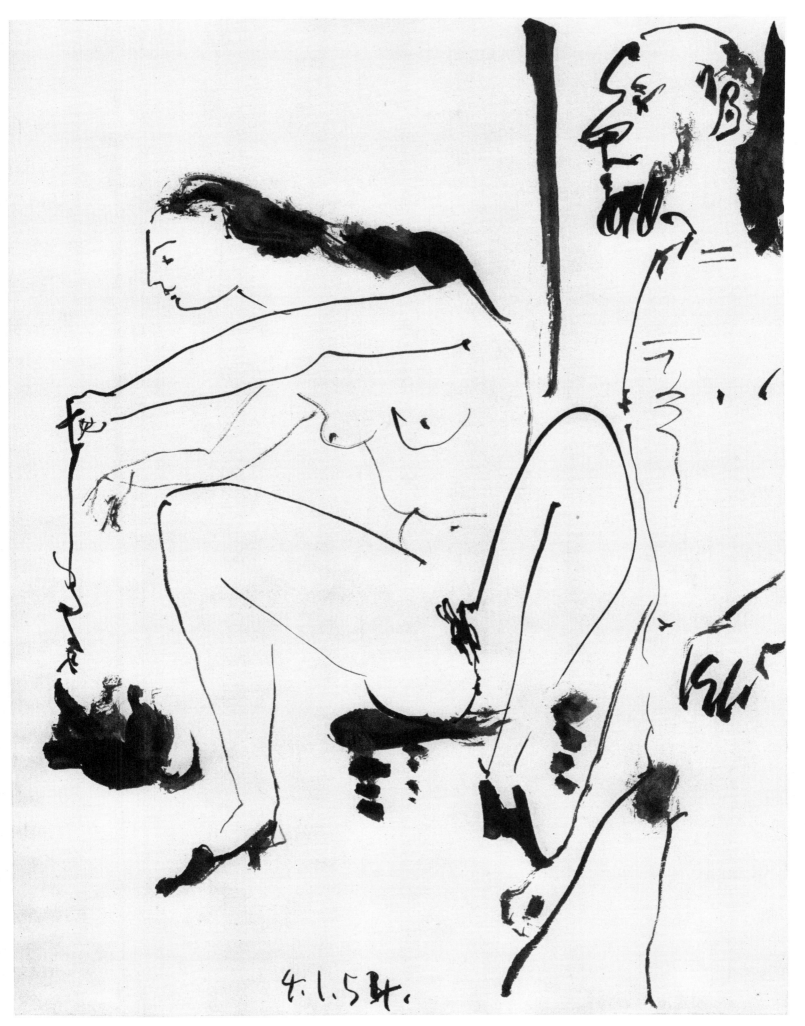

4.1.54.

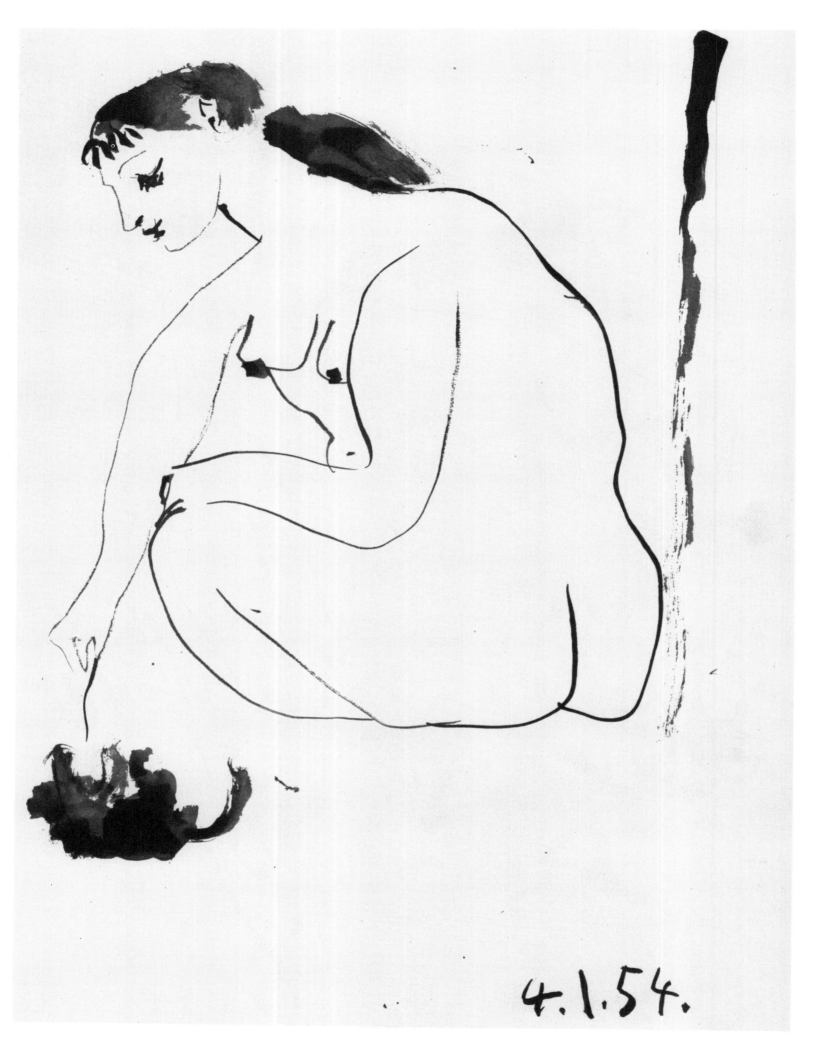

4.1.54.

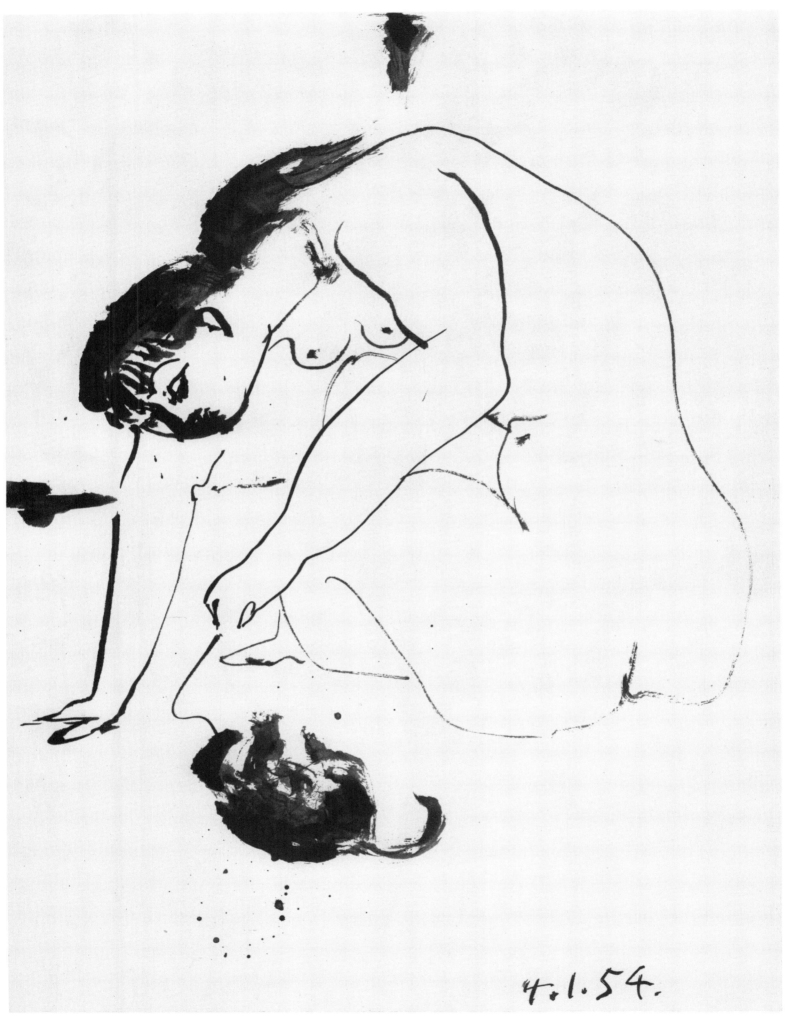

4.1.54.

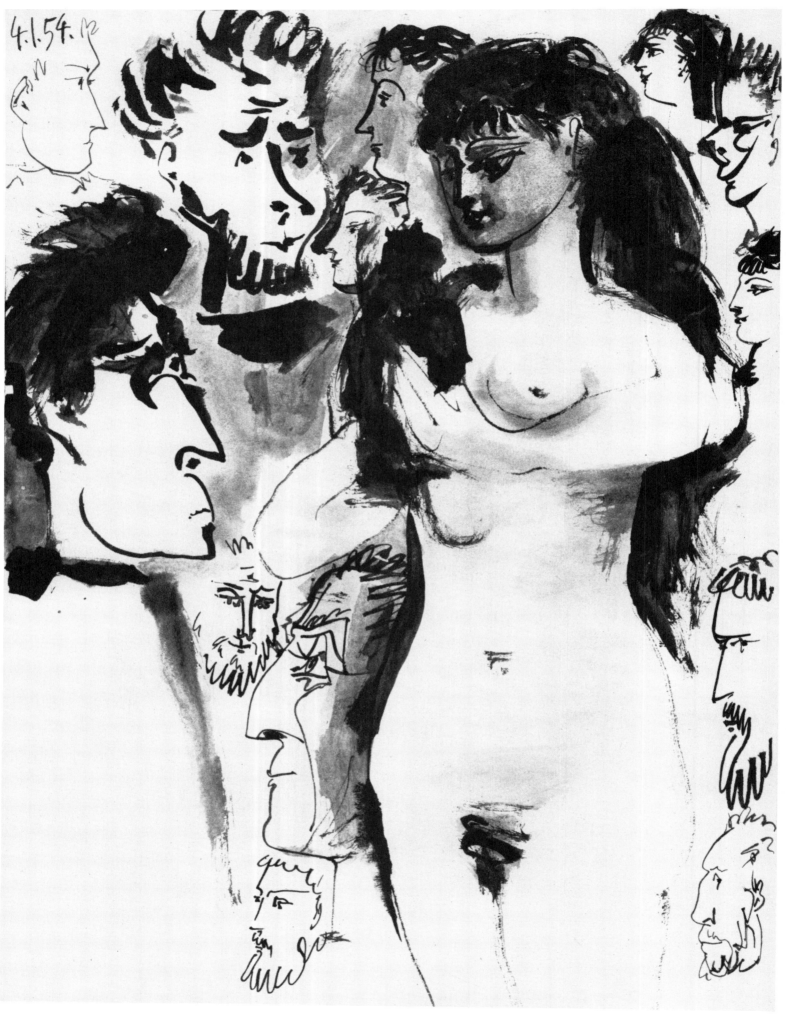

52

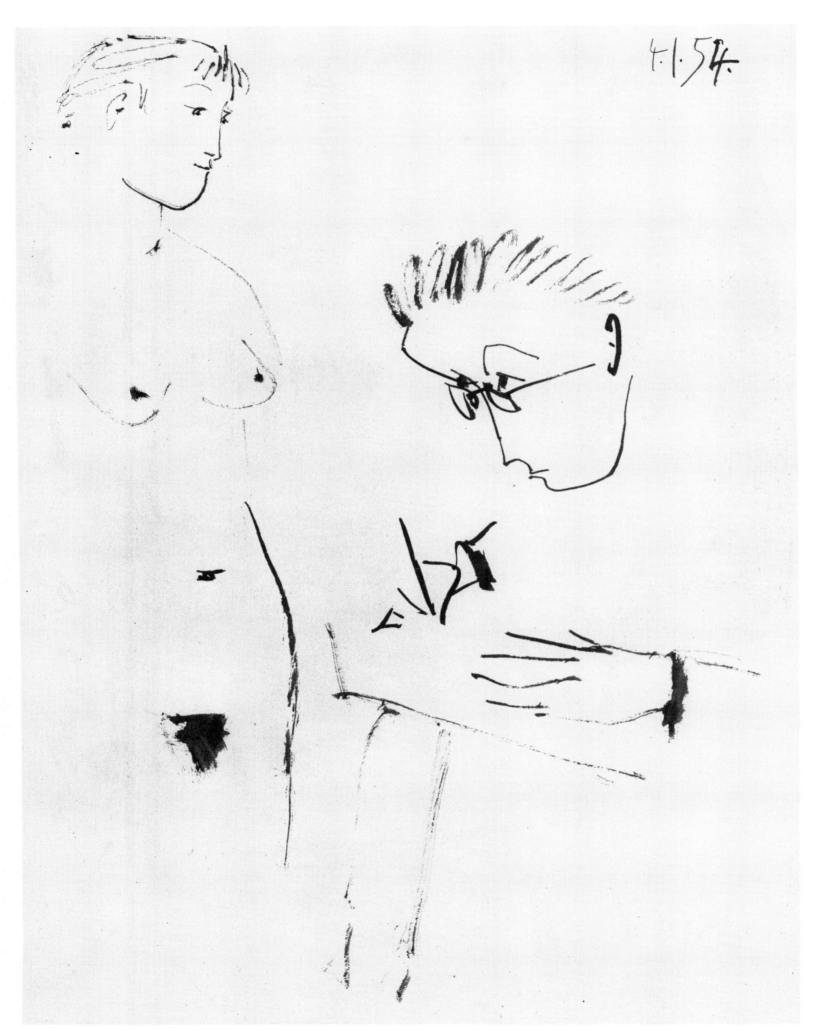

4·1·54.

53

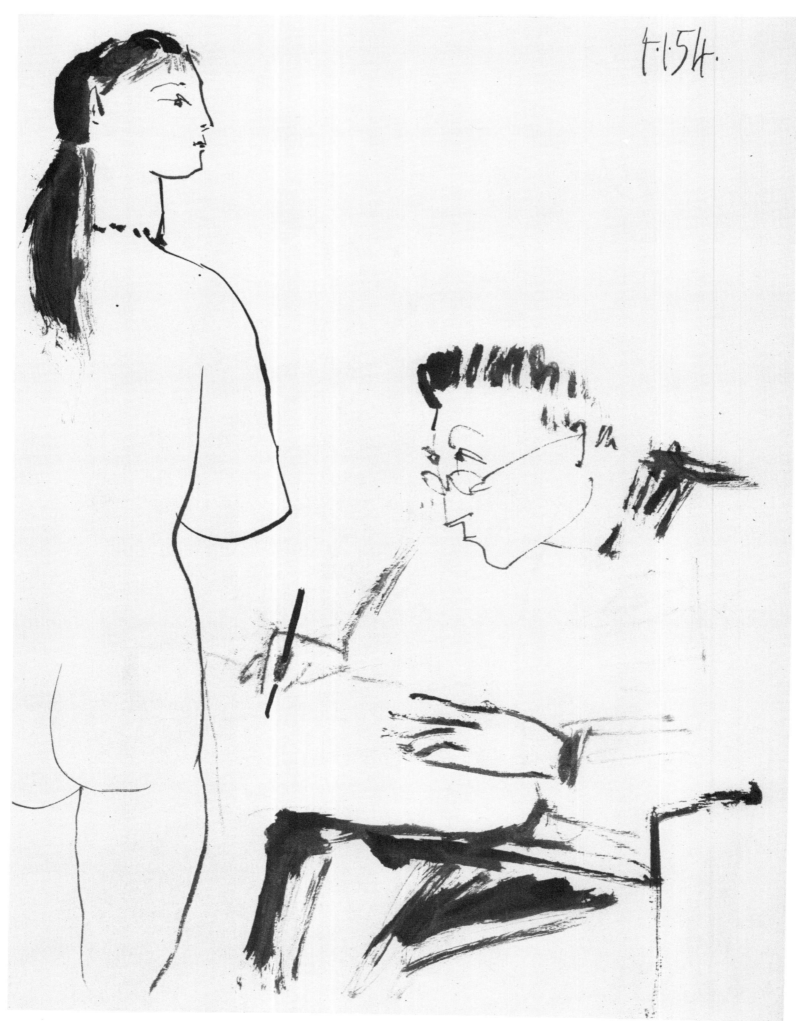

4.1.54.

54

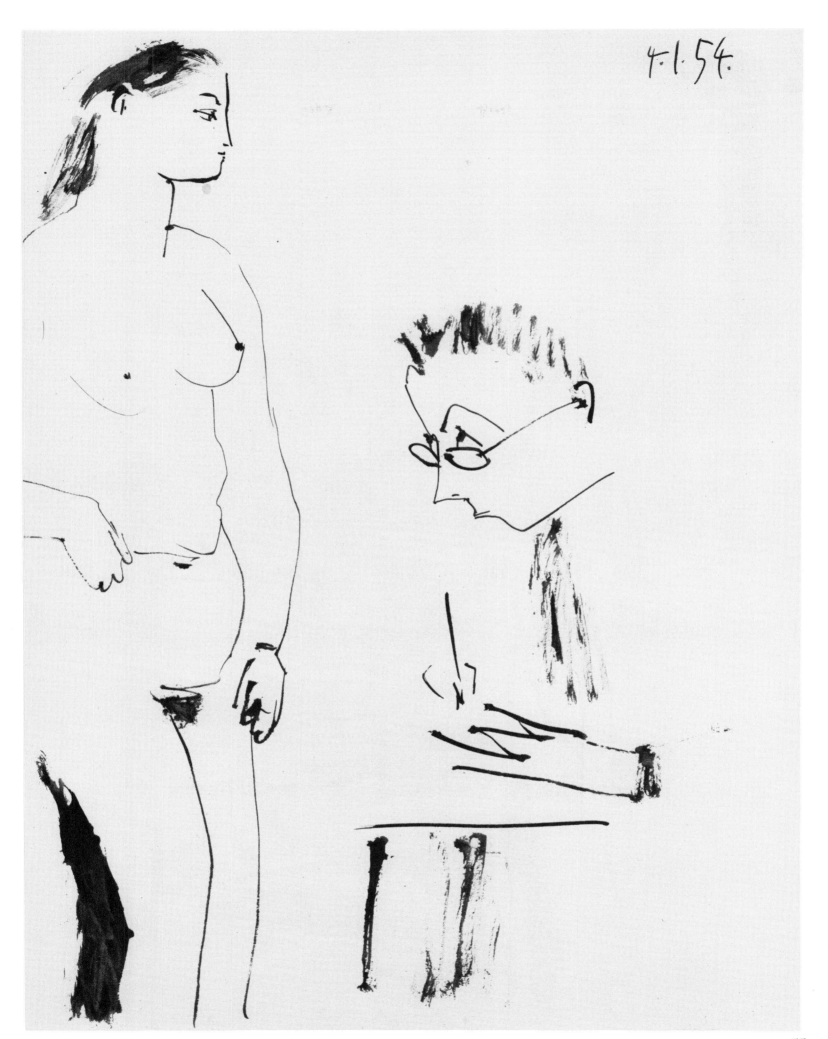

4·1·54.

55

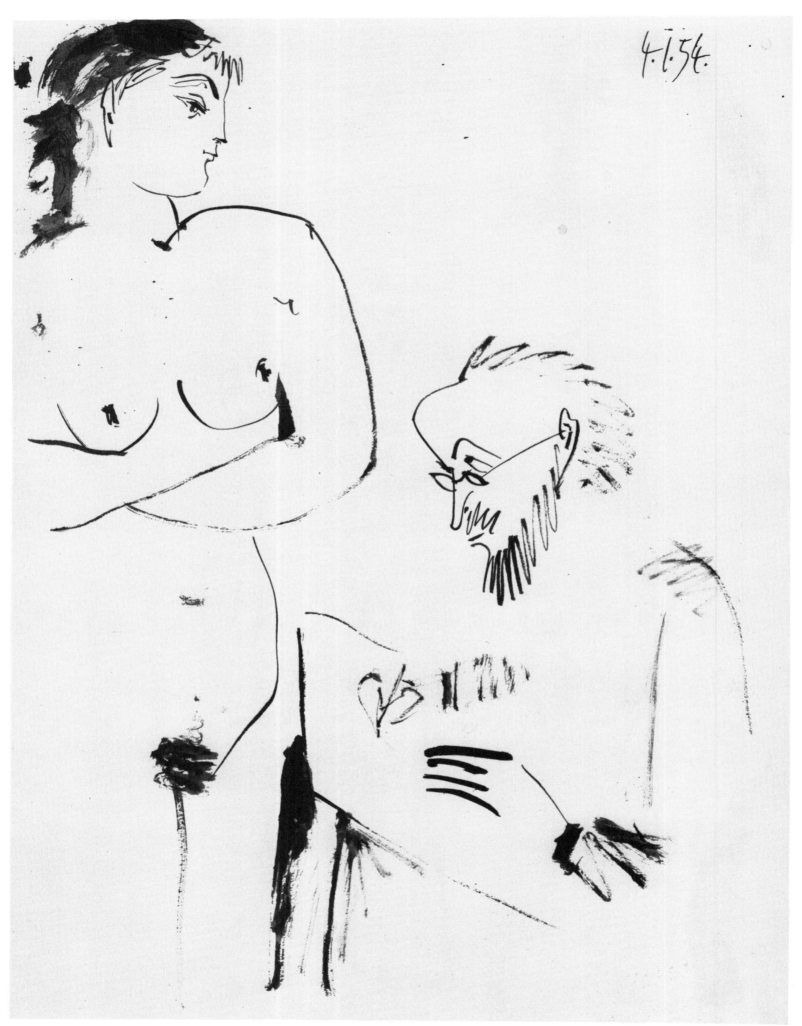

4.1.54.

56

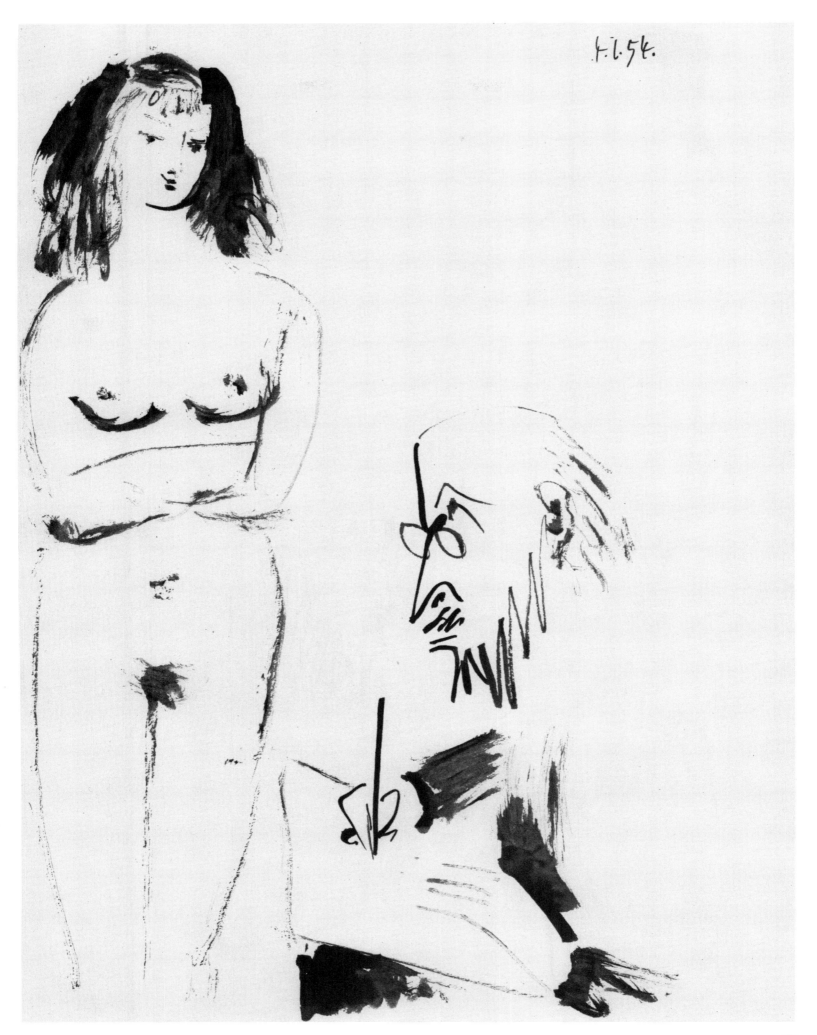

4.1.54.

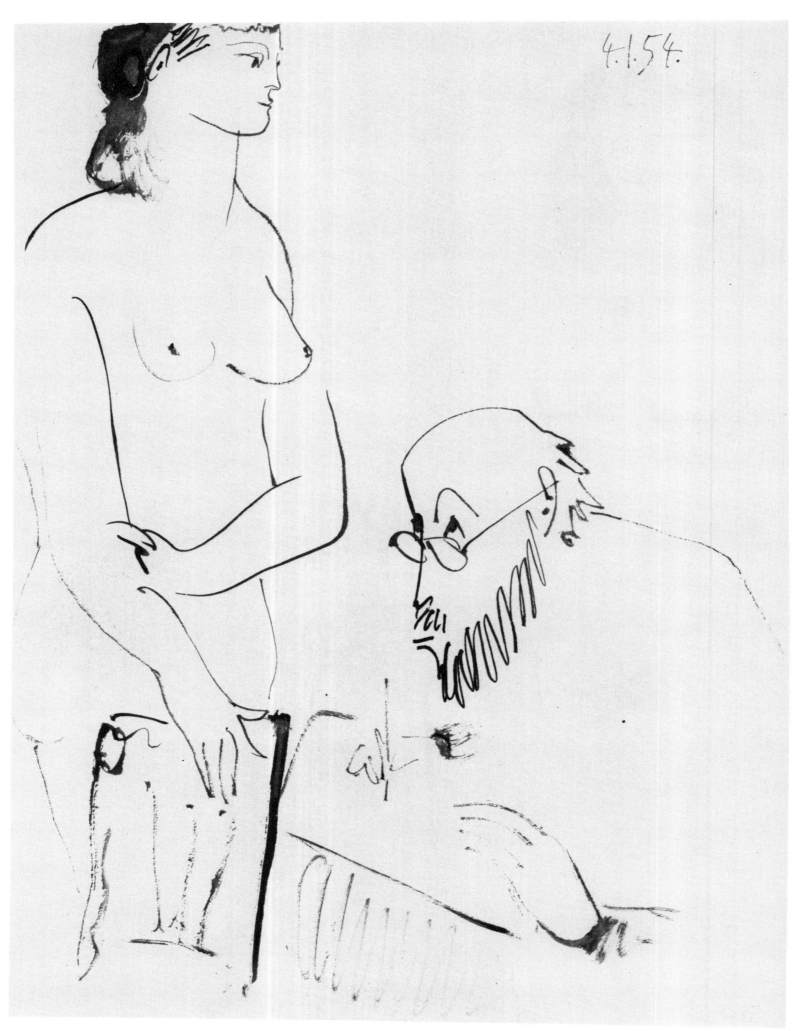

4.1.54.

58

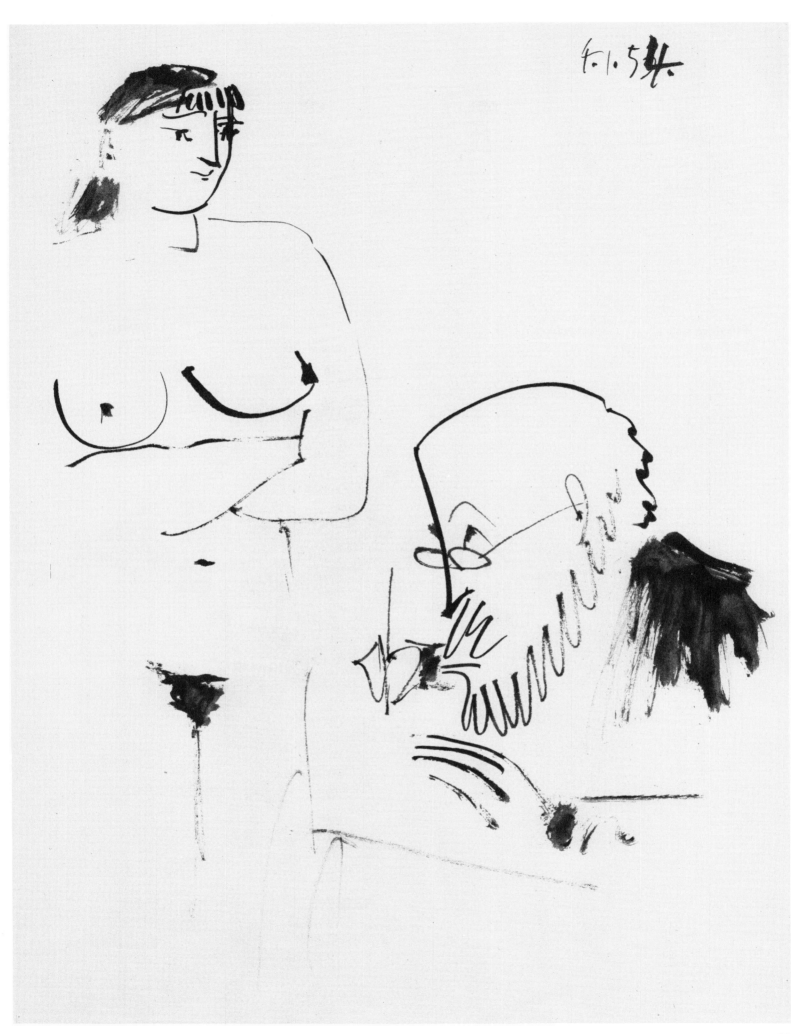

59

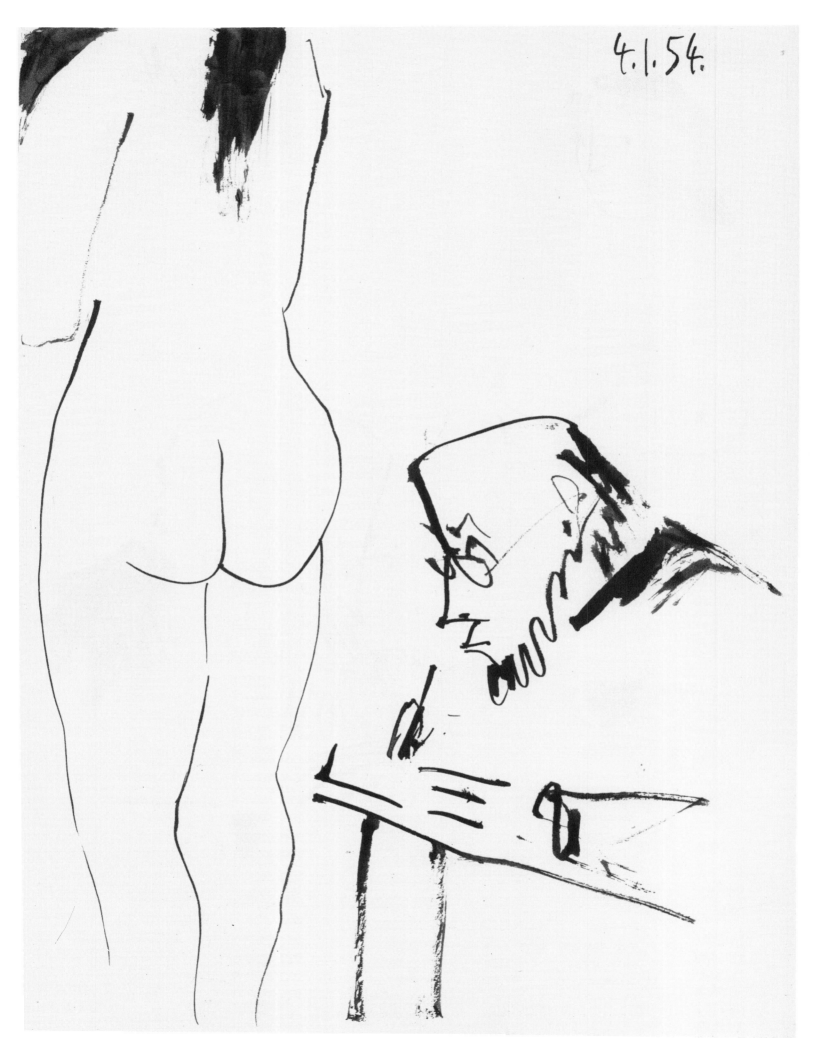

4.1.54.

60

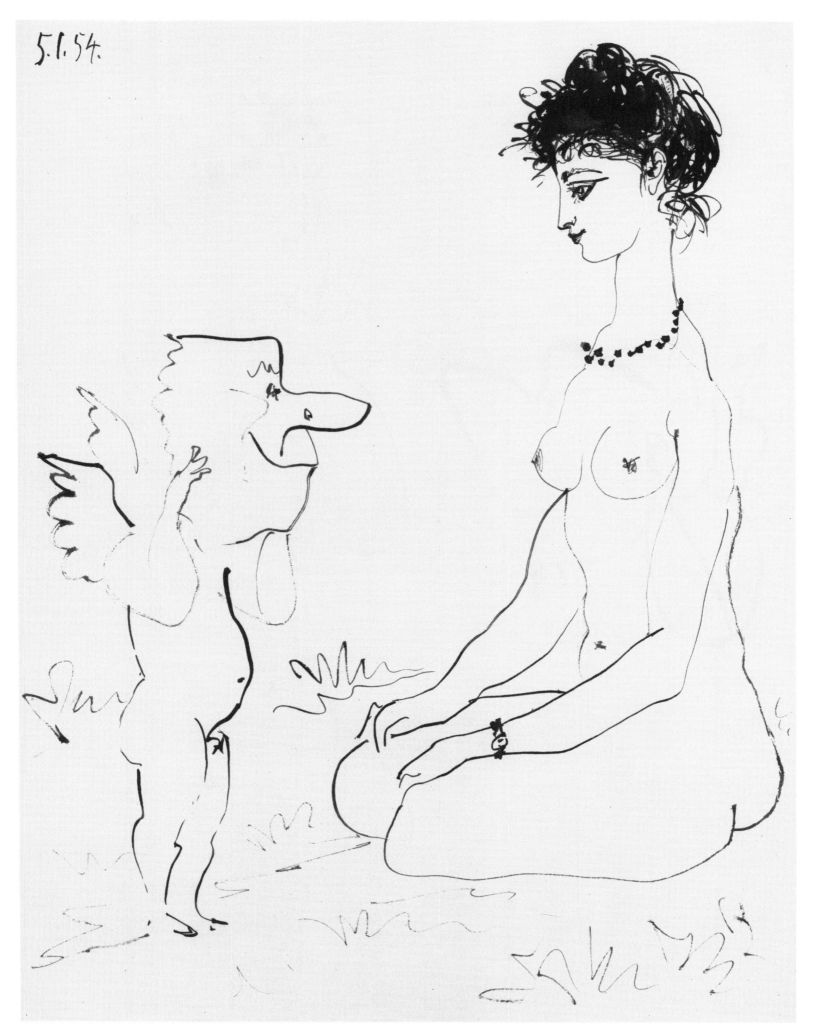

5.1.54.

5.1.54.

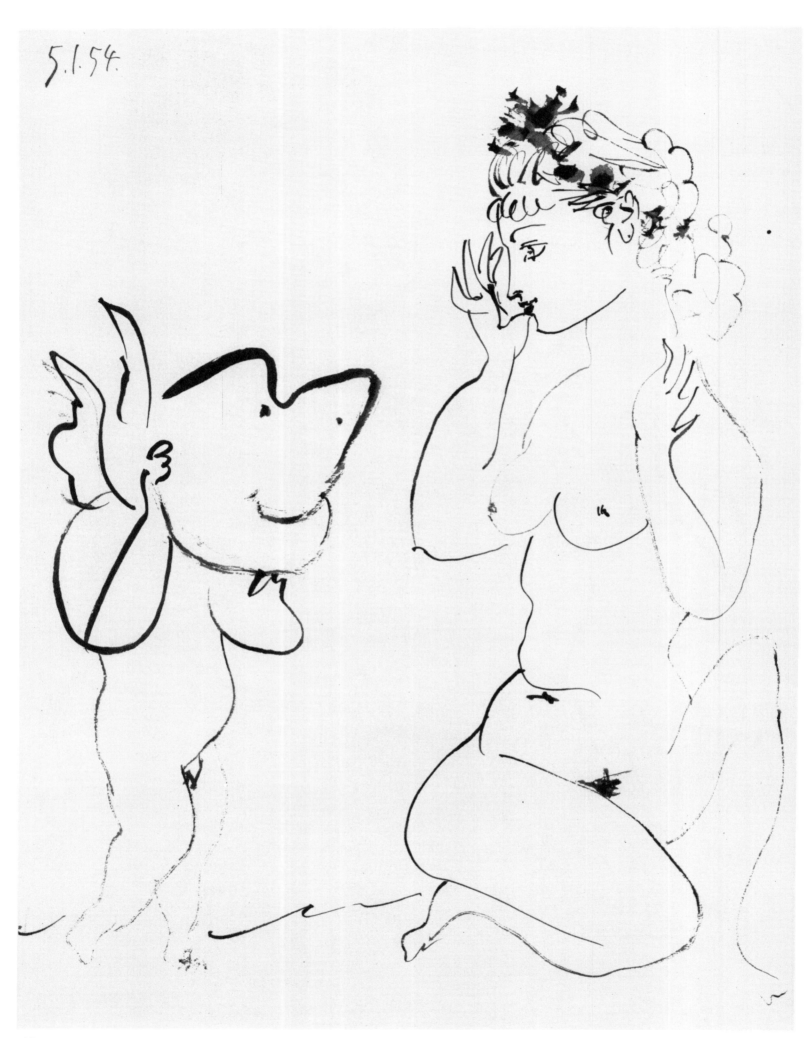

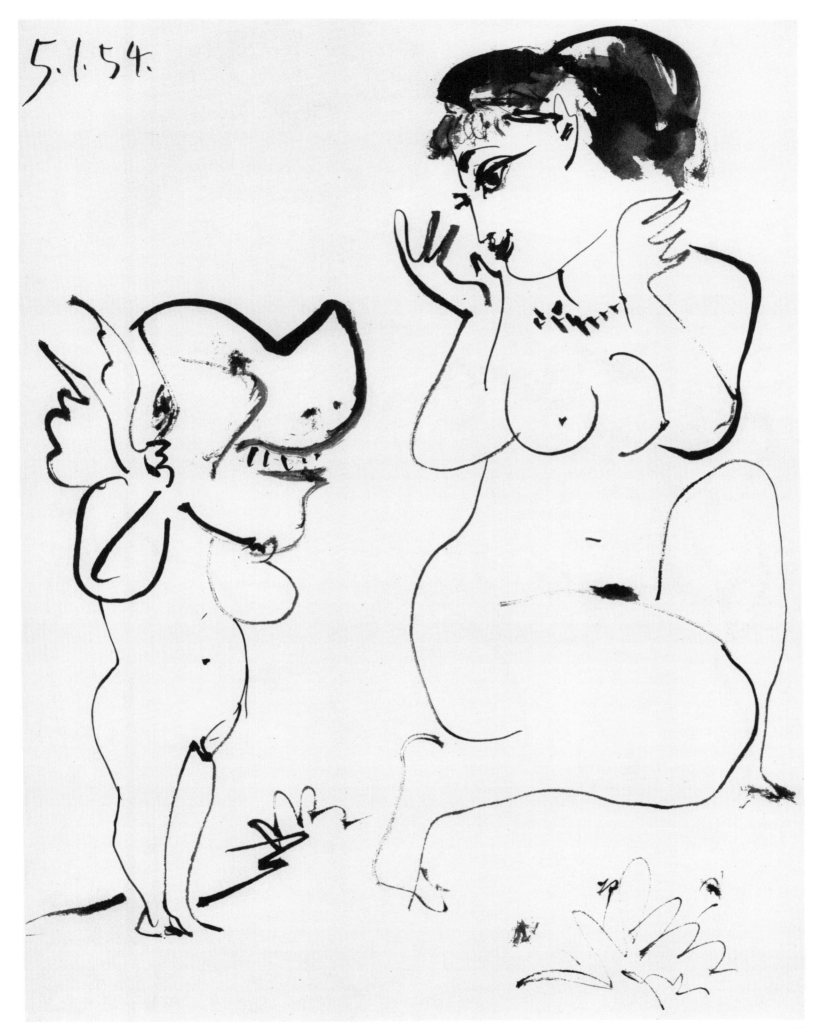

5.1.54.

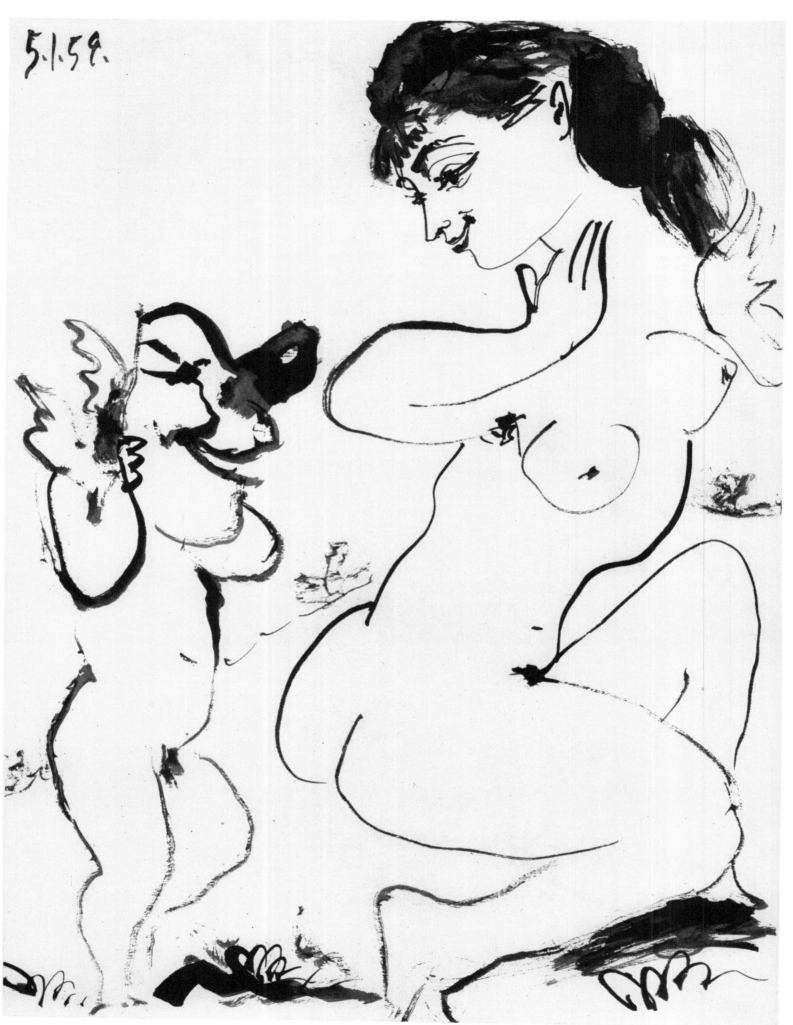

5.1.59.

64

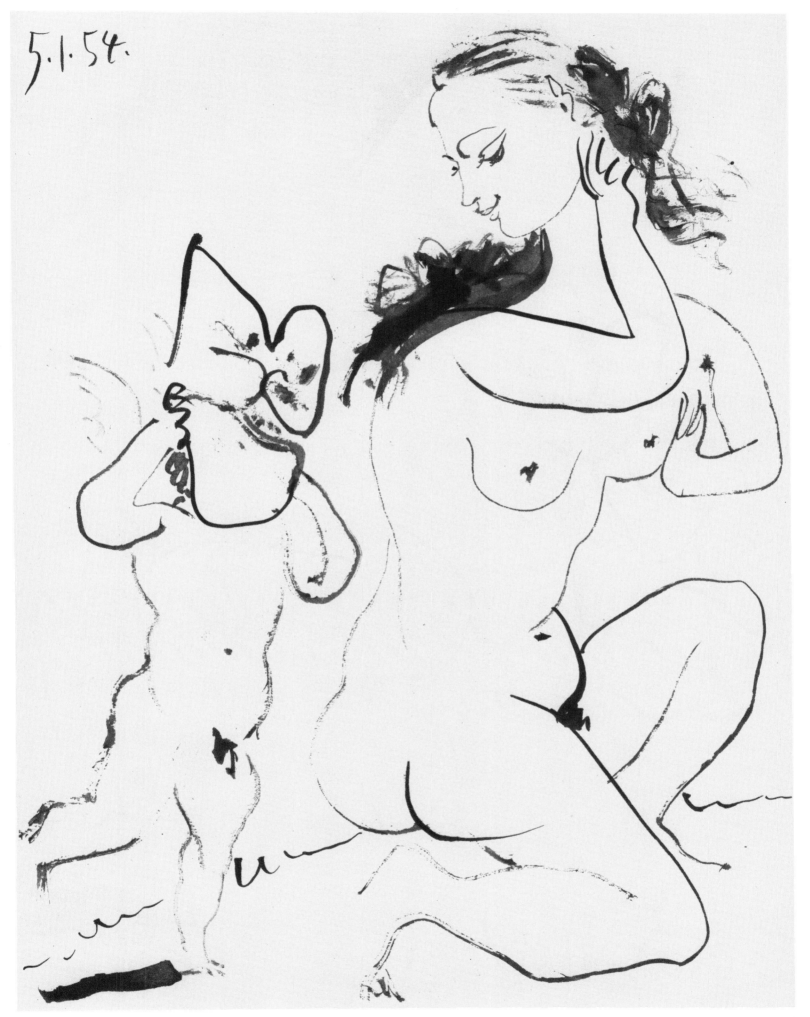

5.1.54.

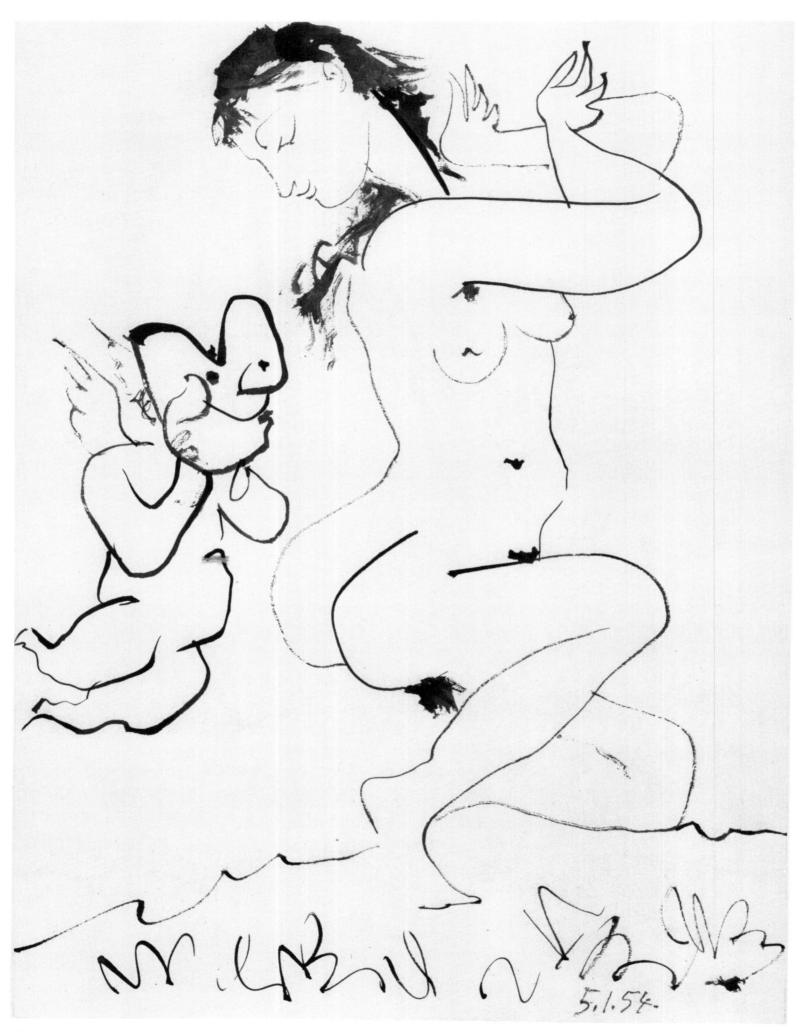

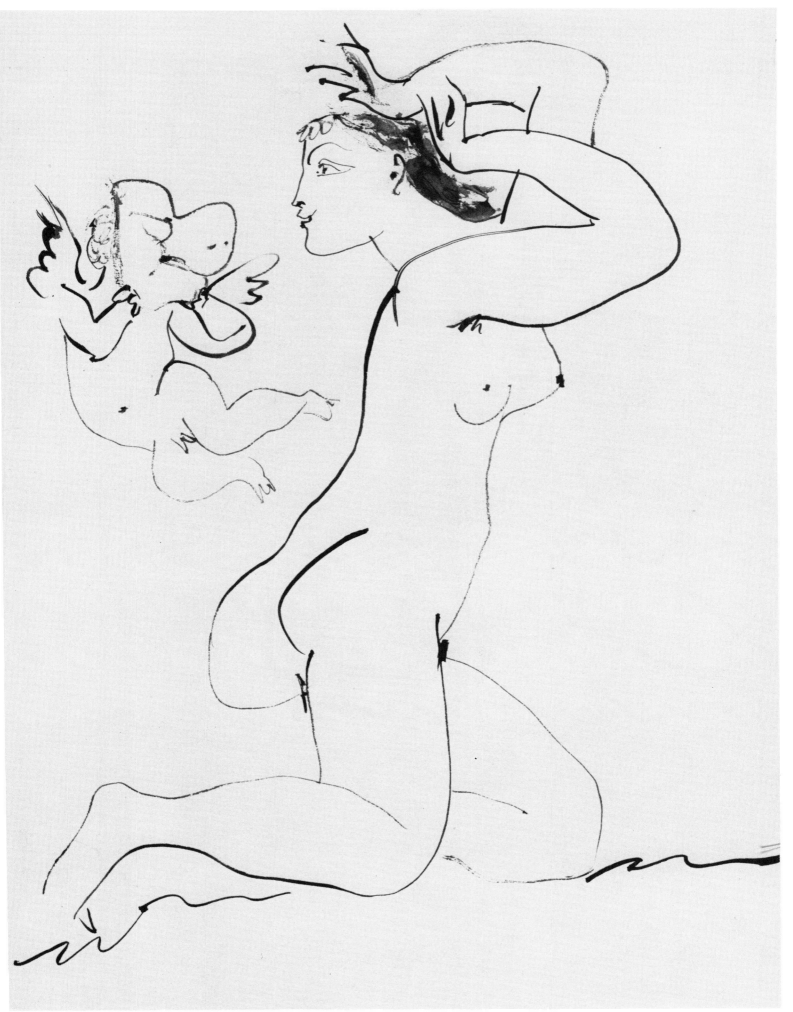

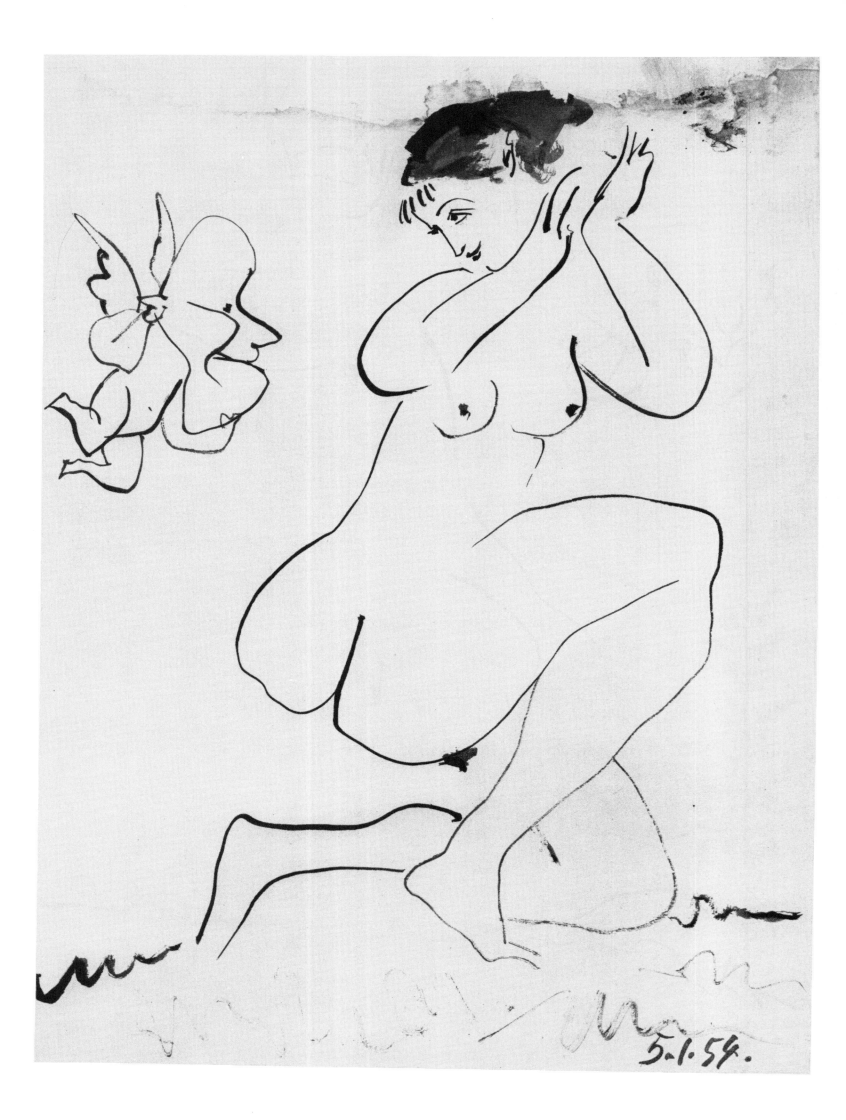

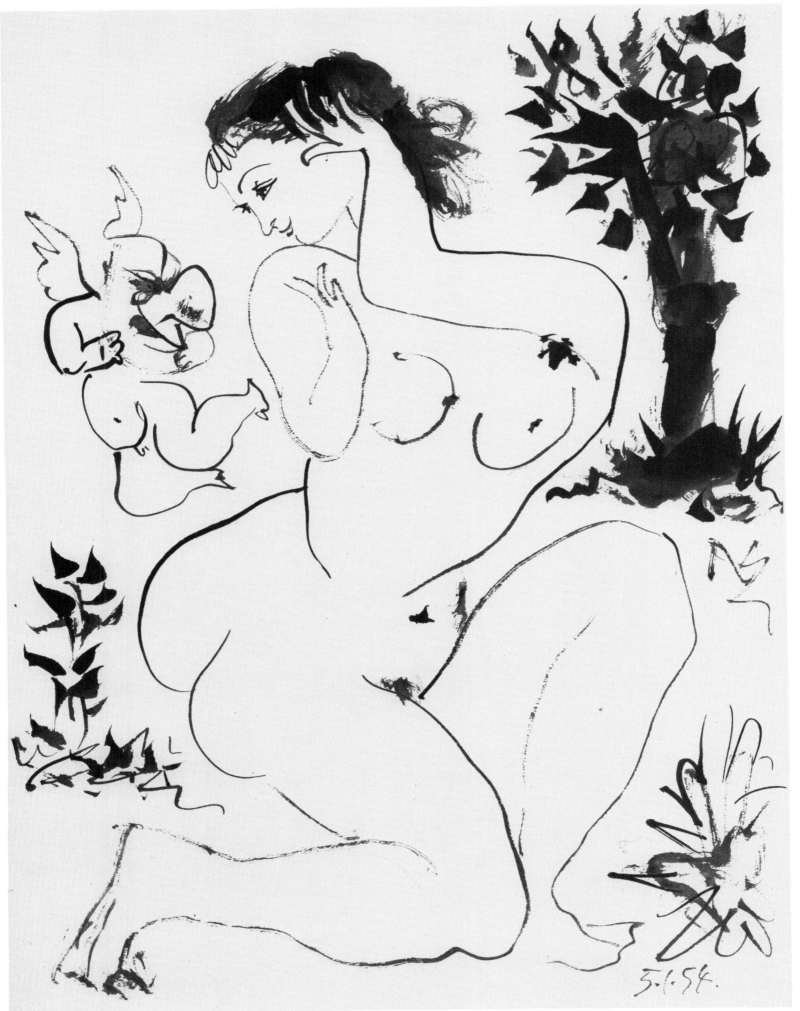

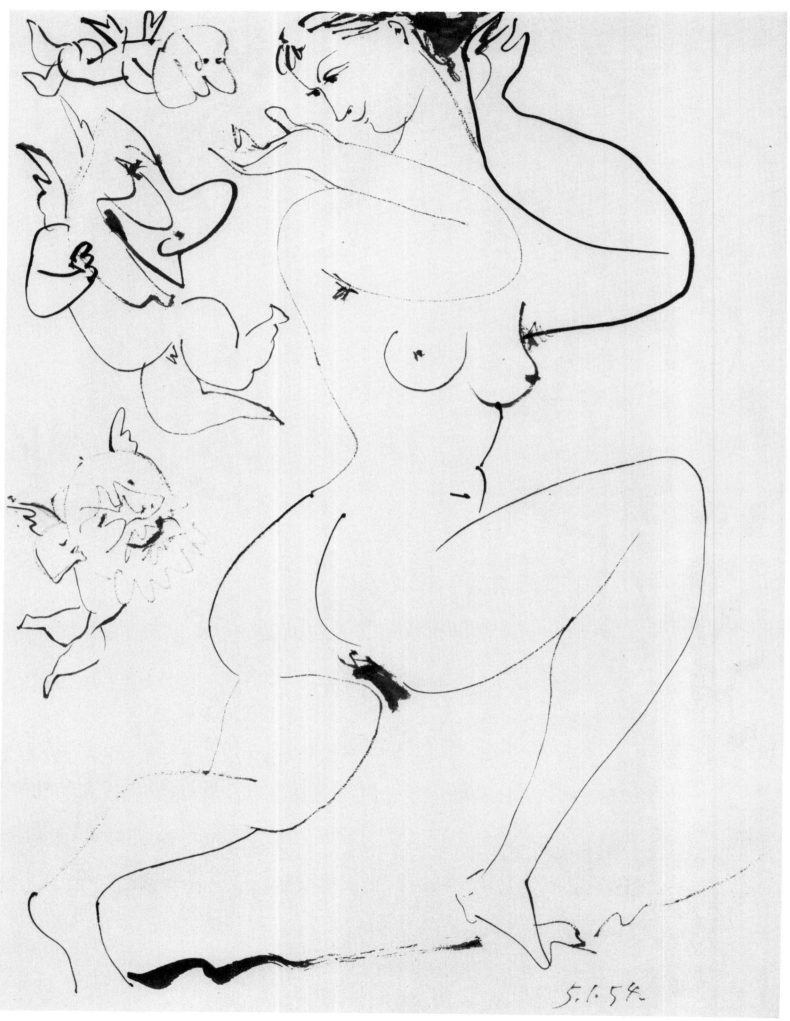

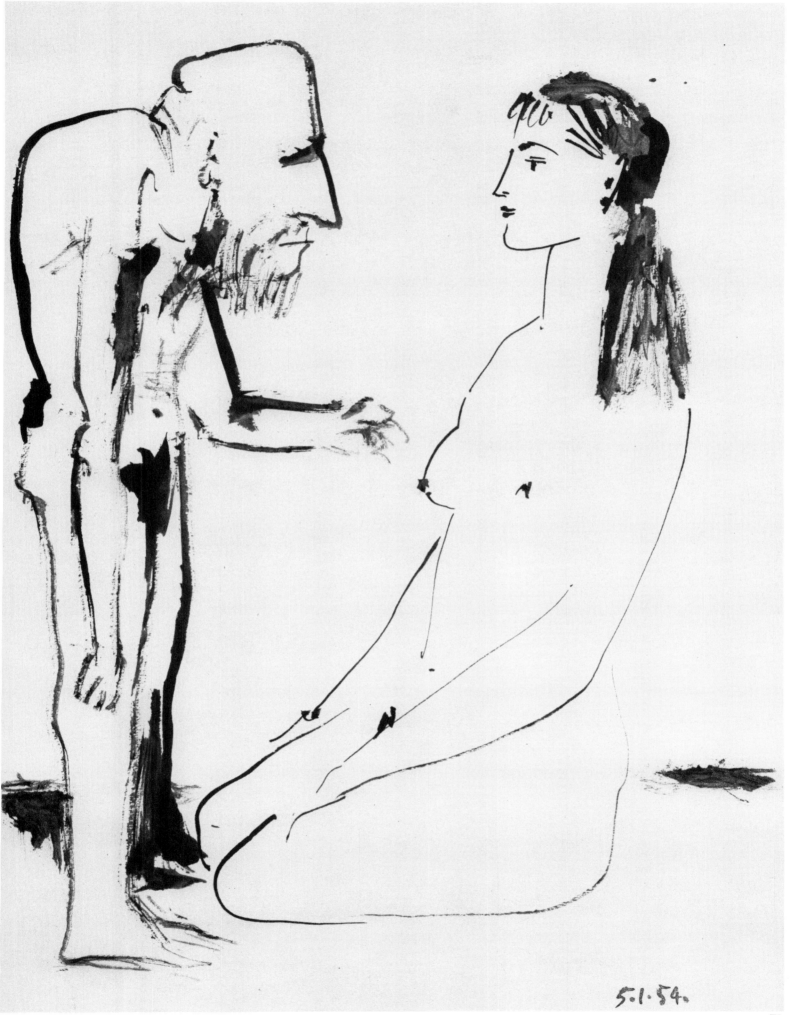

5·1·54·

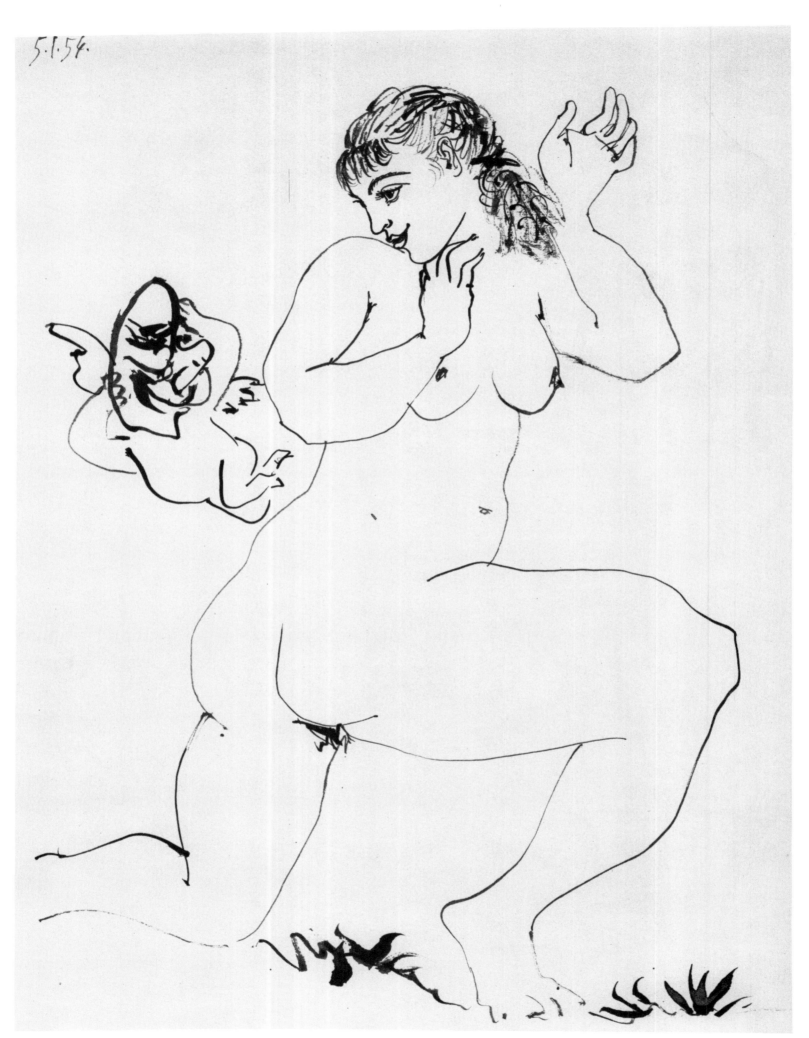

5.1.54.

72

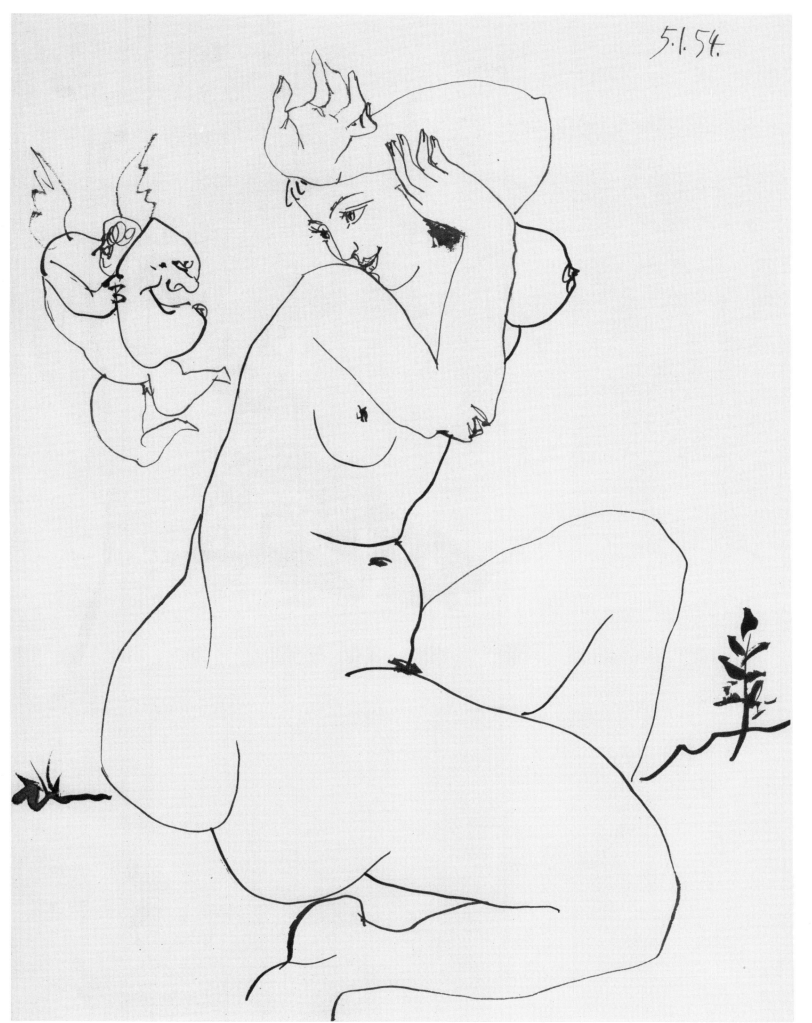

5.1.54.

73

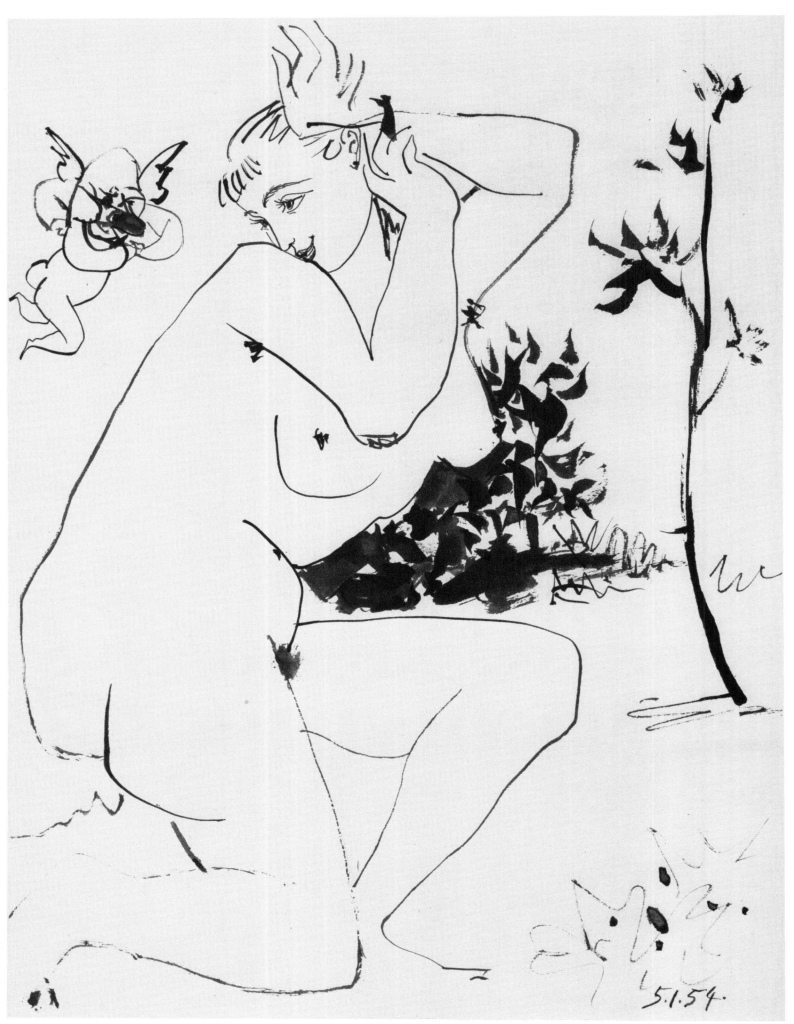

5.1.54.

74

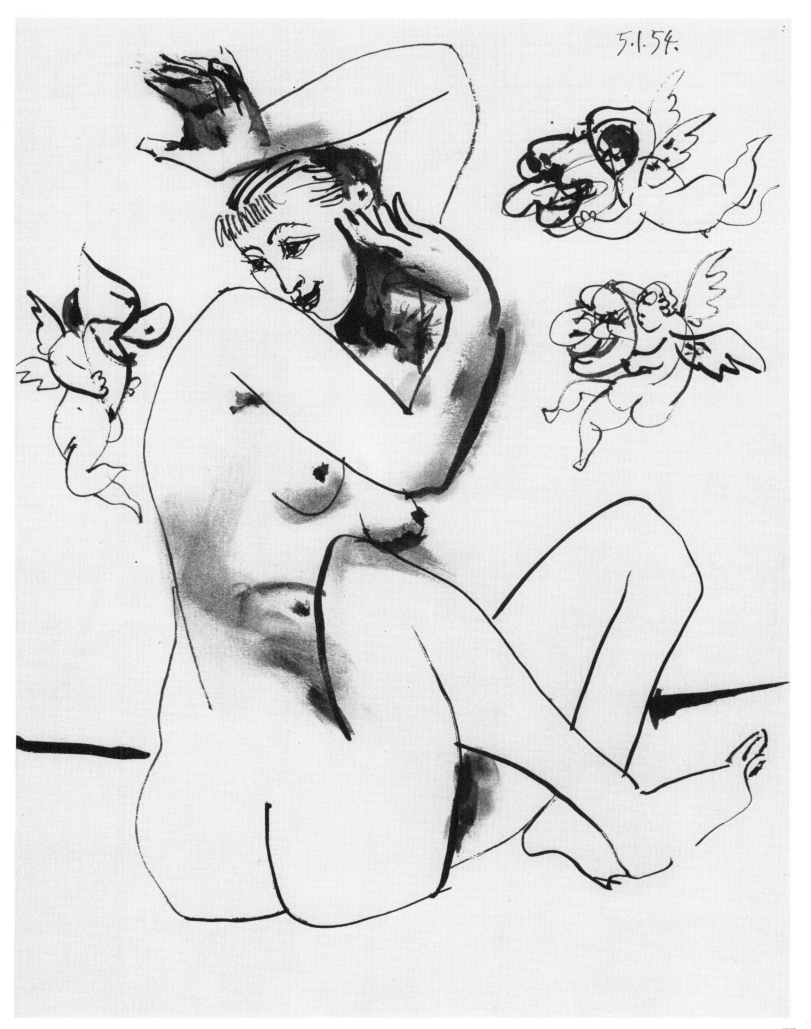

5·1·54.

75

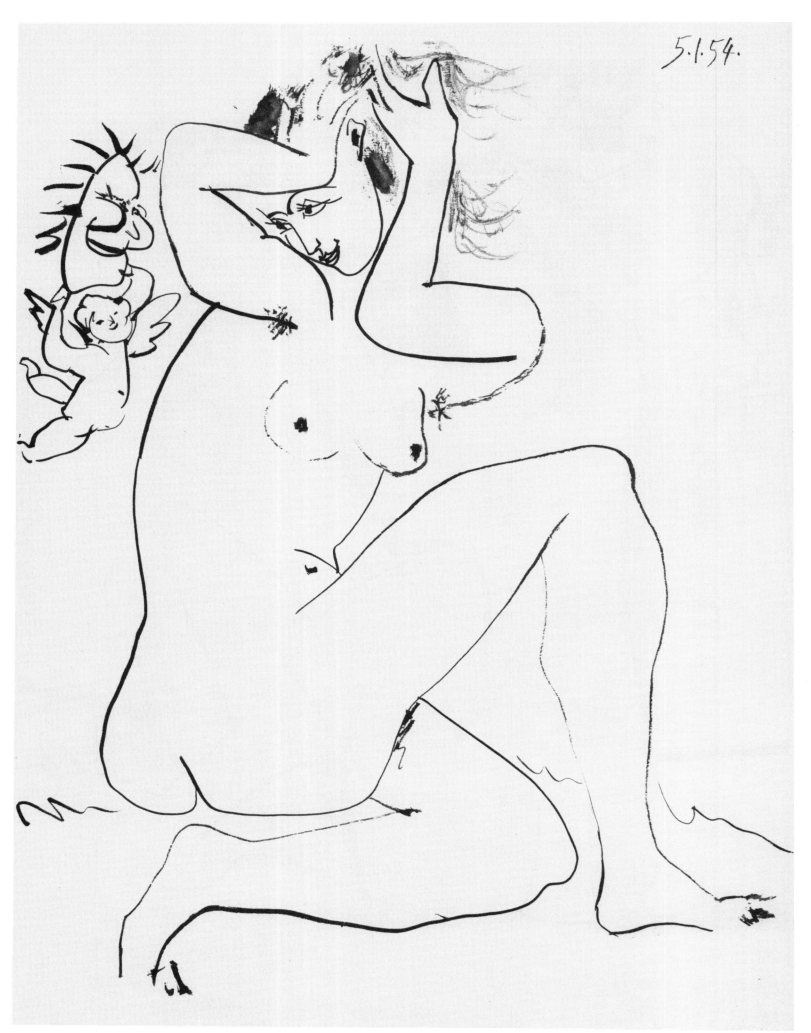

5.1.54.

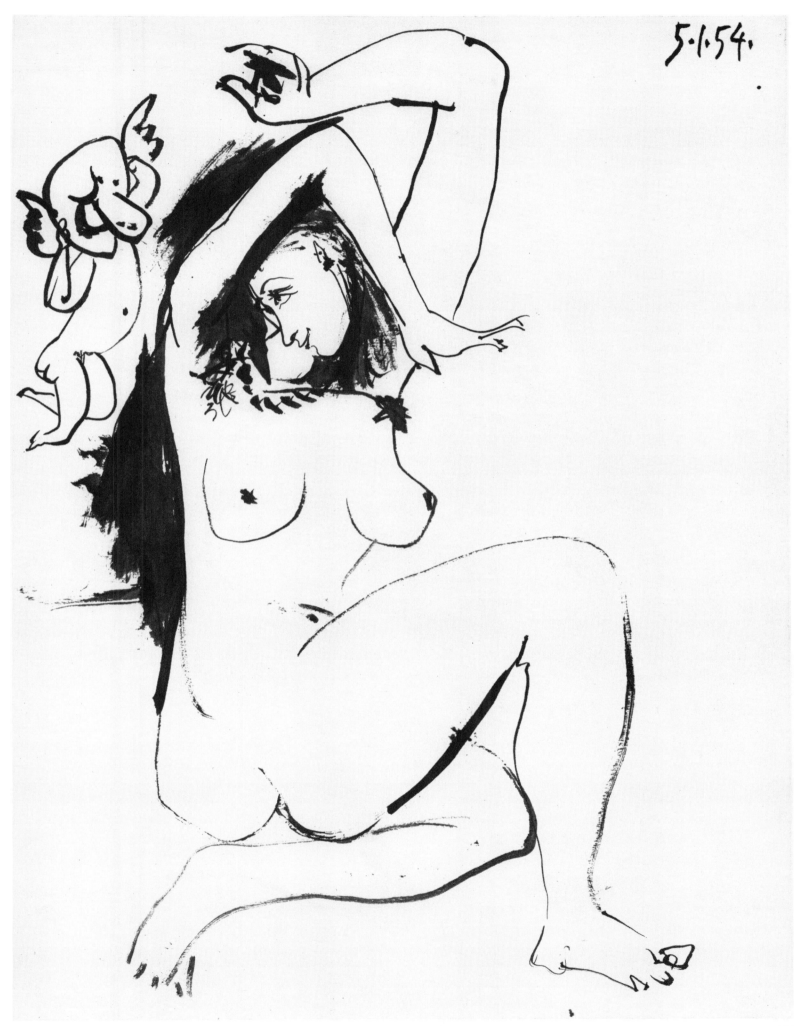

5·1·54·

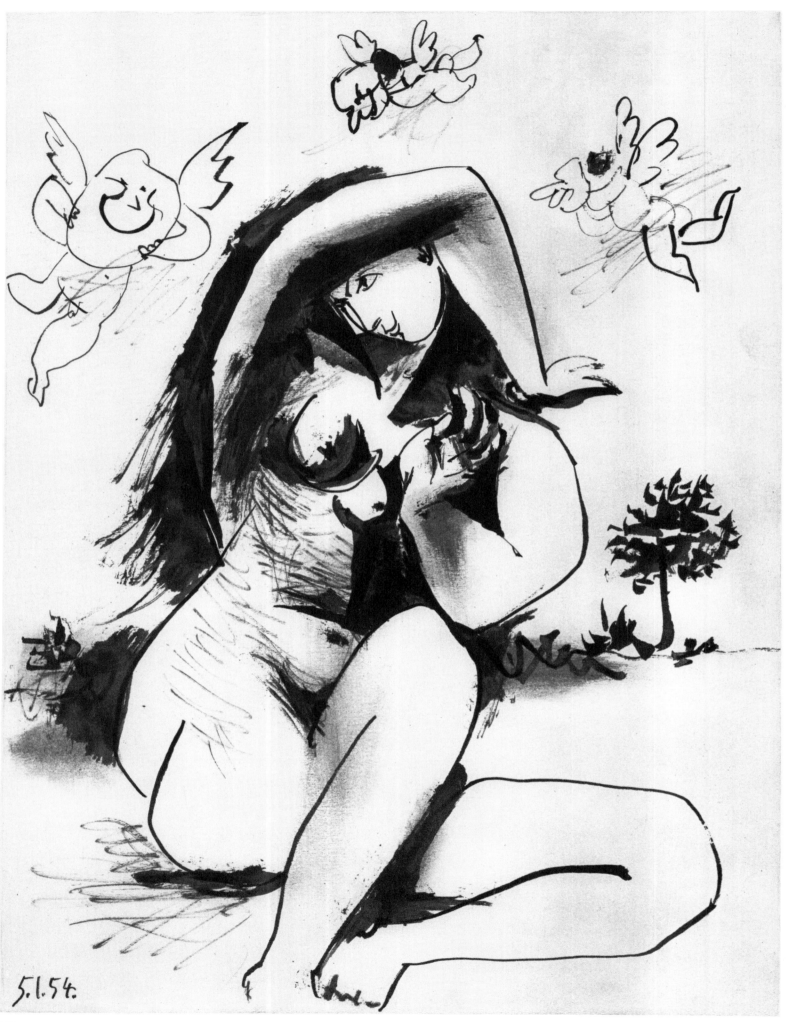

5.1.54.

6.1.54.
I

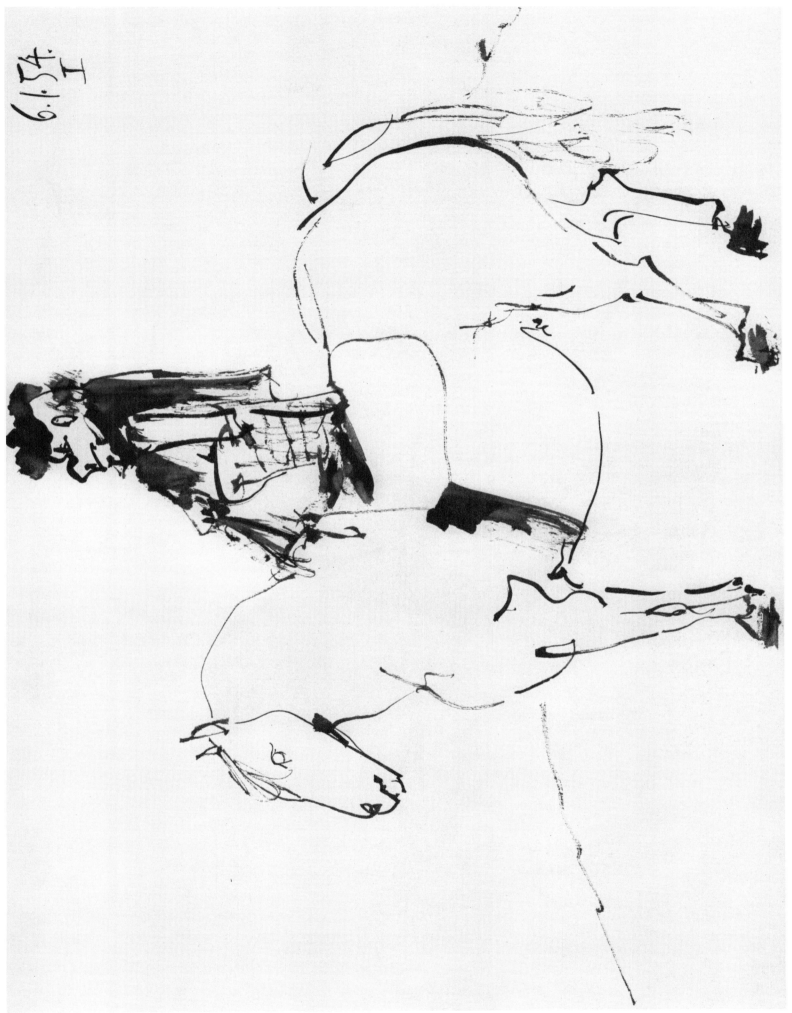

79

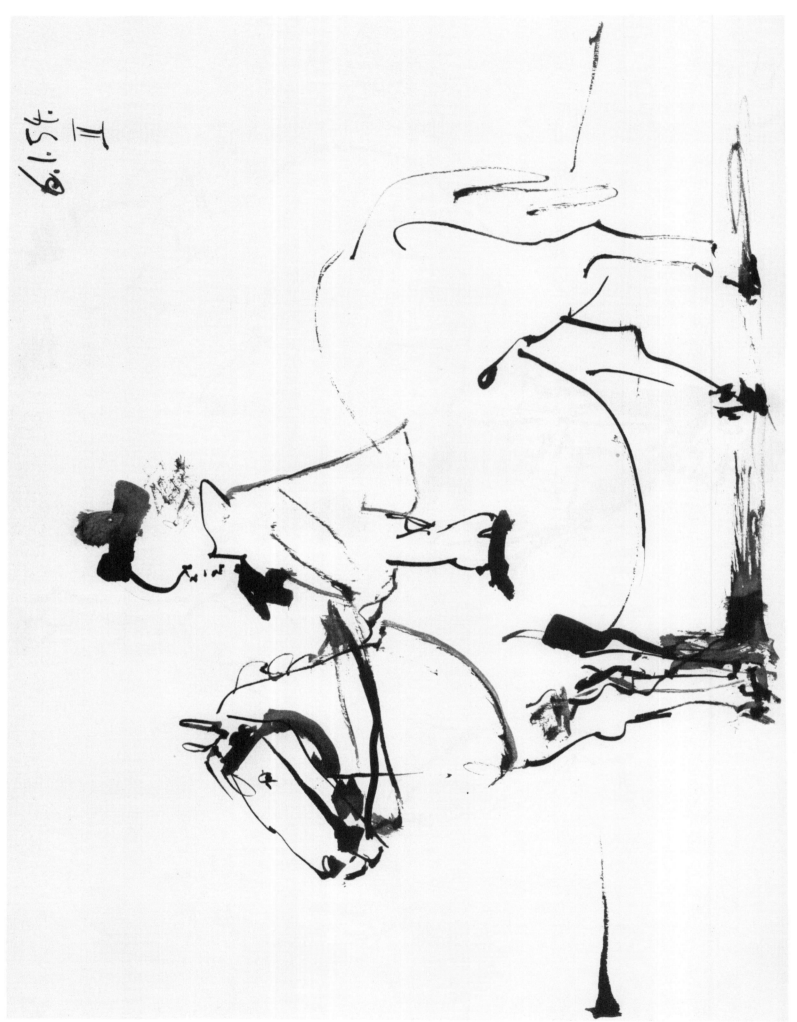

6.1.54.
II

80

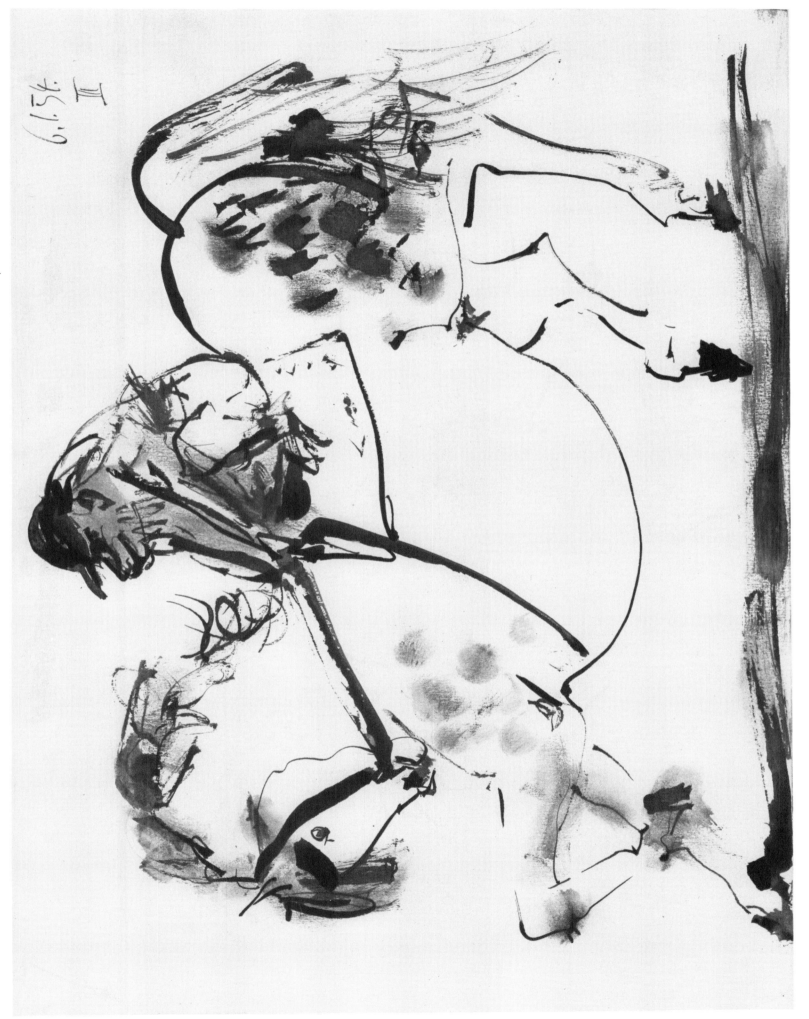

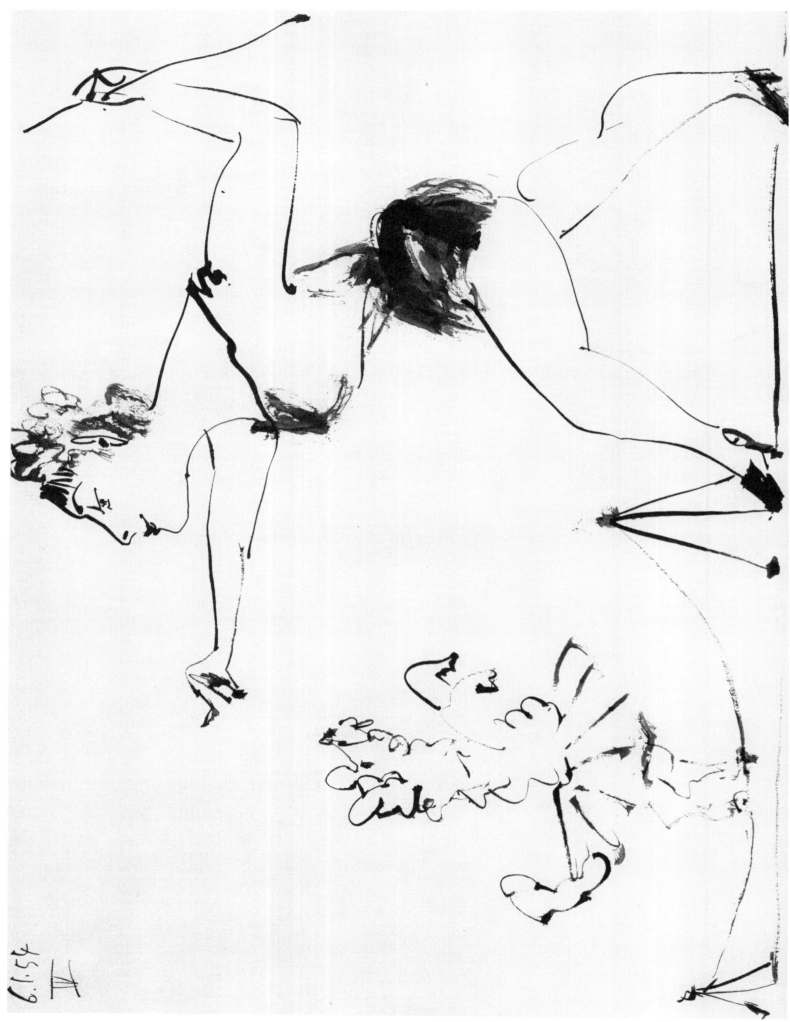

6.1.54

6.1.54.
V

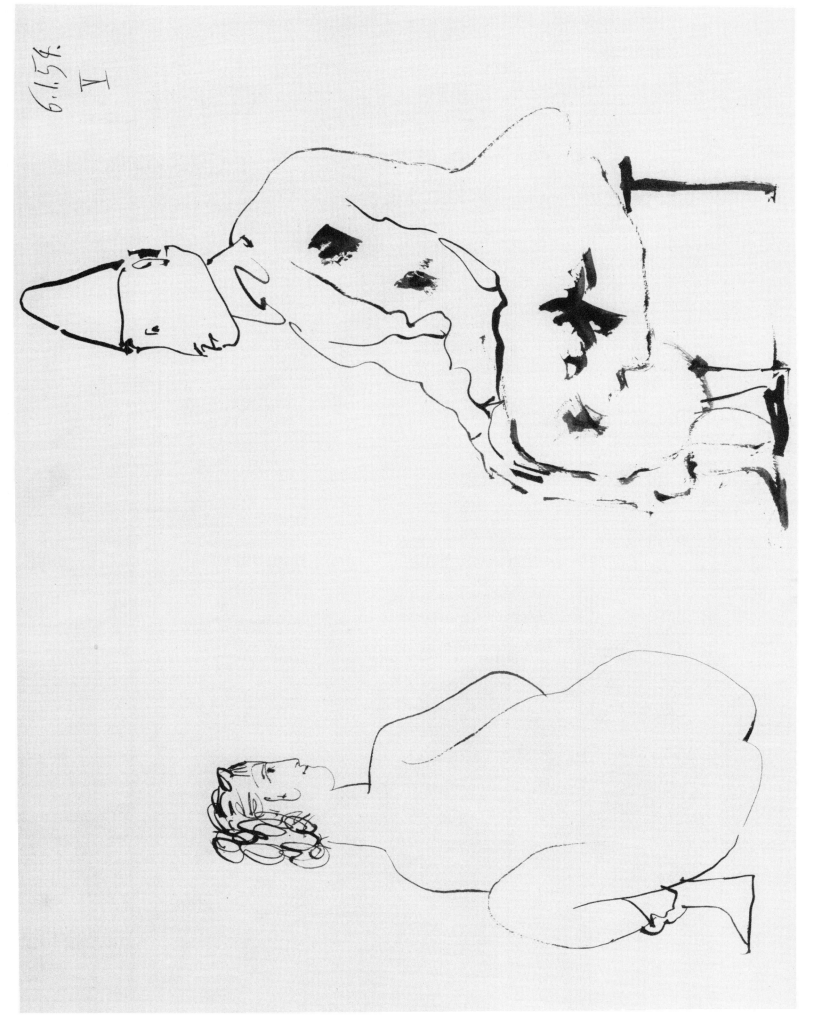

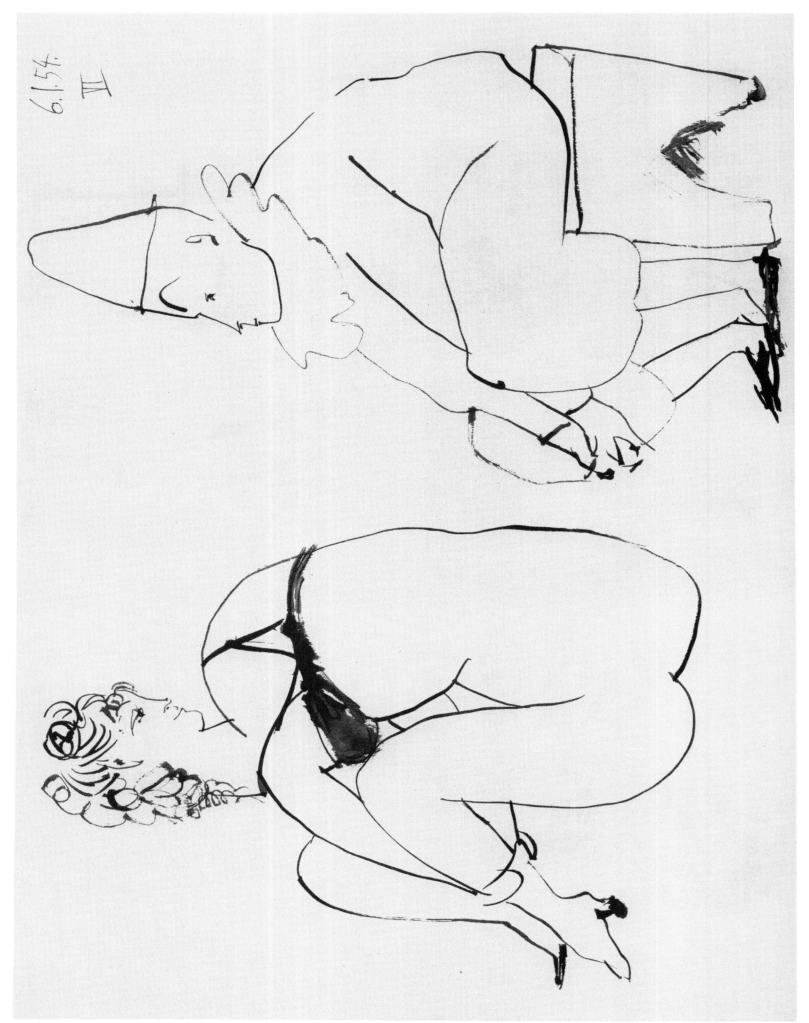

6.1.54.
VI

84

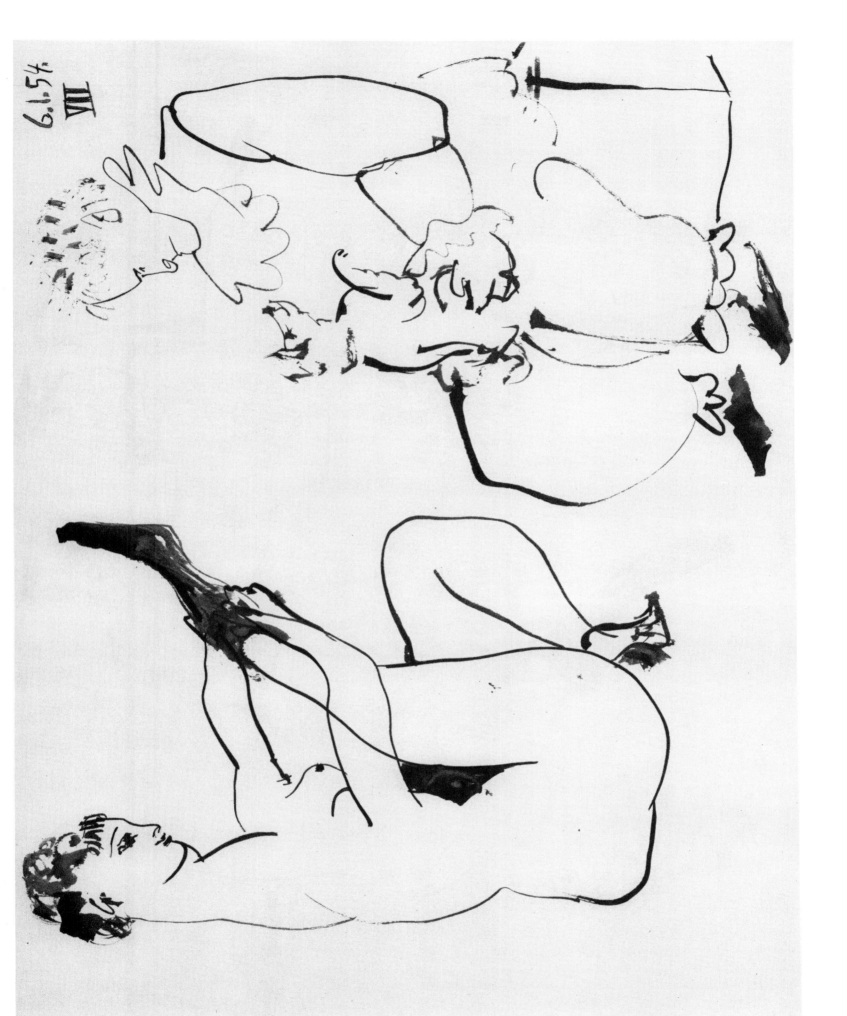

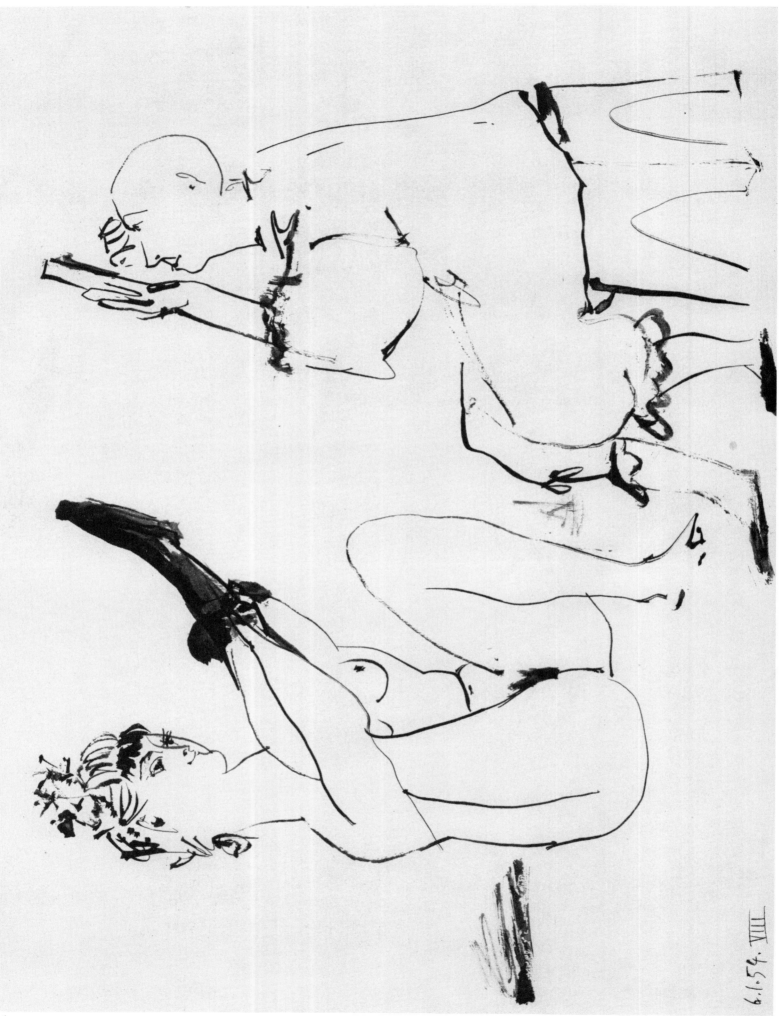

6.1.54. VIII

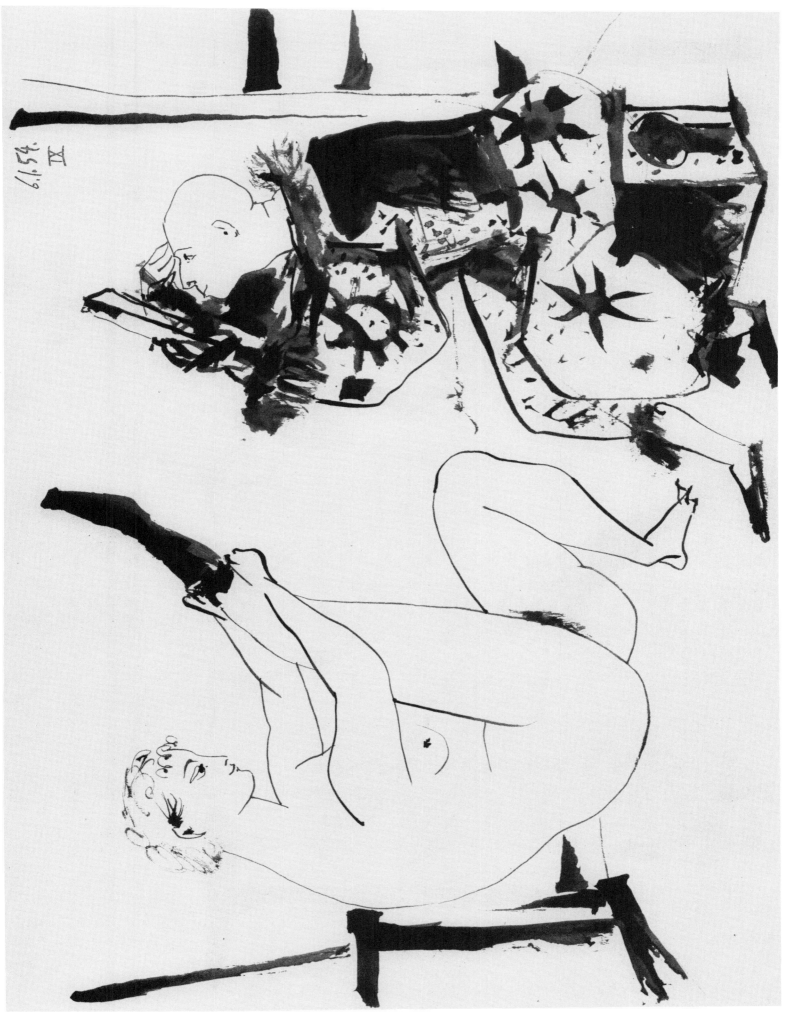

87

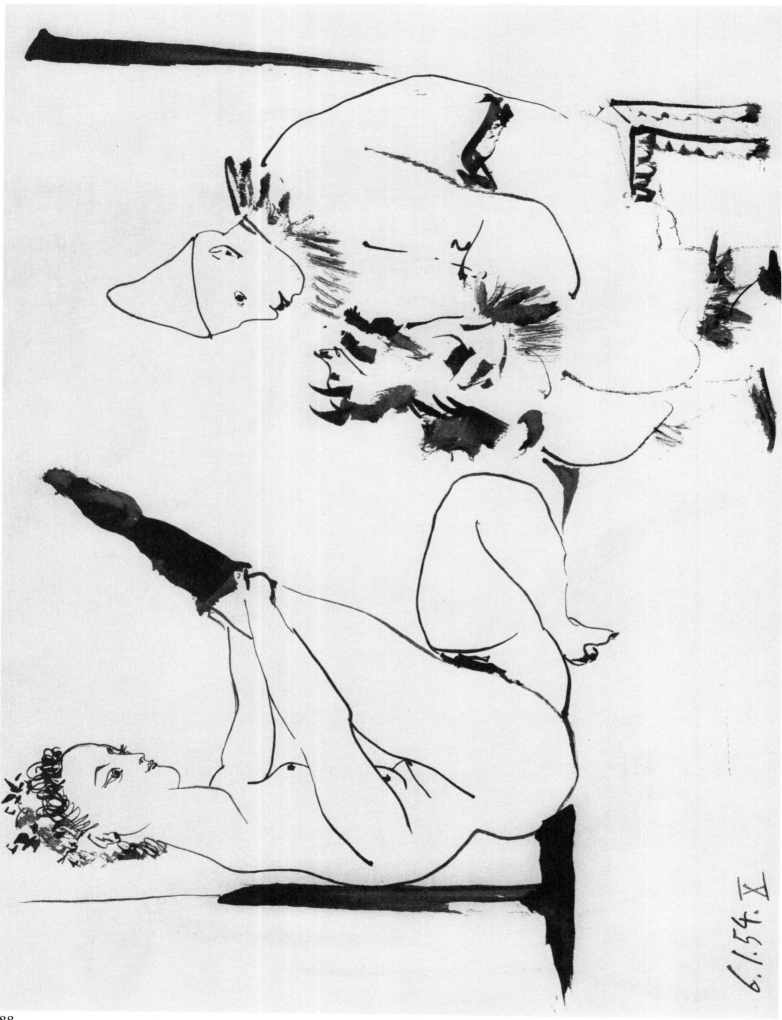

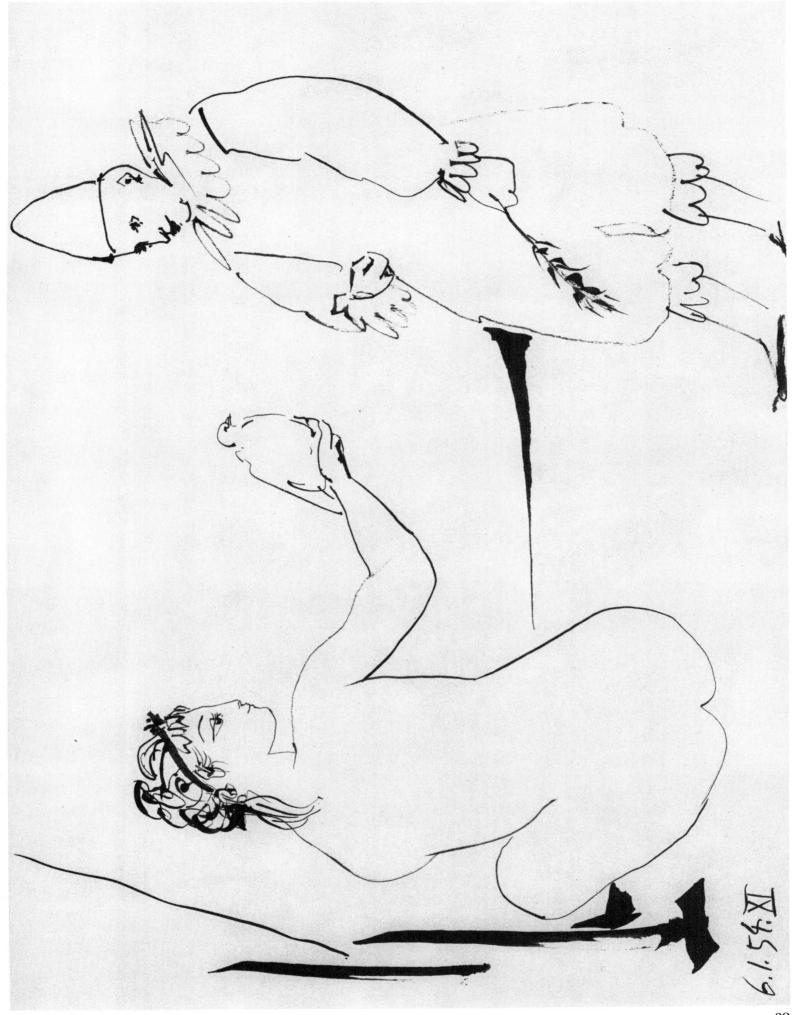

89

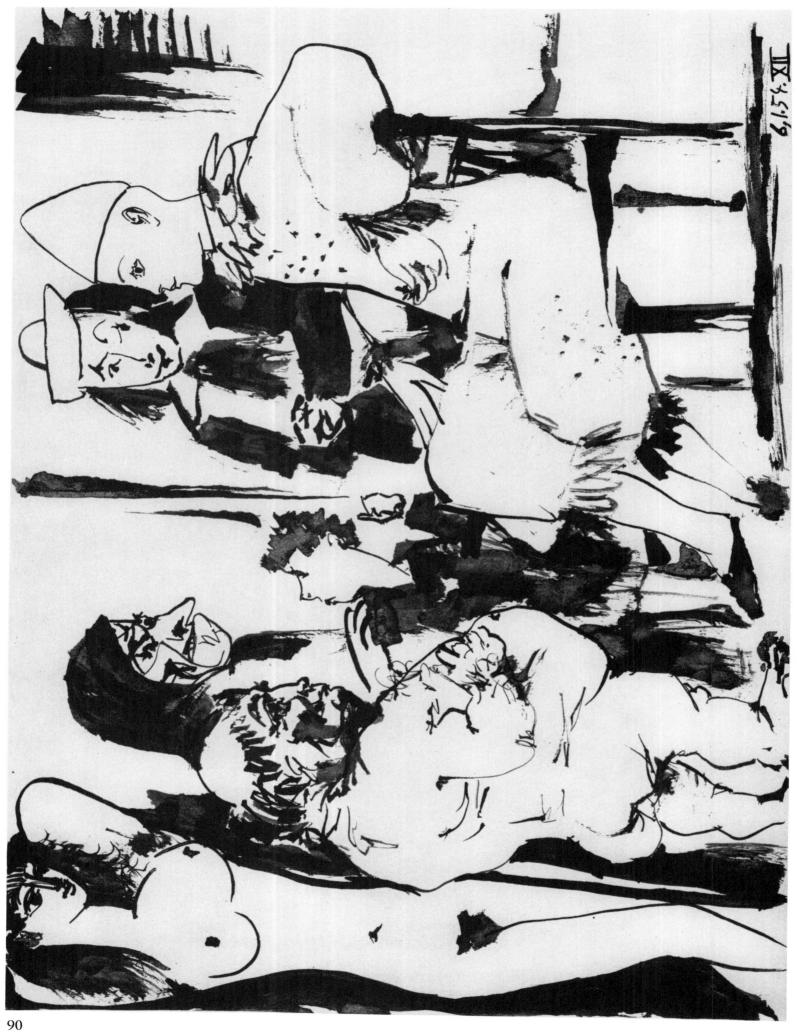

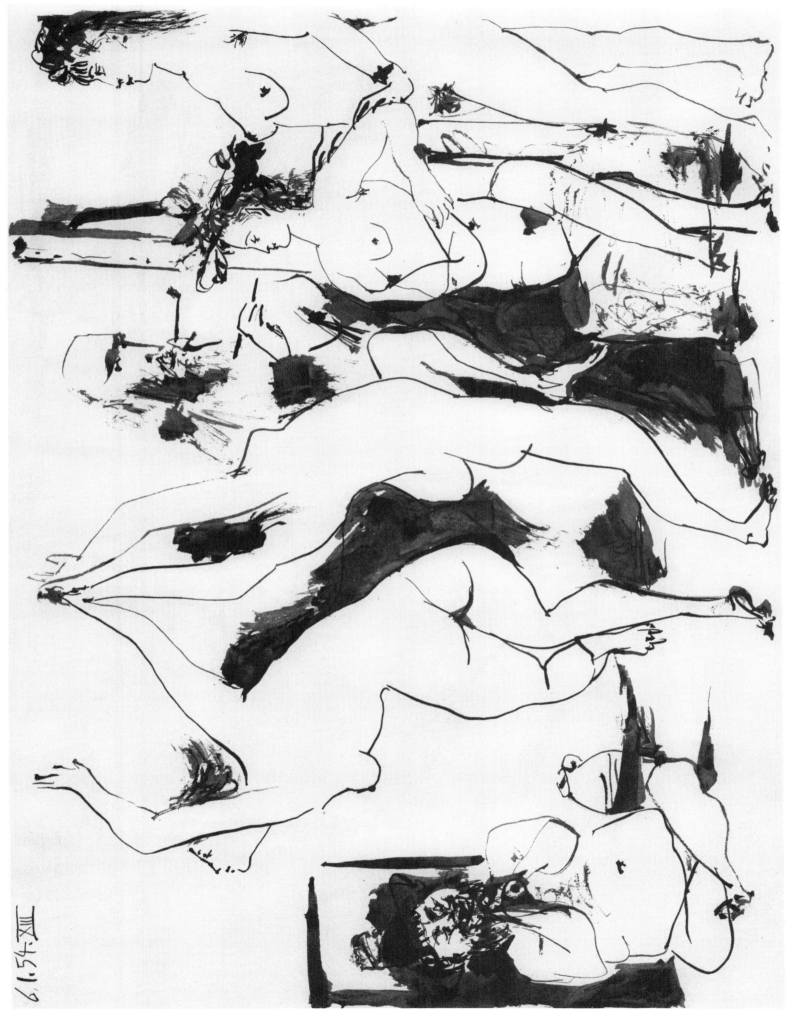

6.1.54·XIII

91

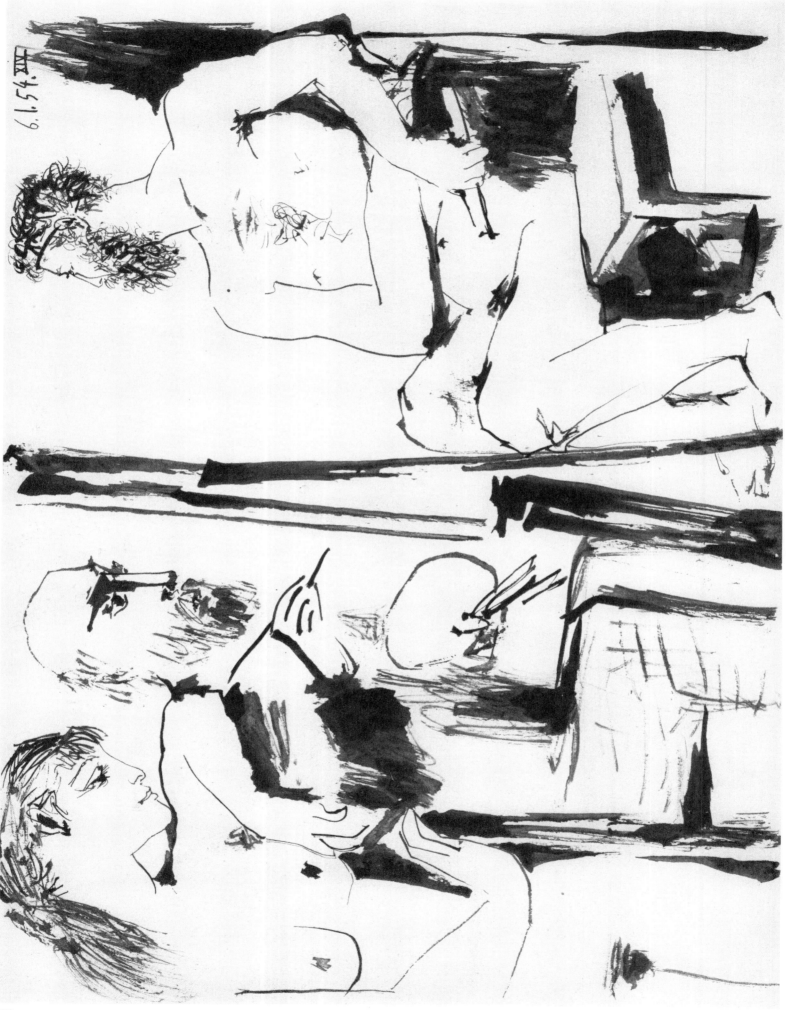

92

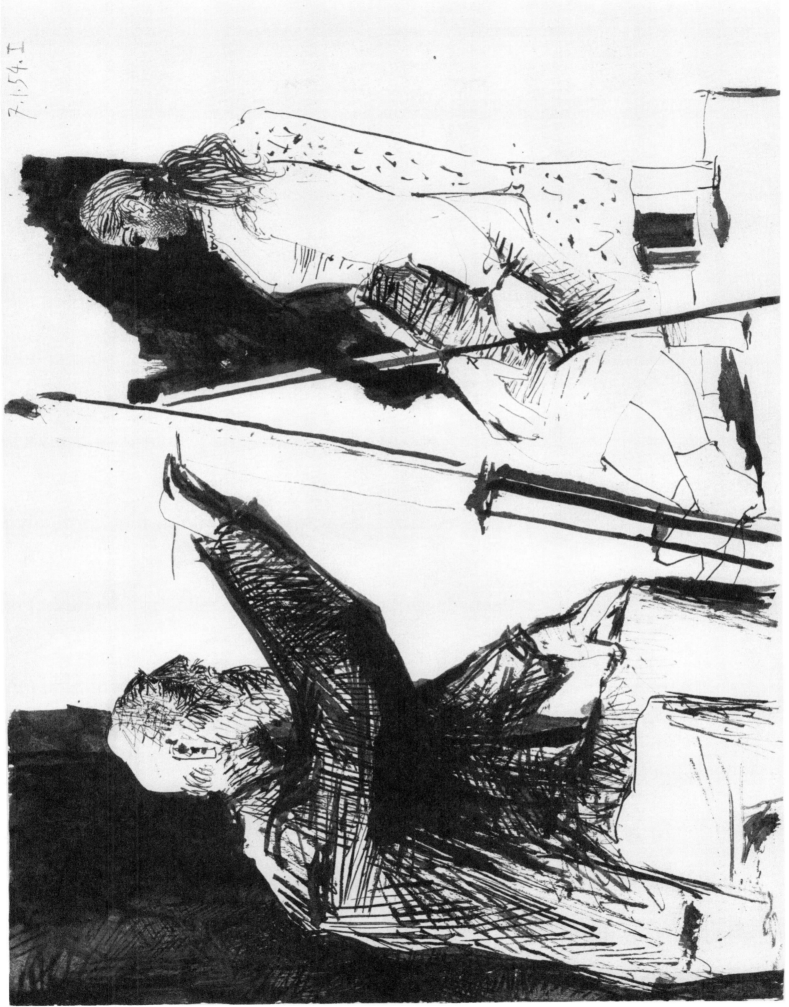

7.1.54.I

93

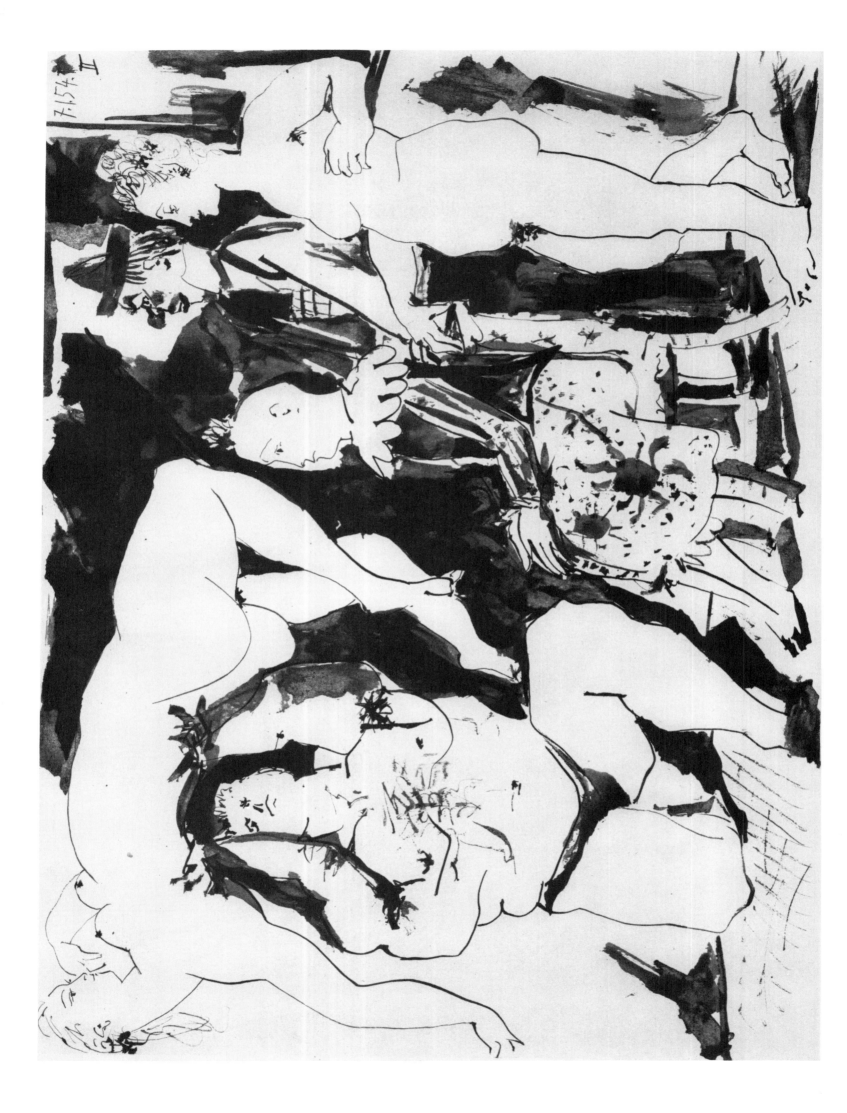

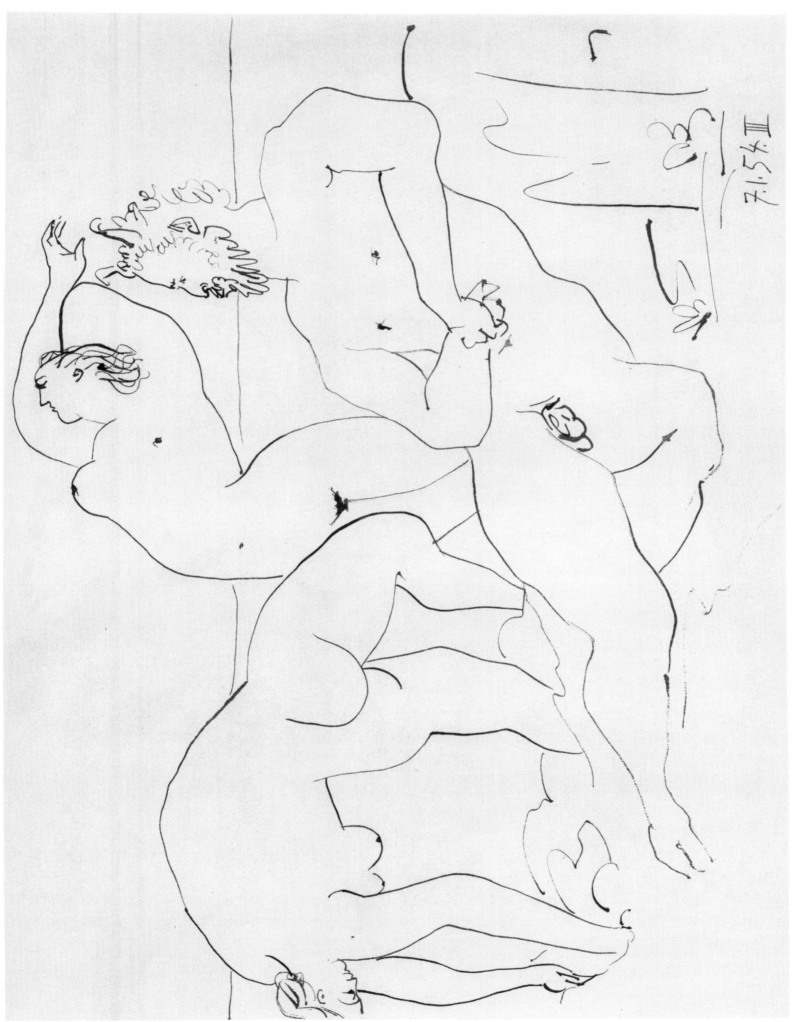

7.1.54. III

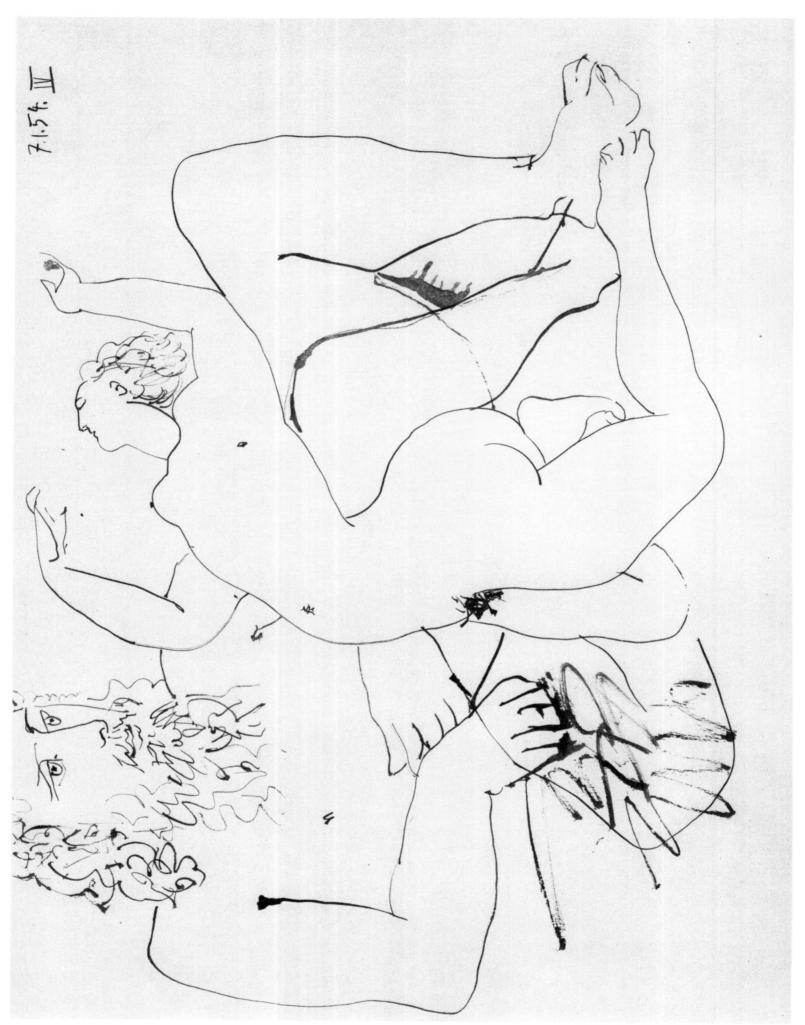

7.1.54. III

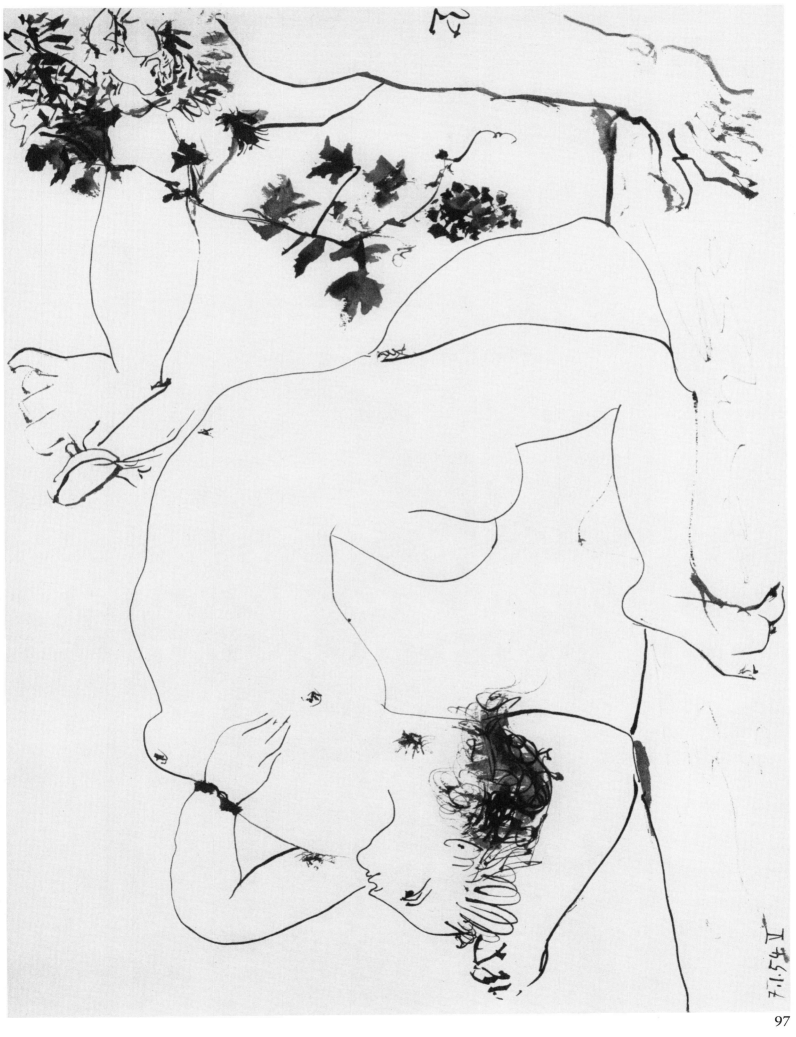

7.1.54 V

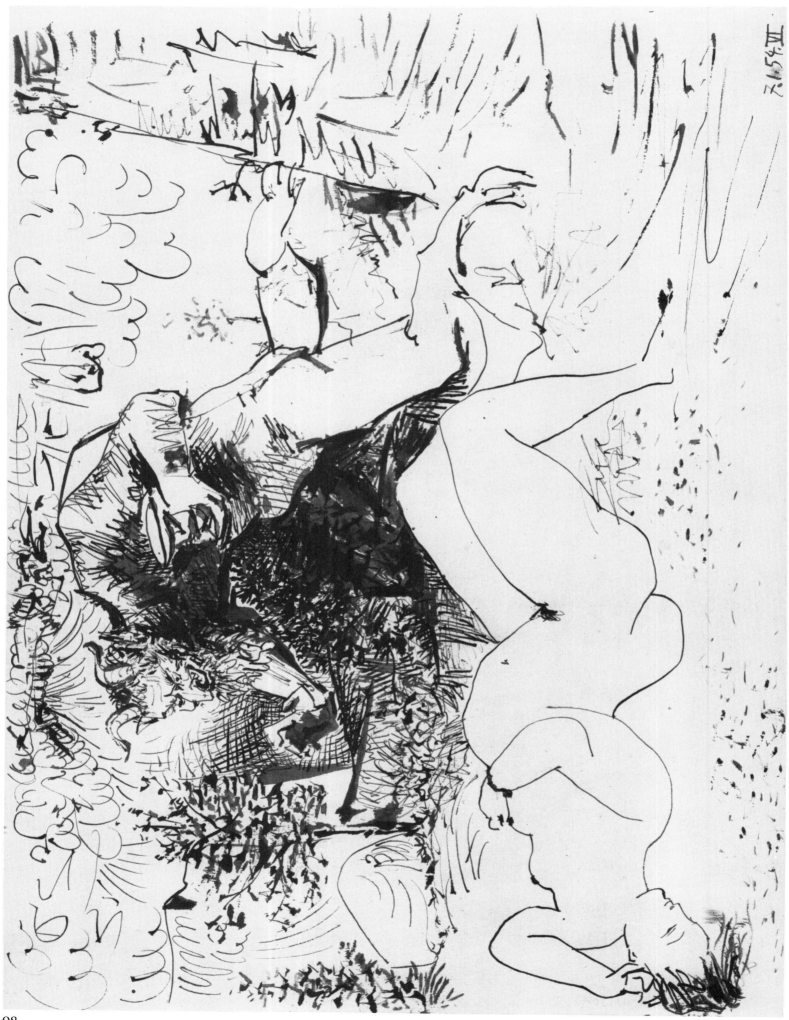

98

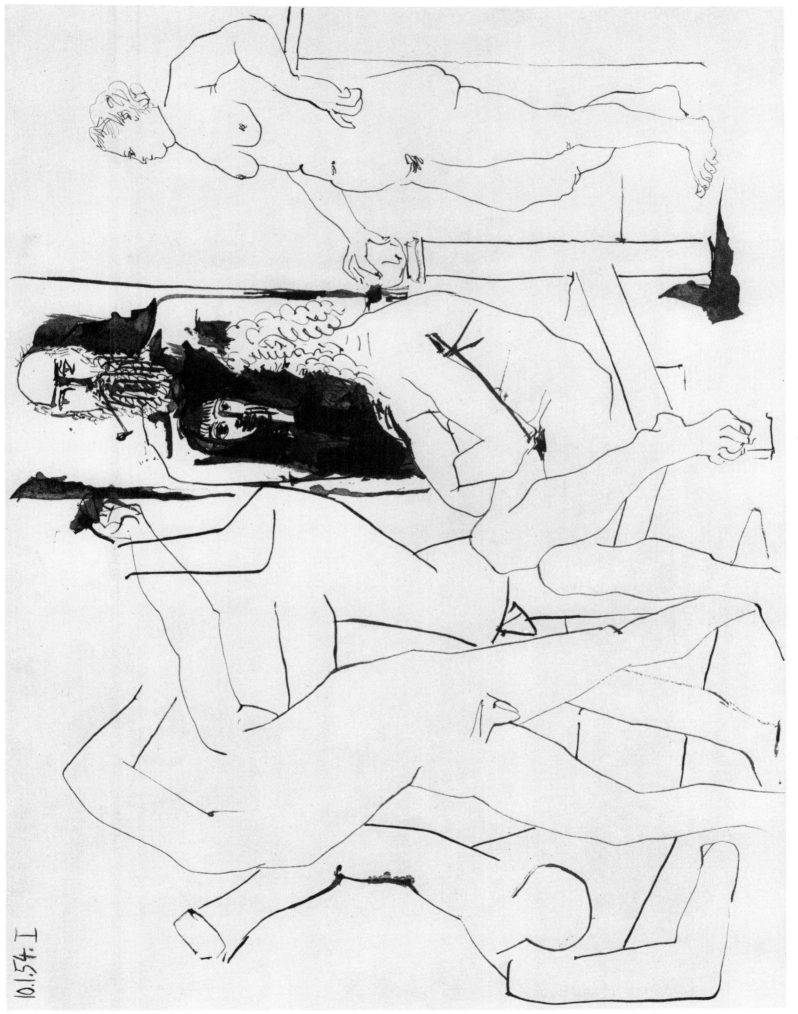

10.1.54.I

99

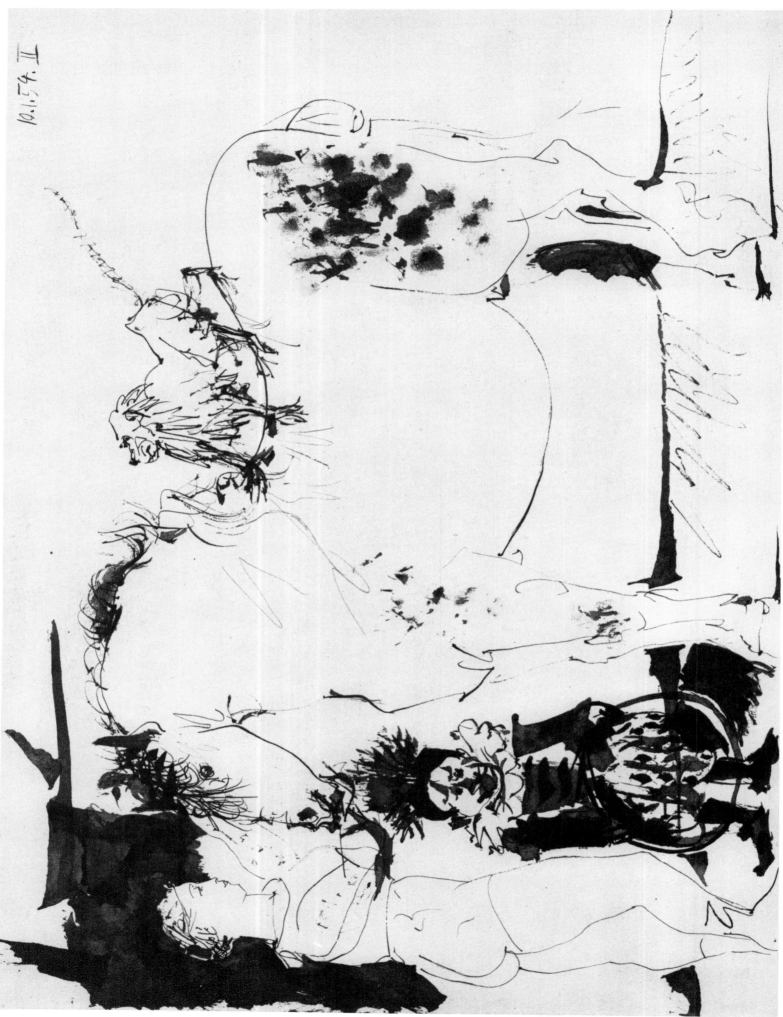

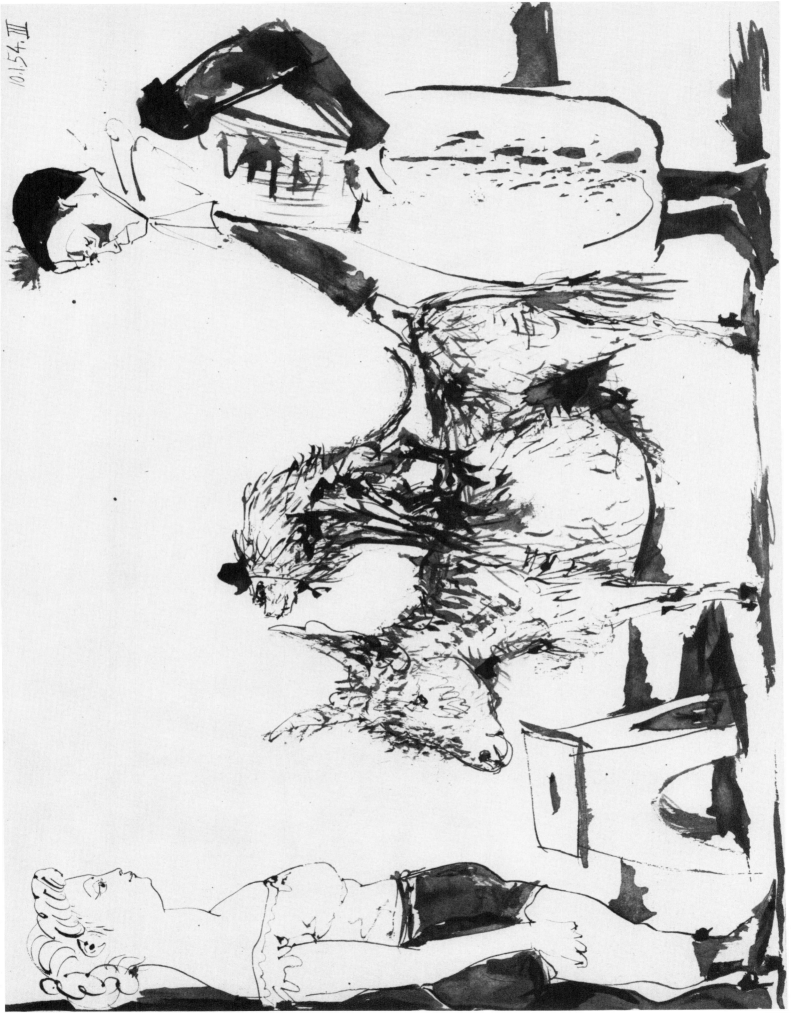

10.1.54.III

101

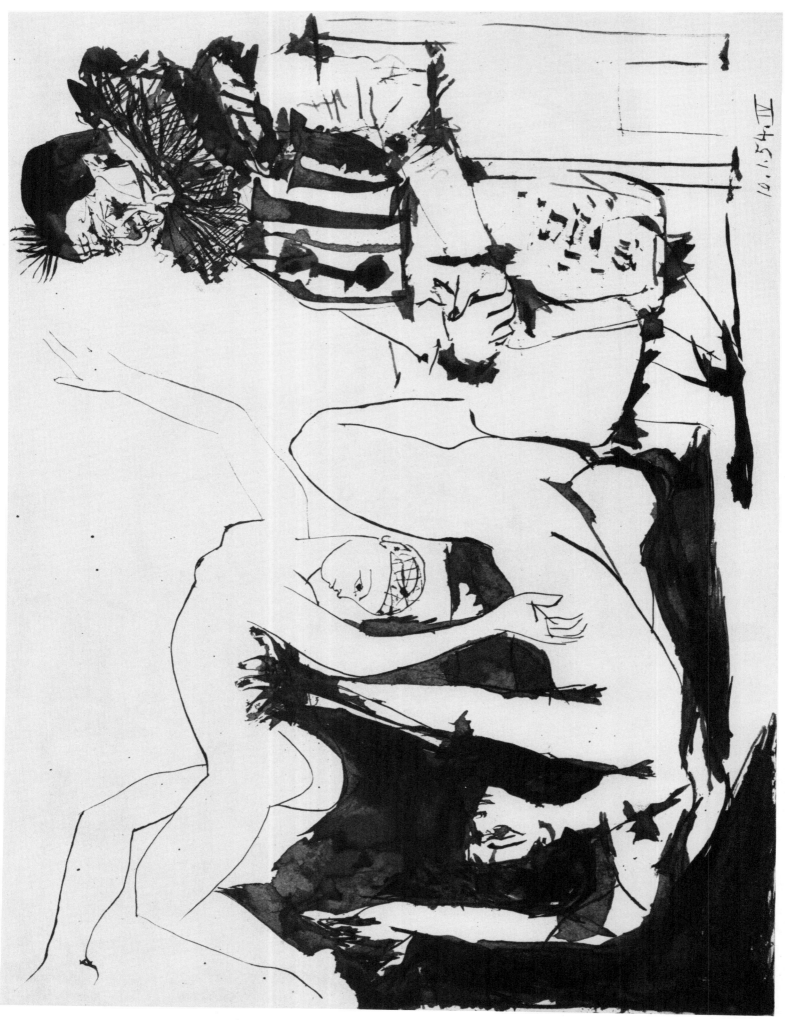

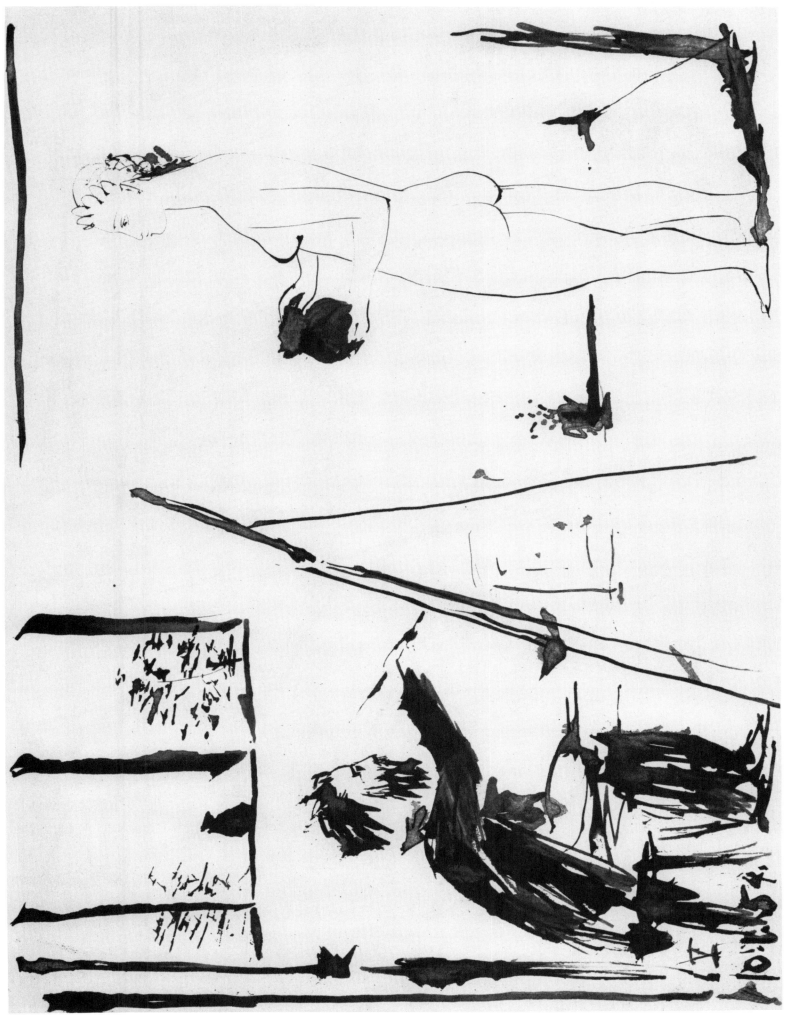

103

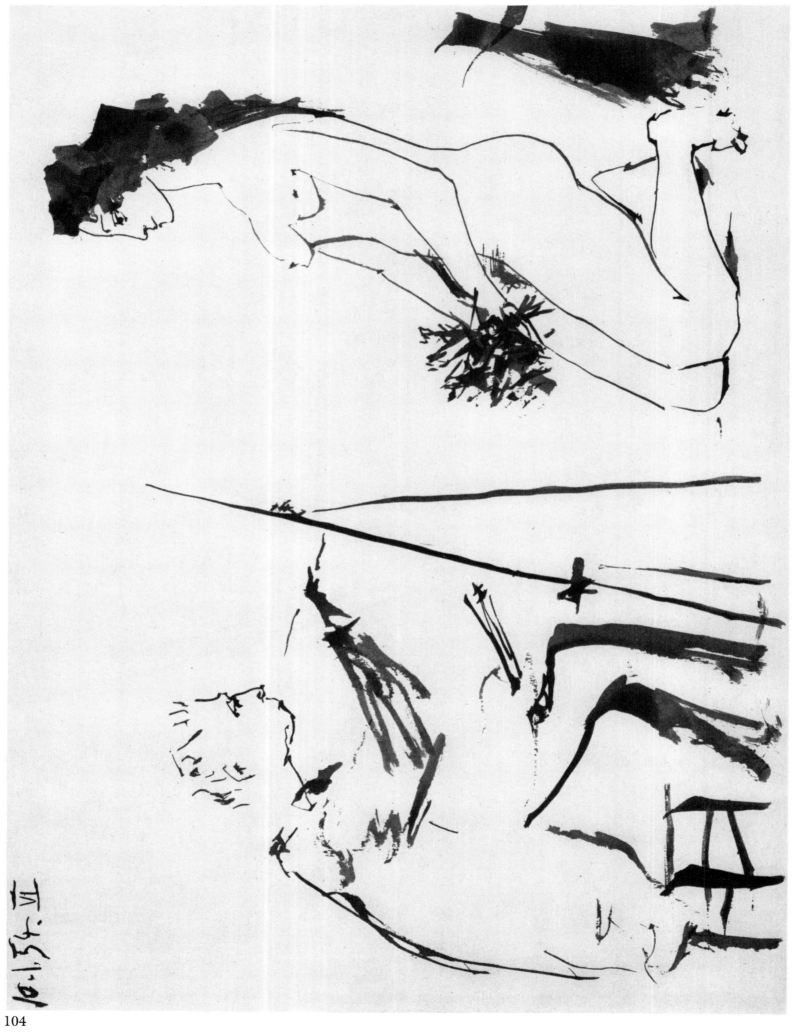

10·1·54. VI

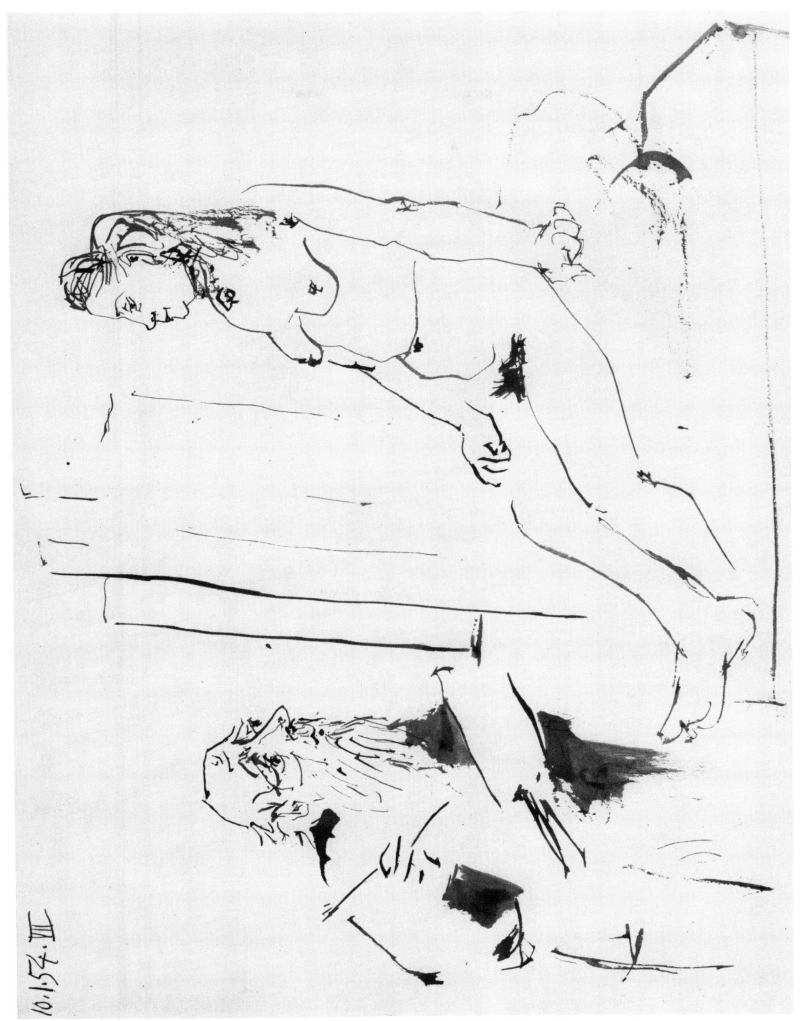

10.1.54.VII

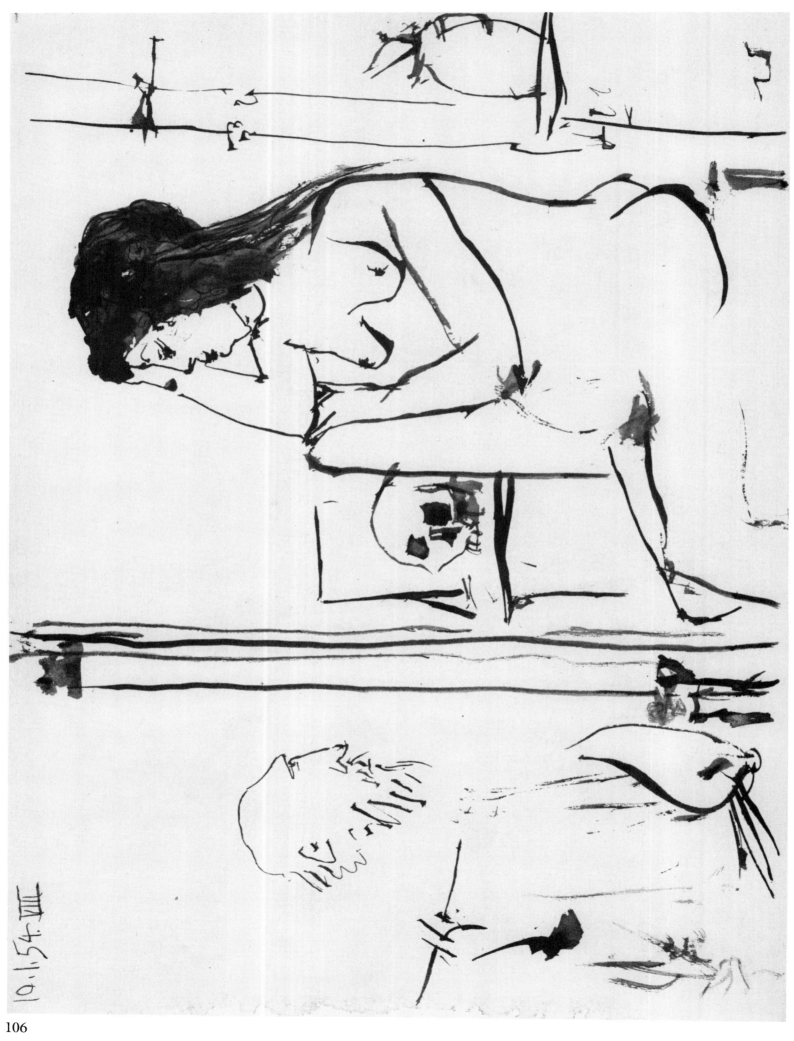

10.1.54.VIII

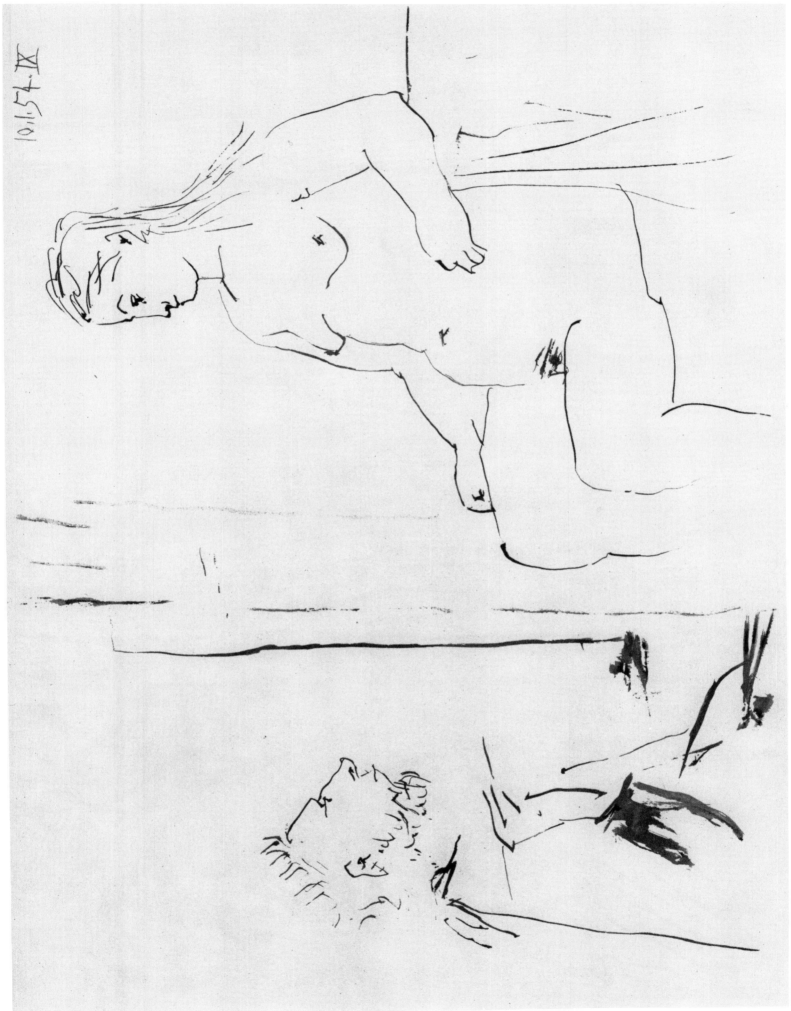

10.1.54.IX

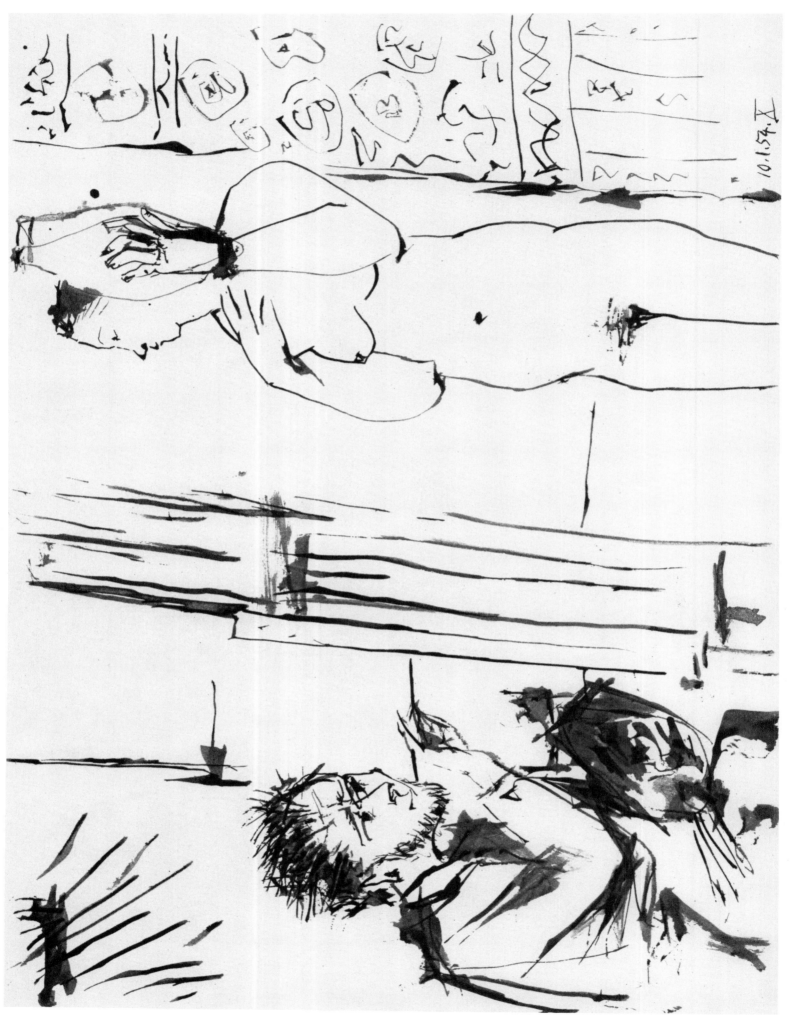

108

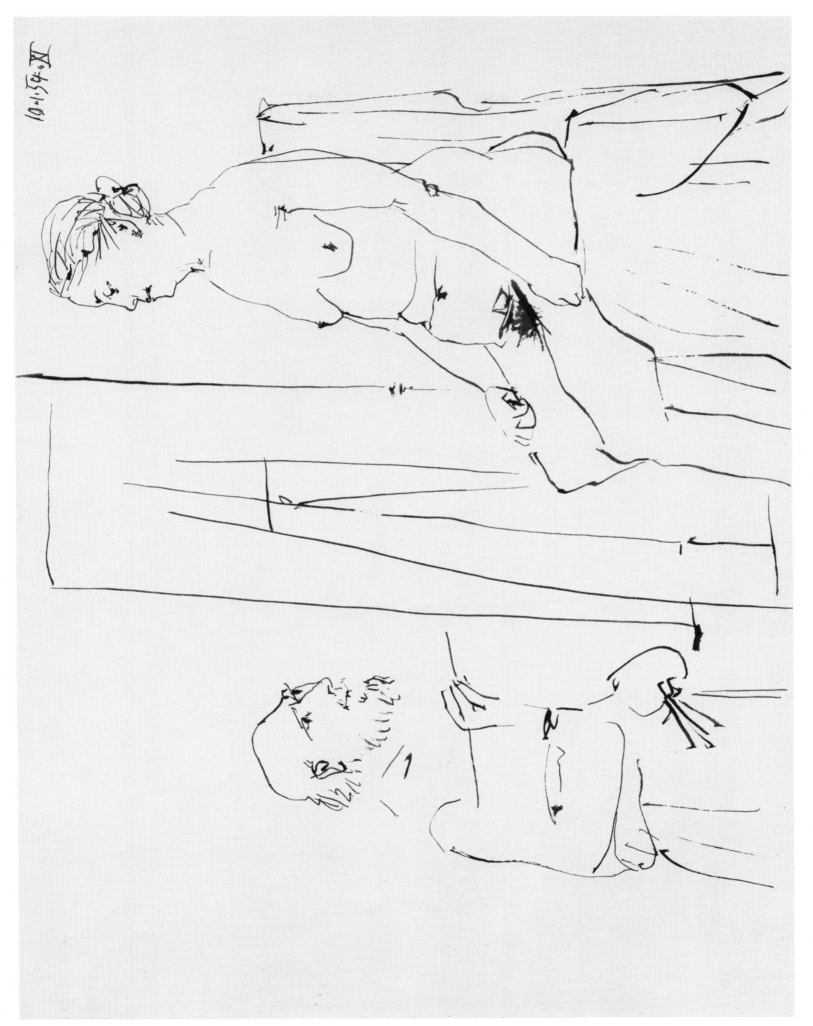

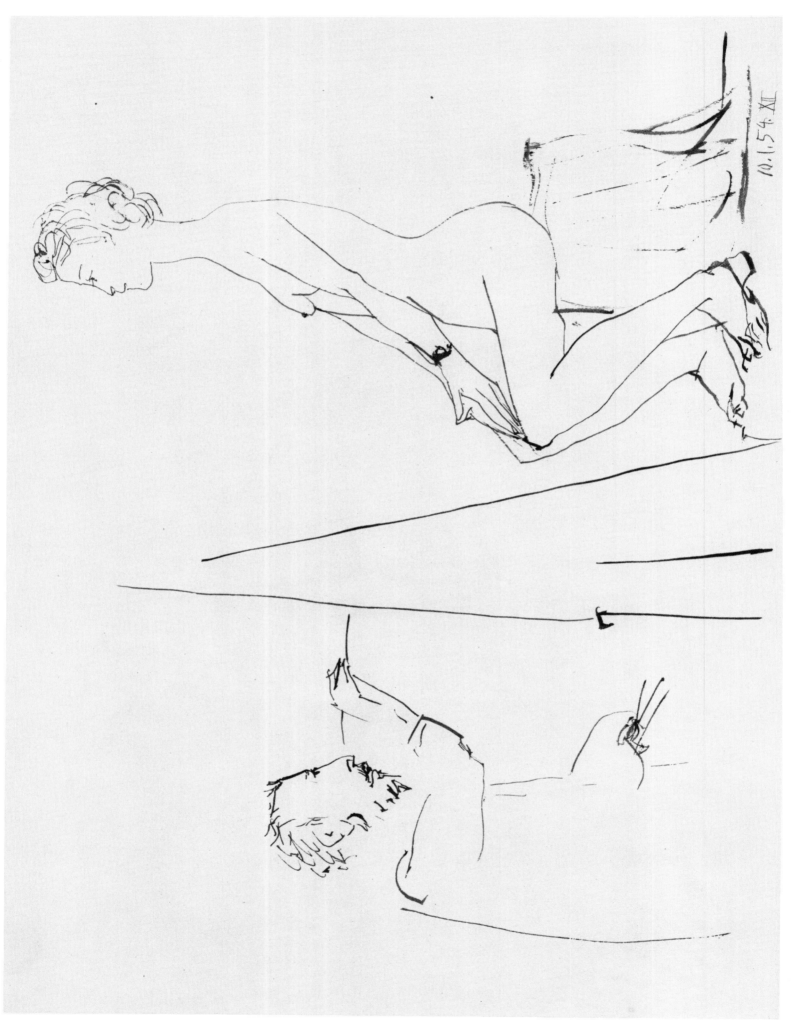

110

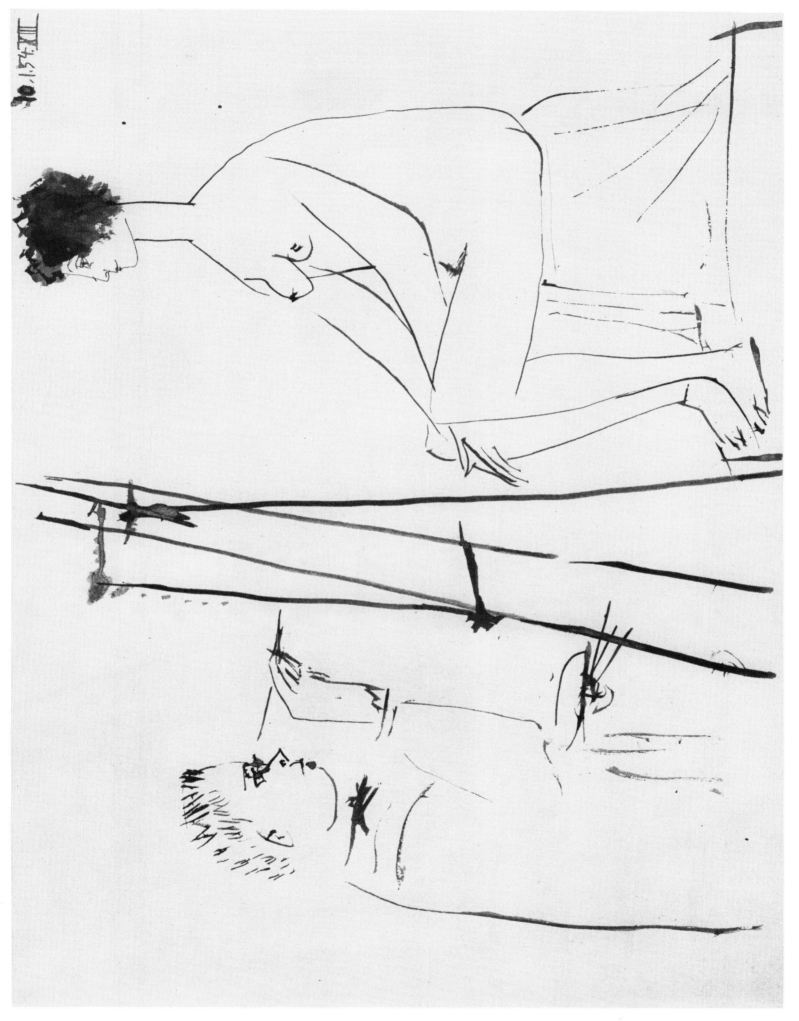

111

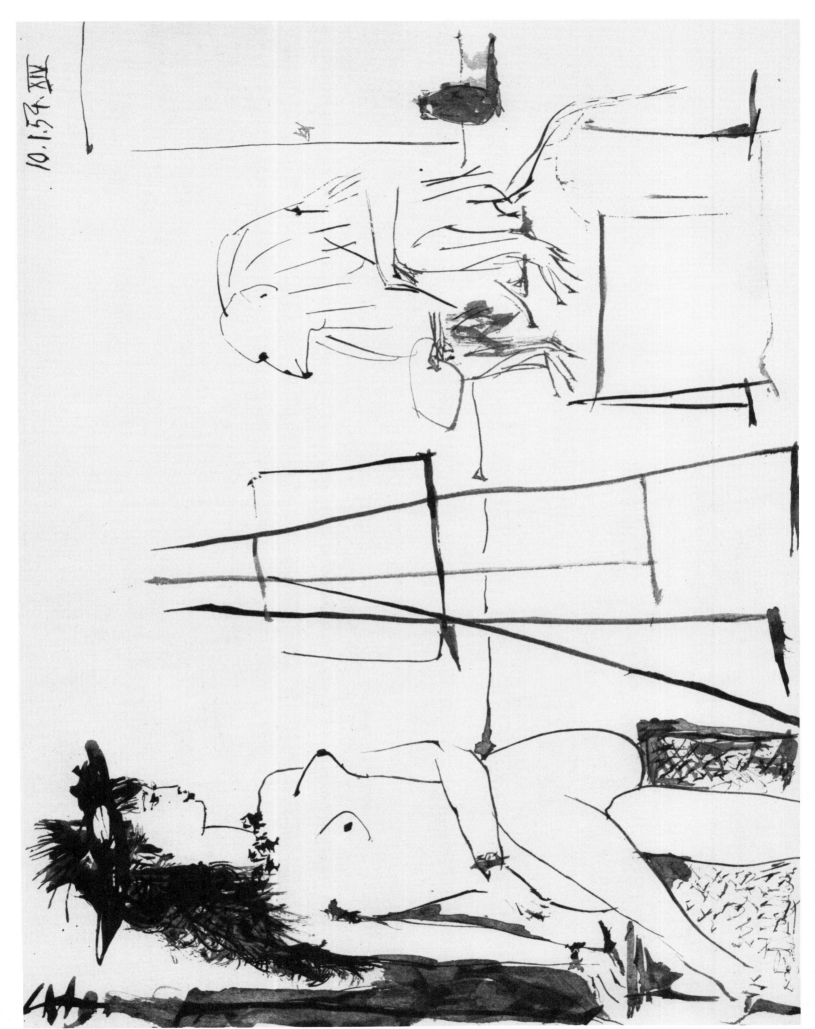

10.1.57. XIV

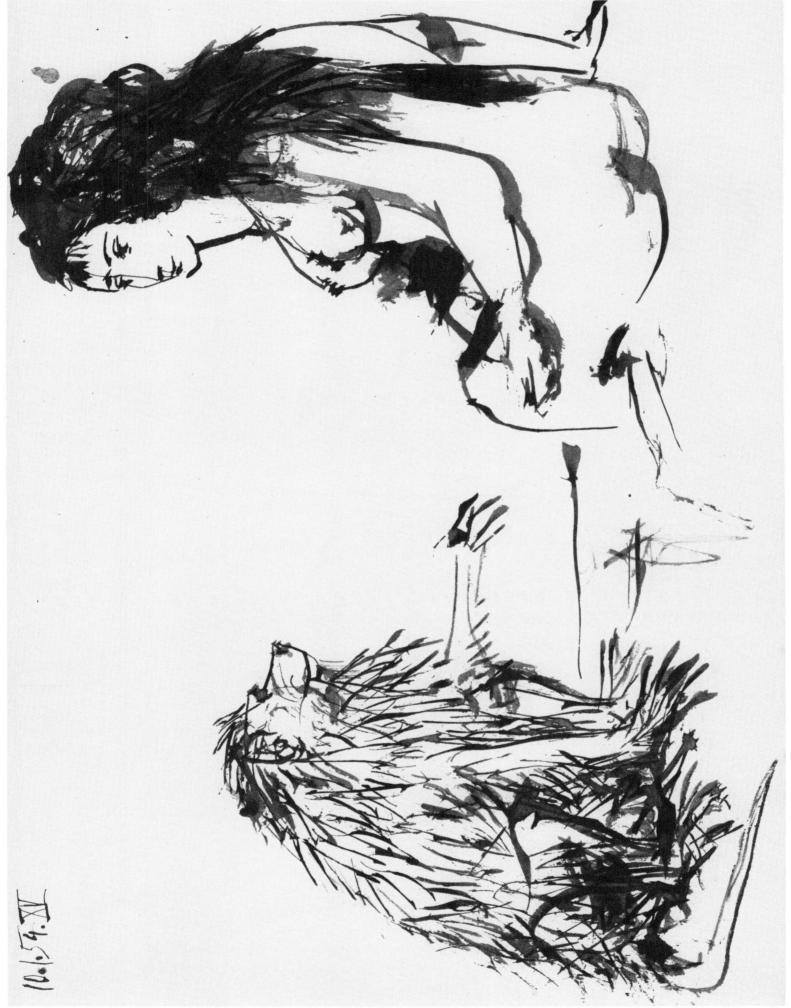

113

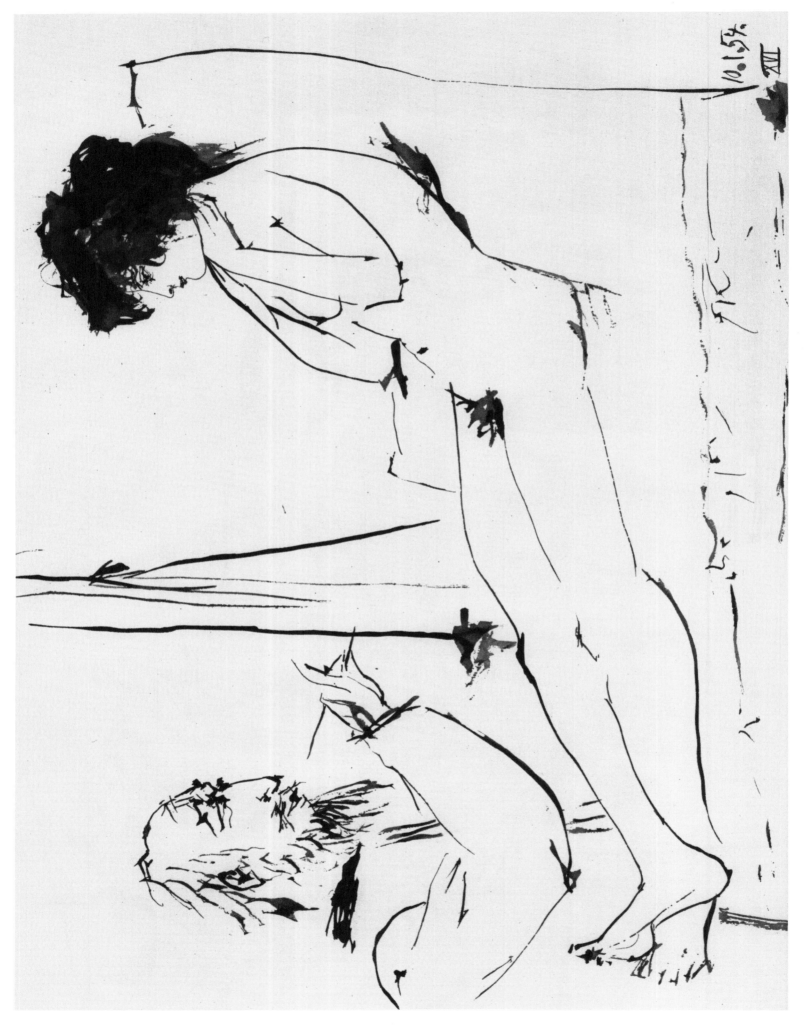

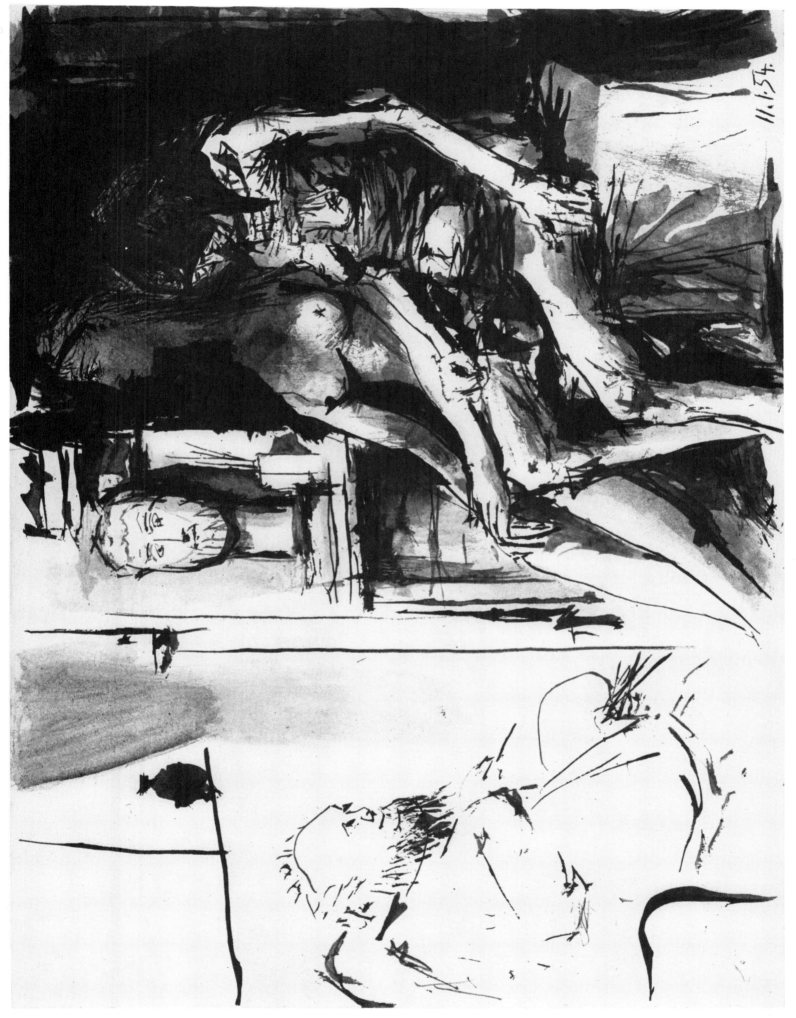

115

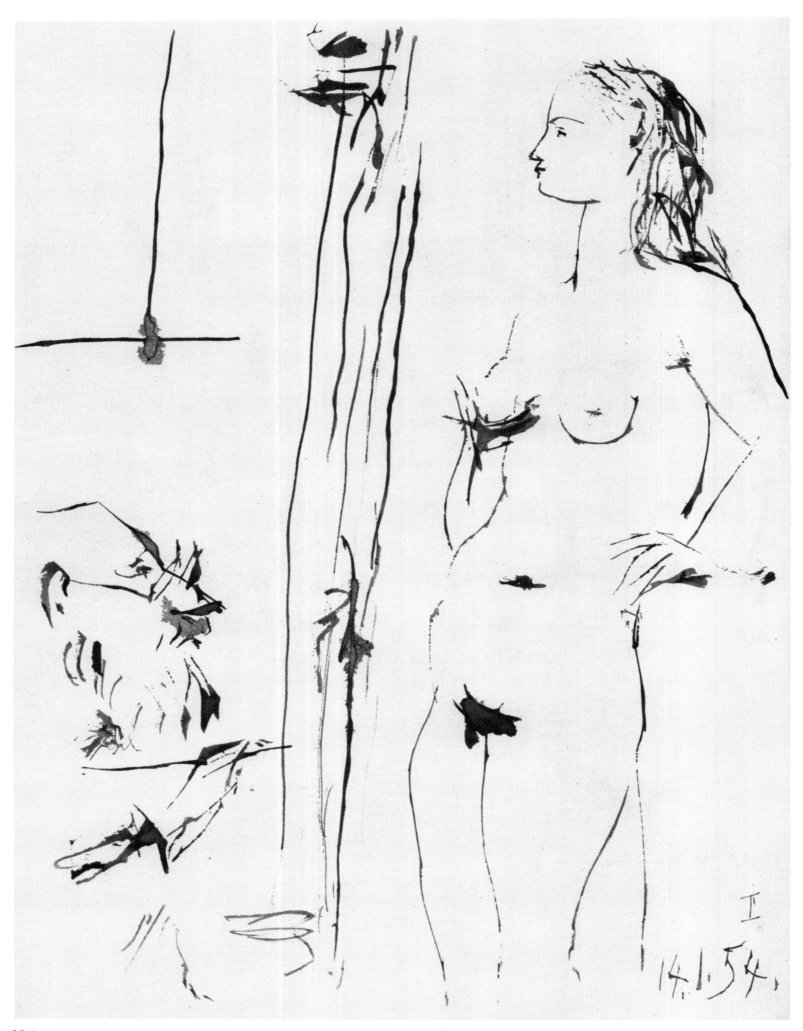

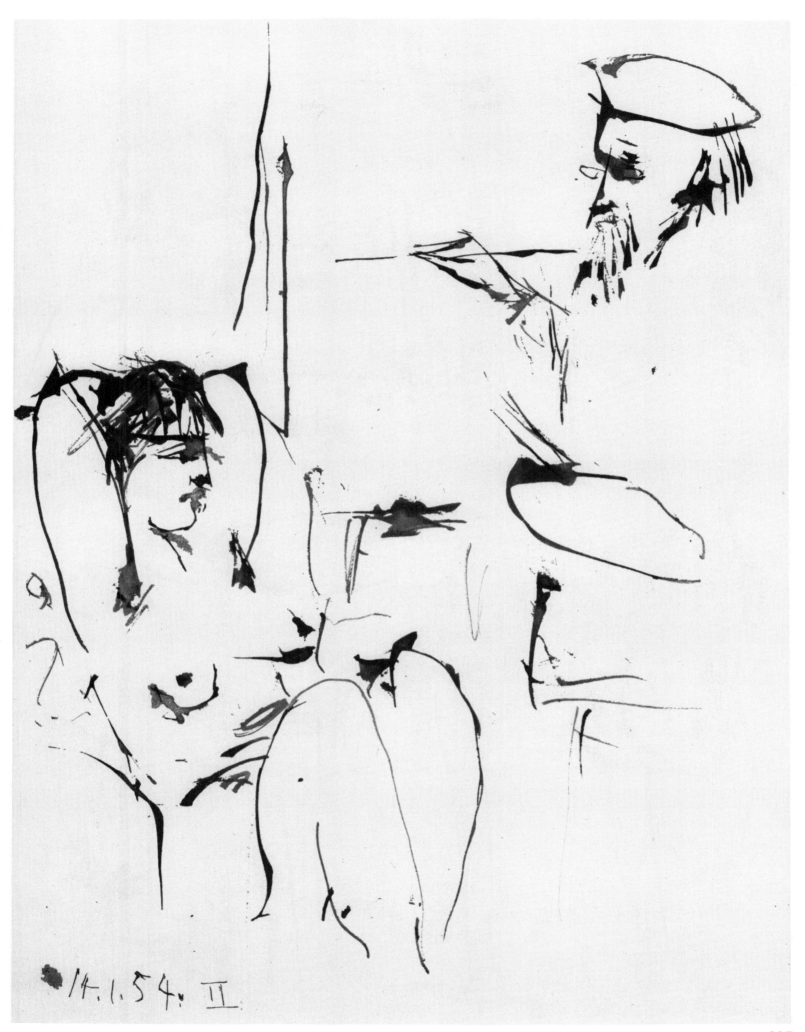

14.1.54. II

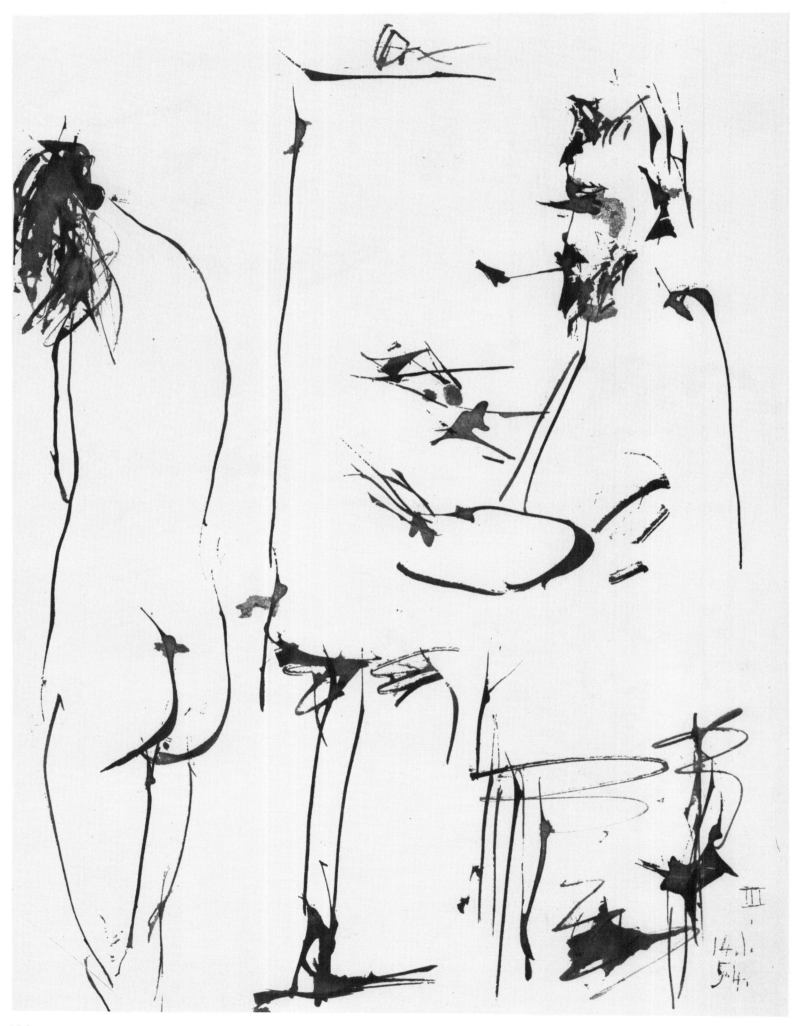

118

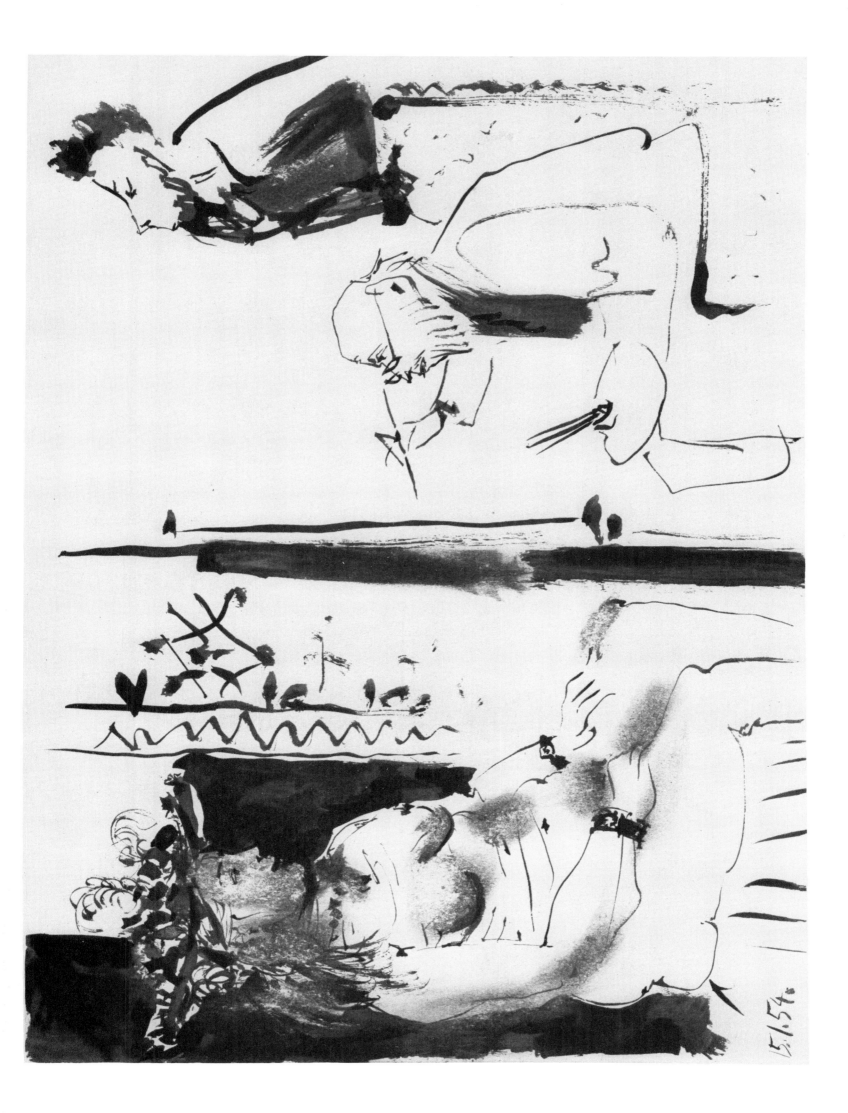

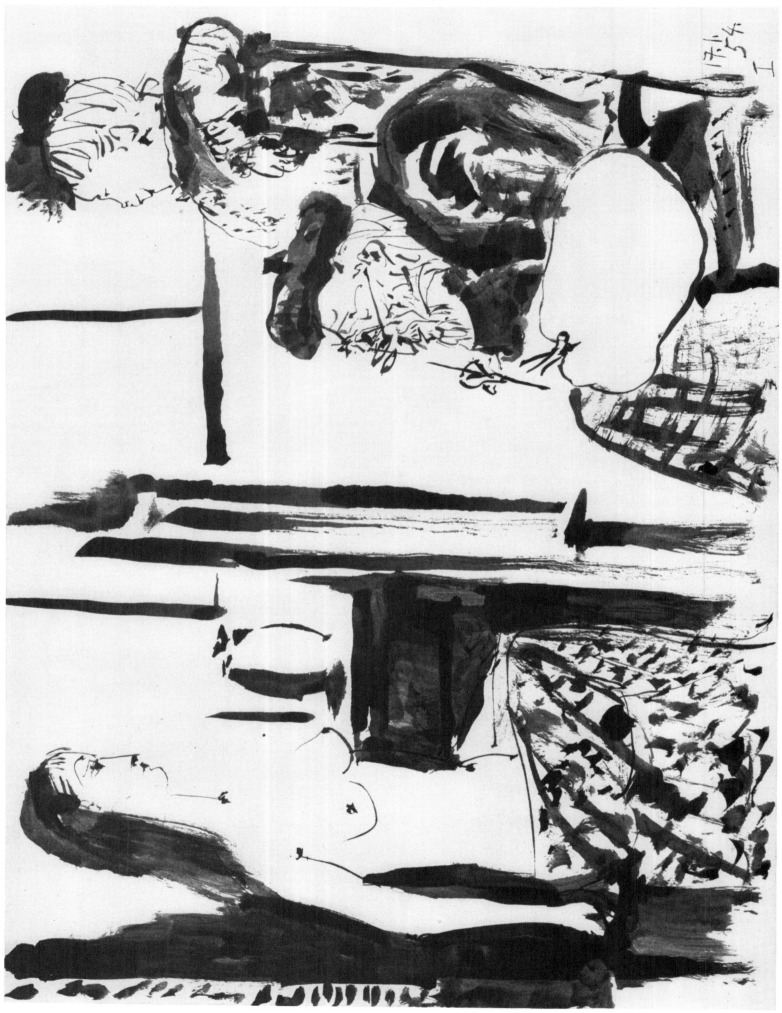

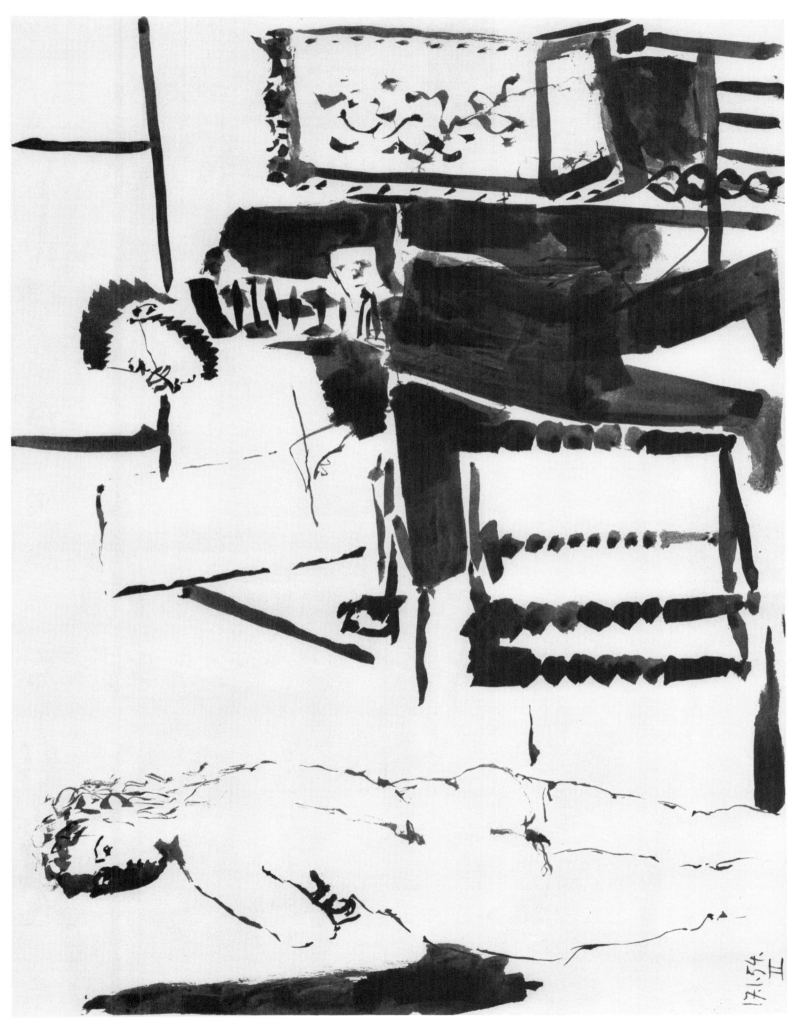

121

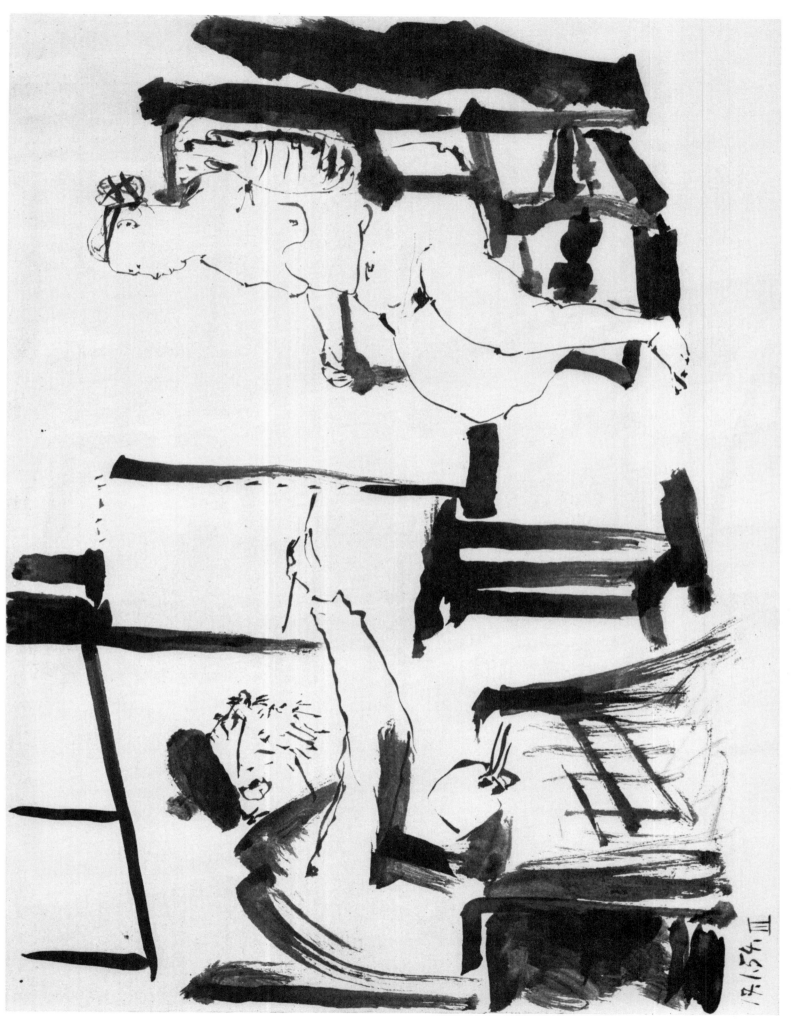

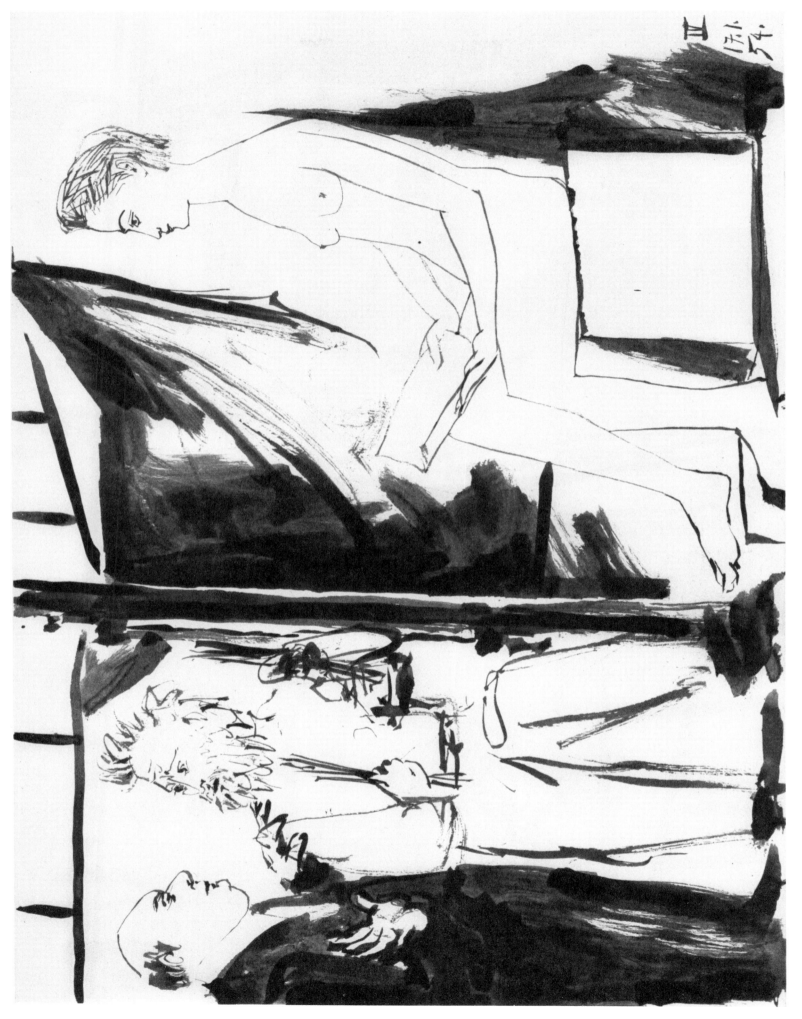

123

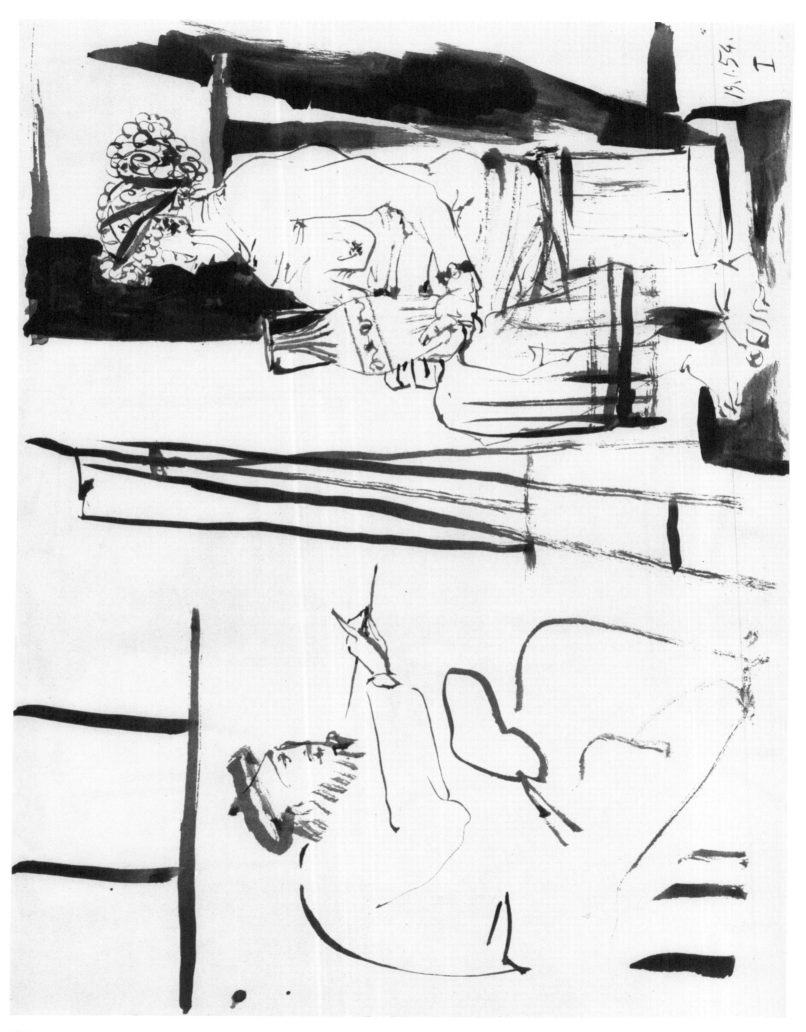

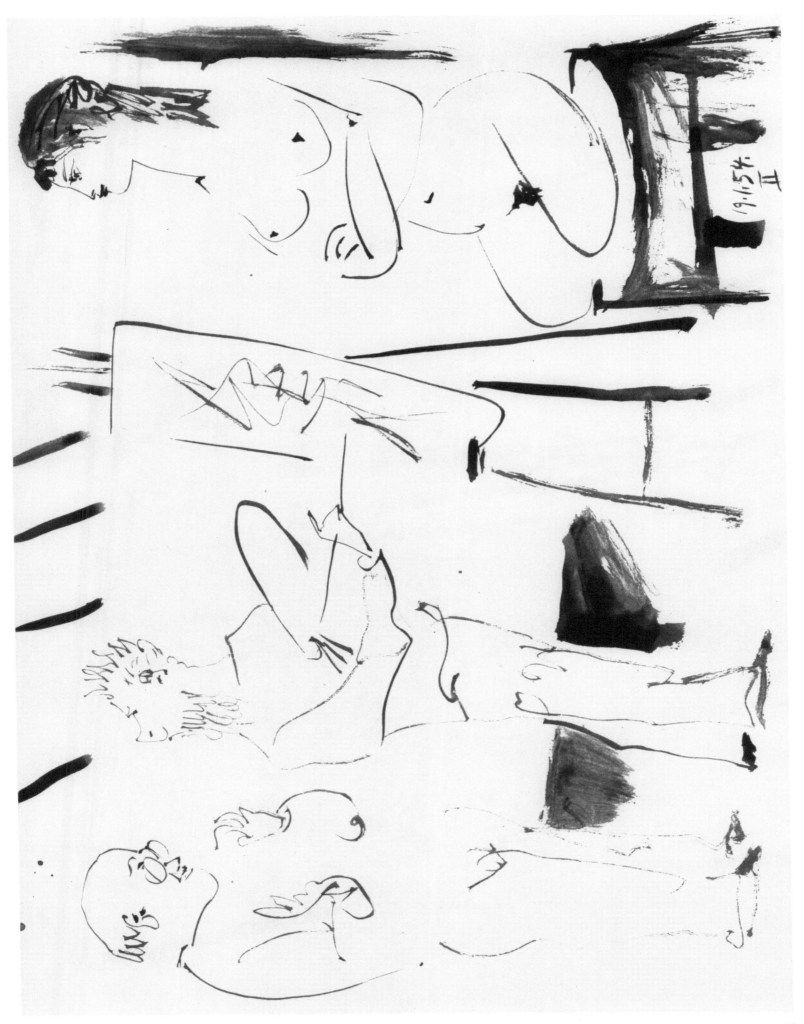

125

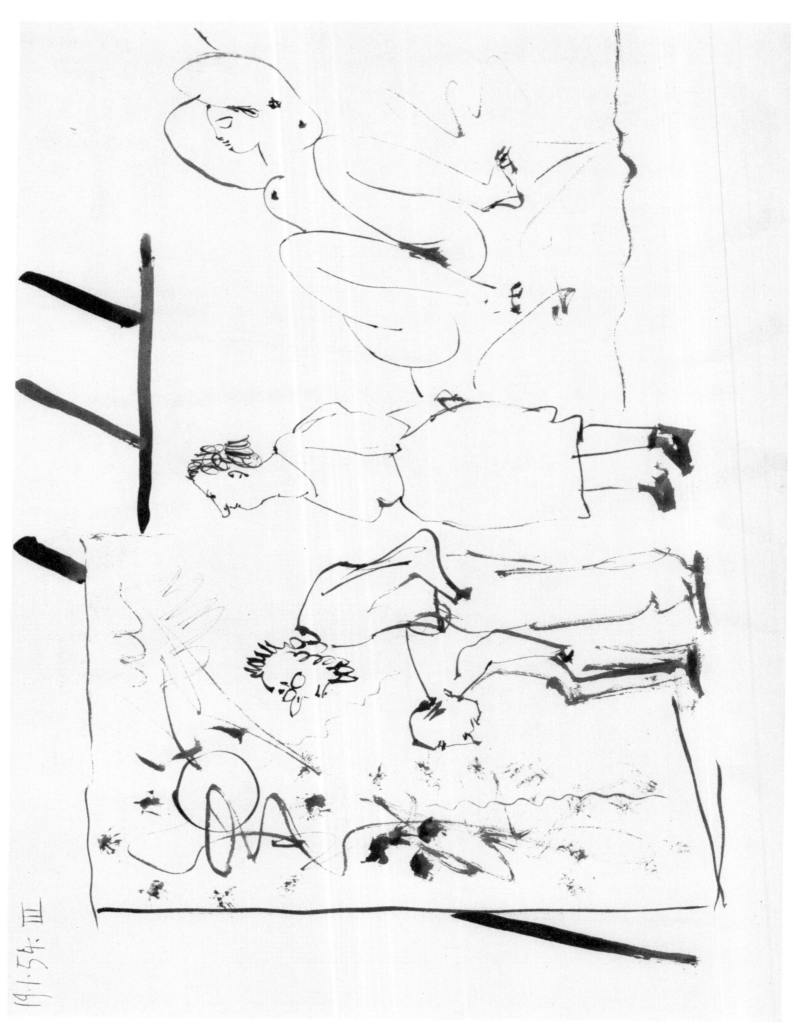

19.1.54. III

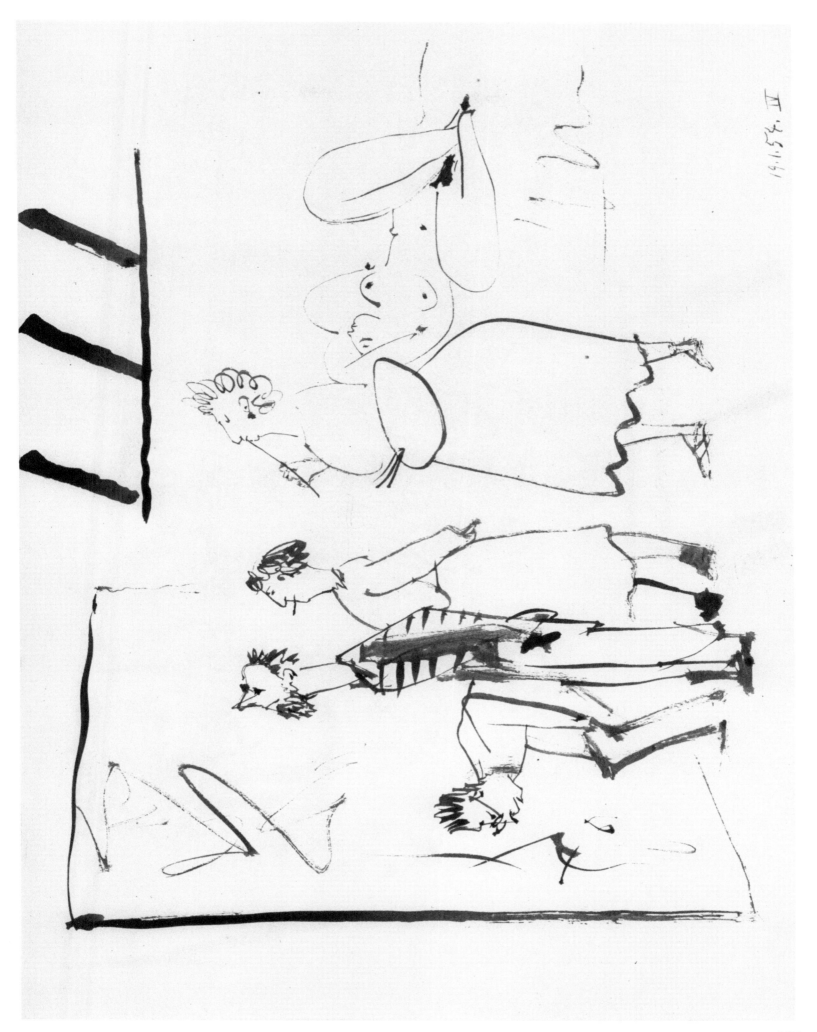

127

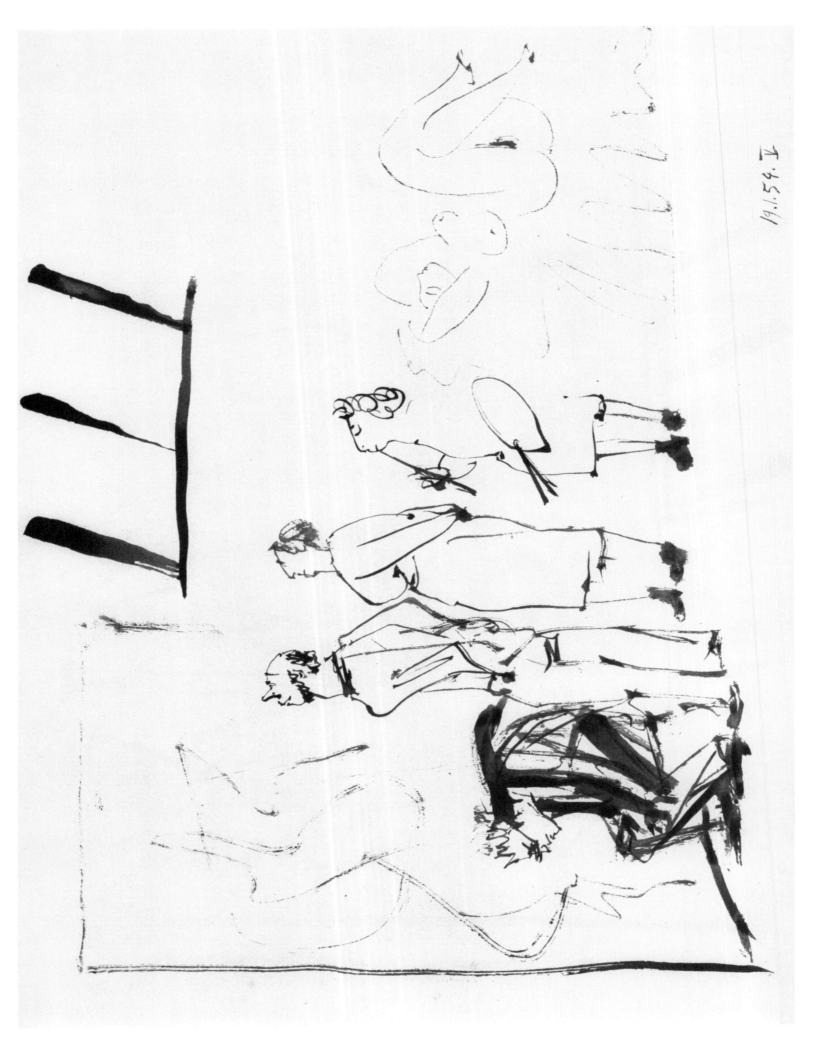

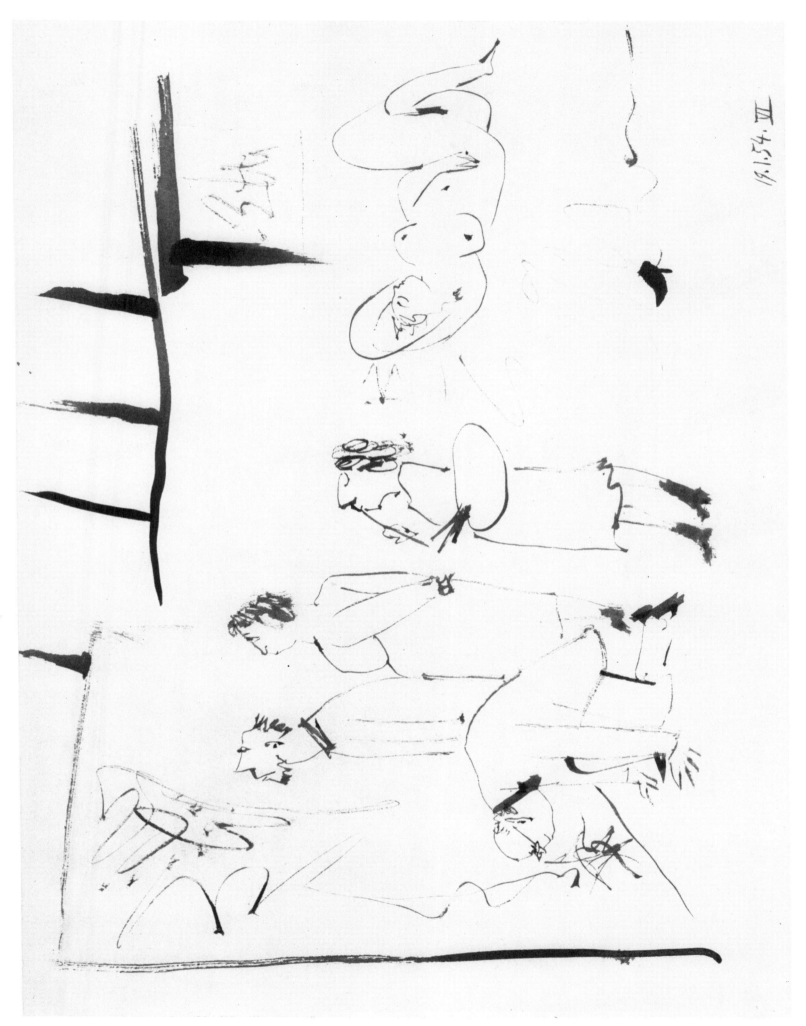

19.1.54. VII

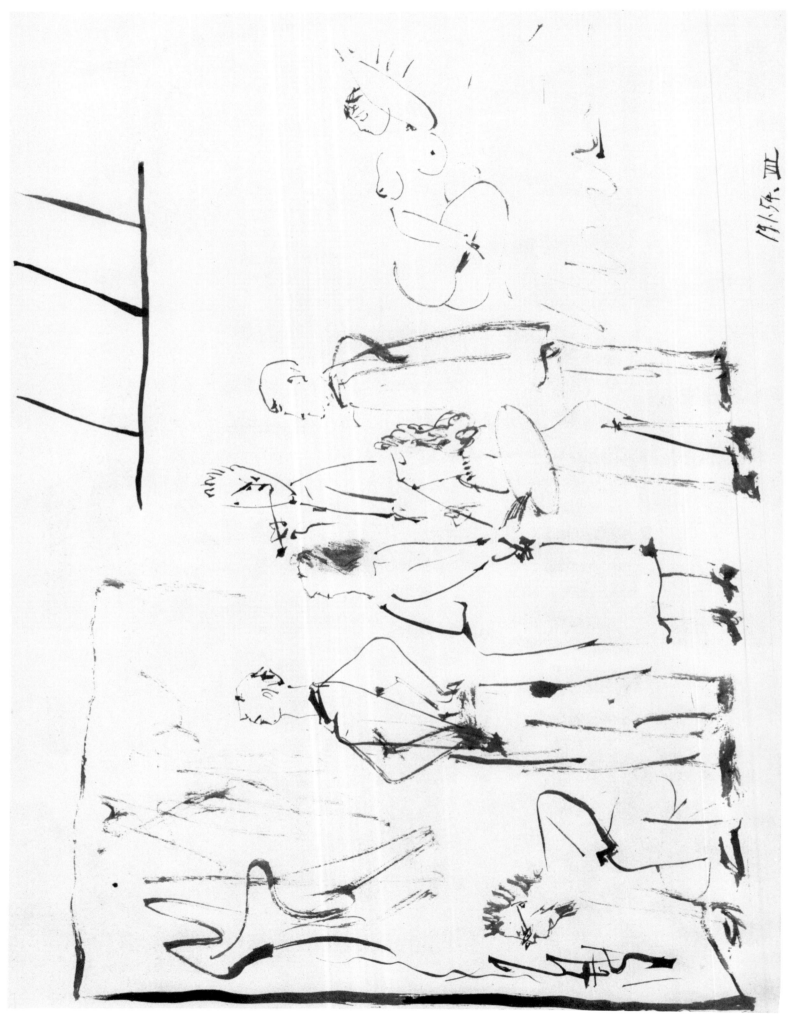

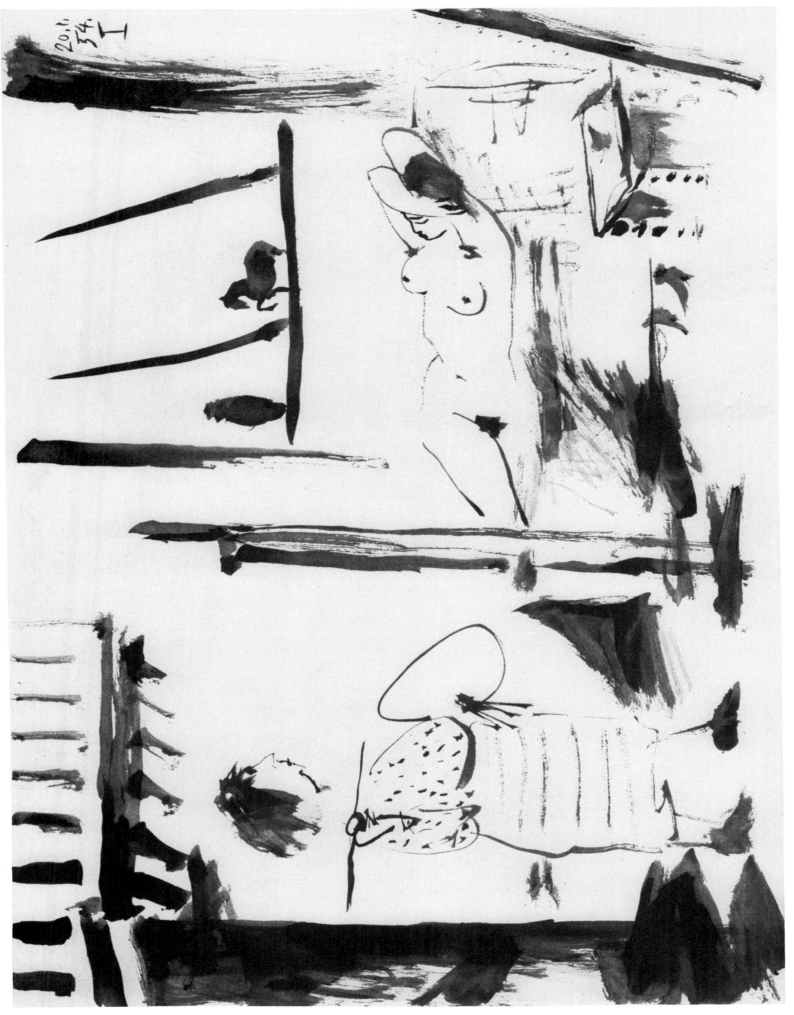

131

20.1.54.
II

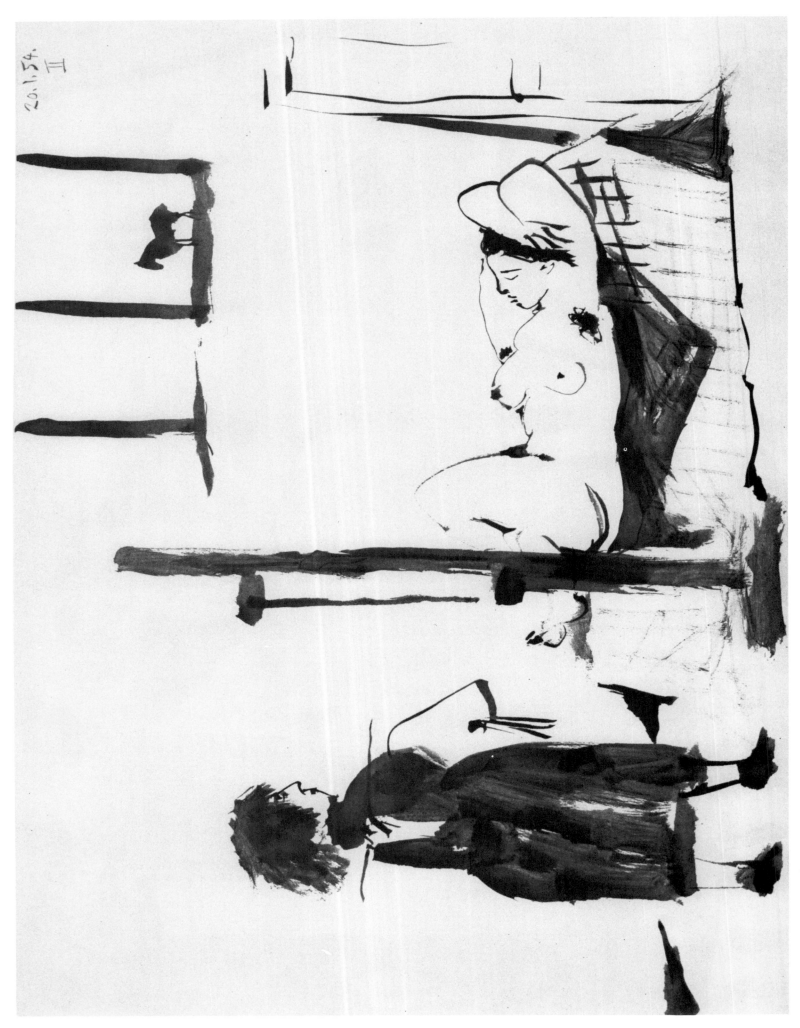

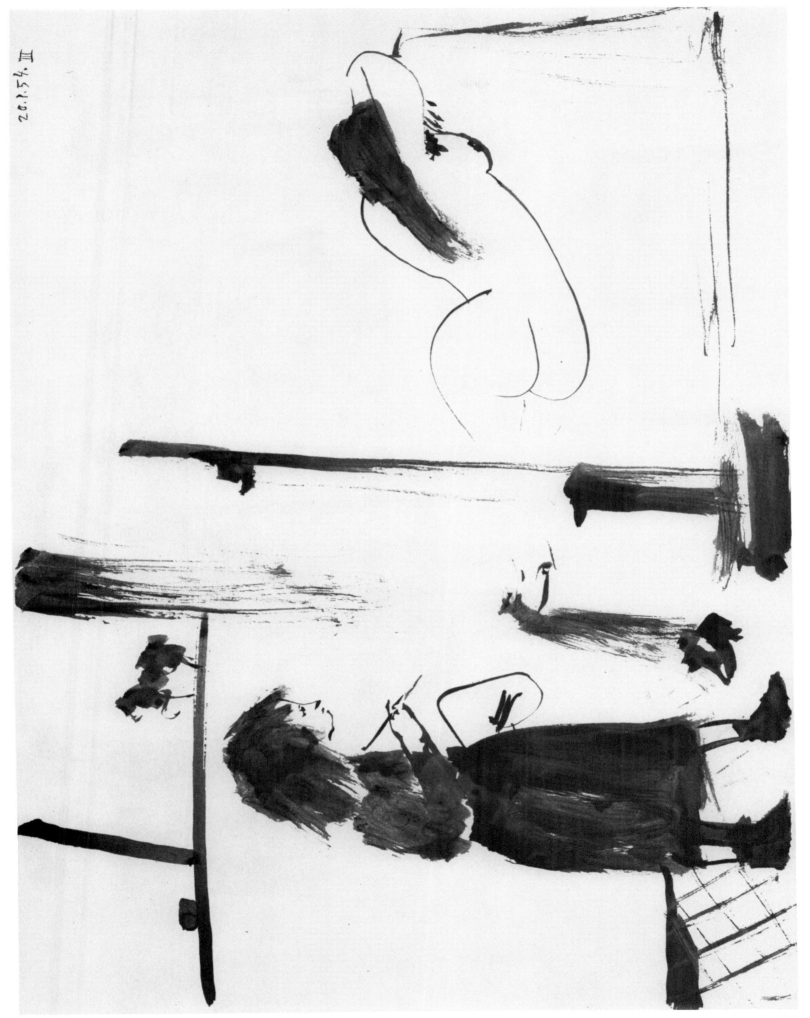

20.1.54. II

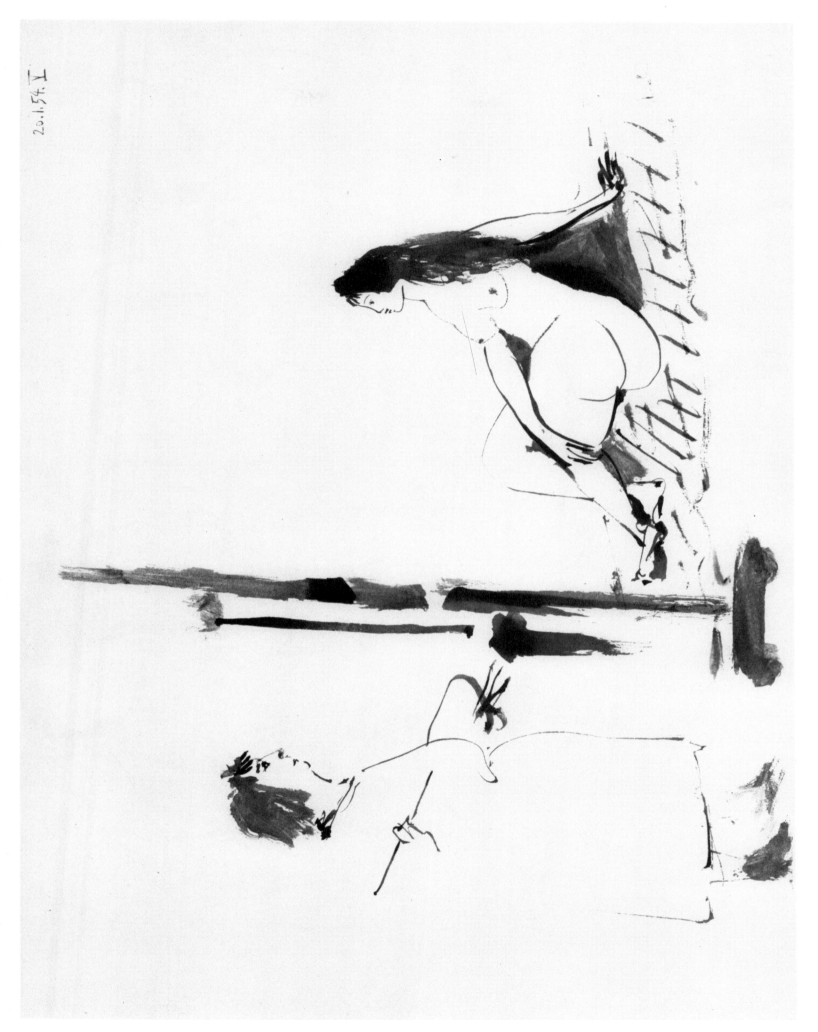

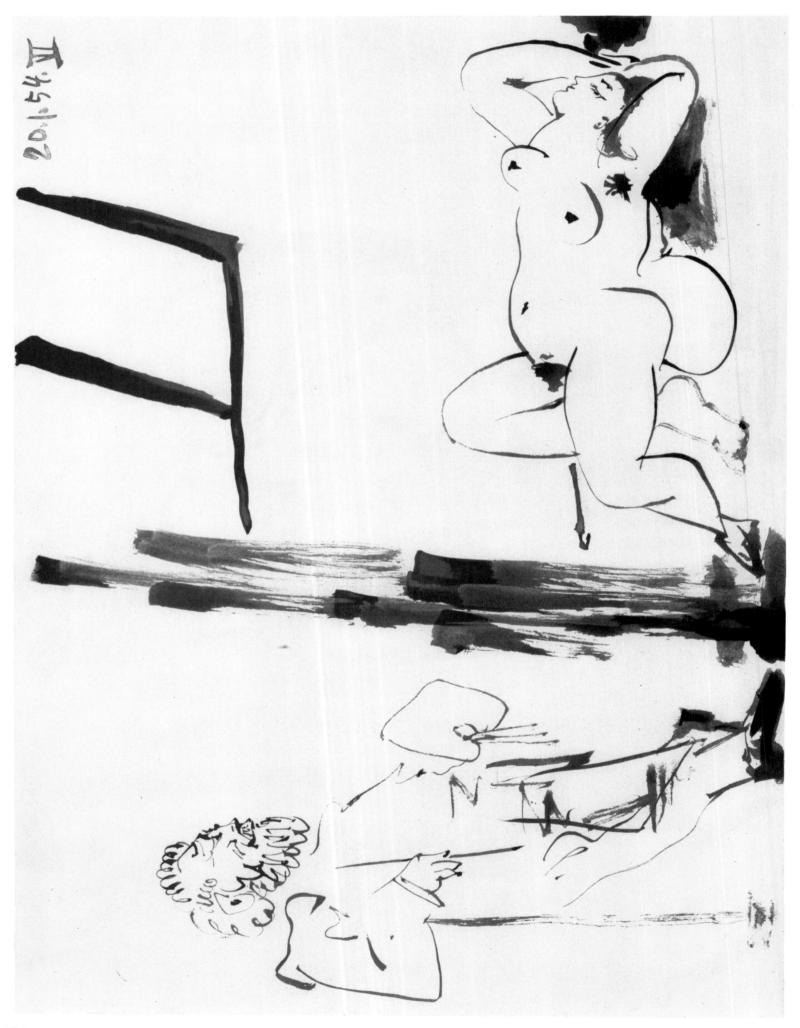

136

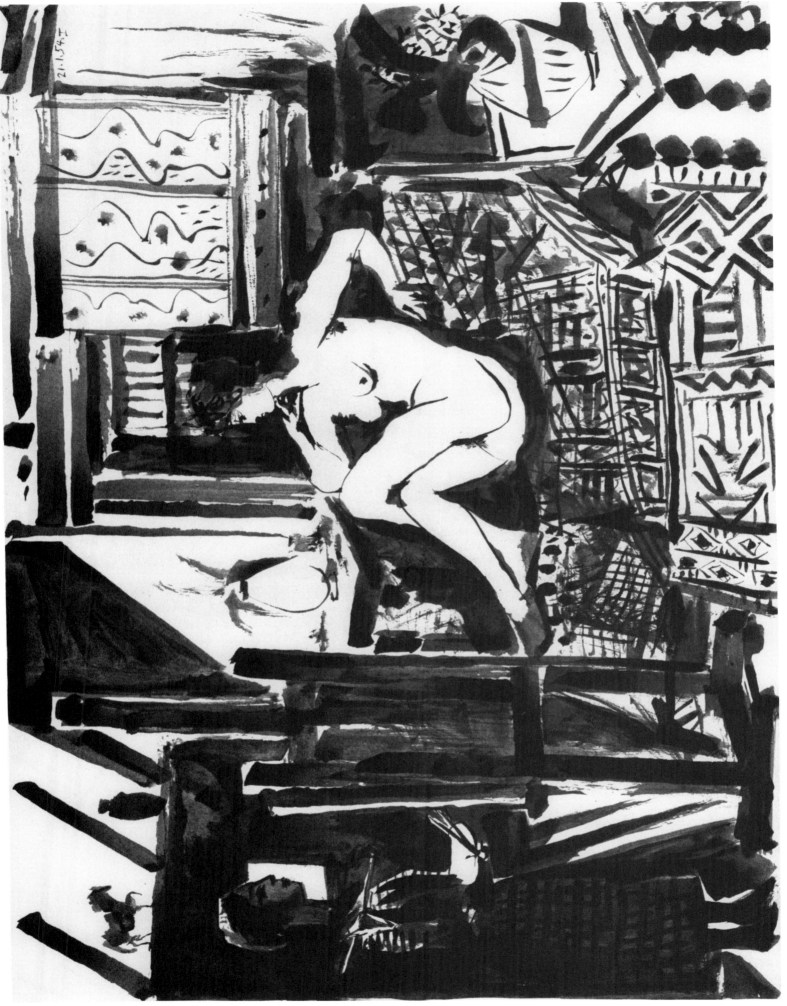

137

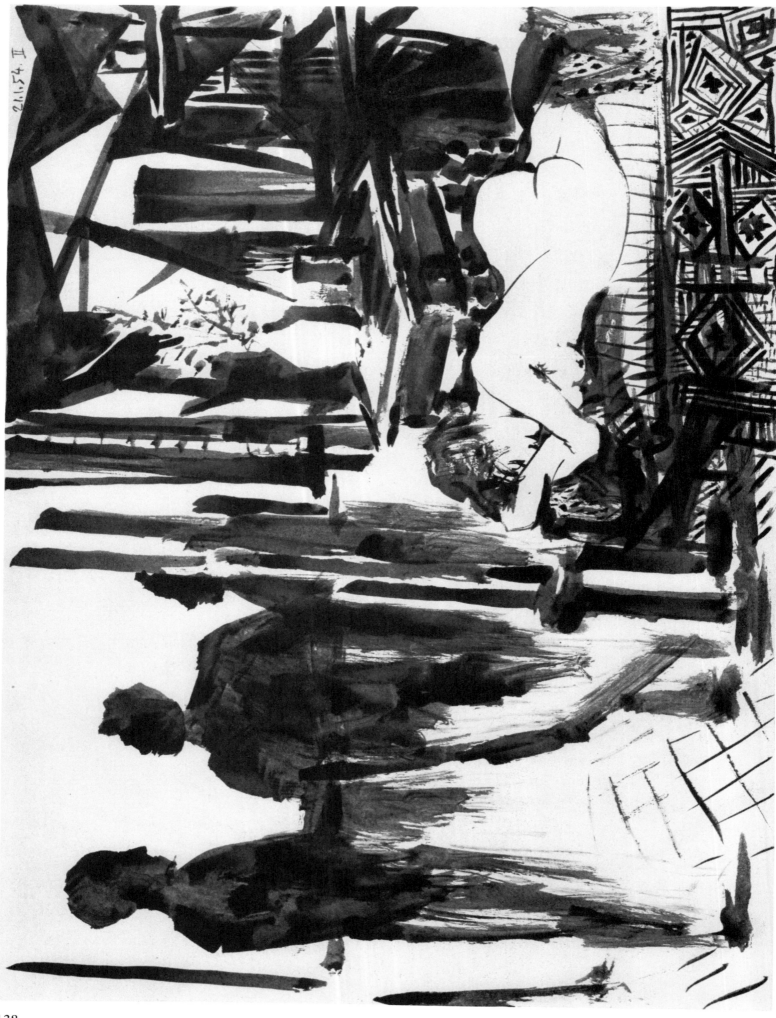

138

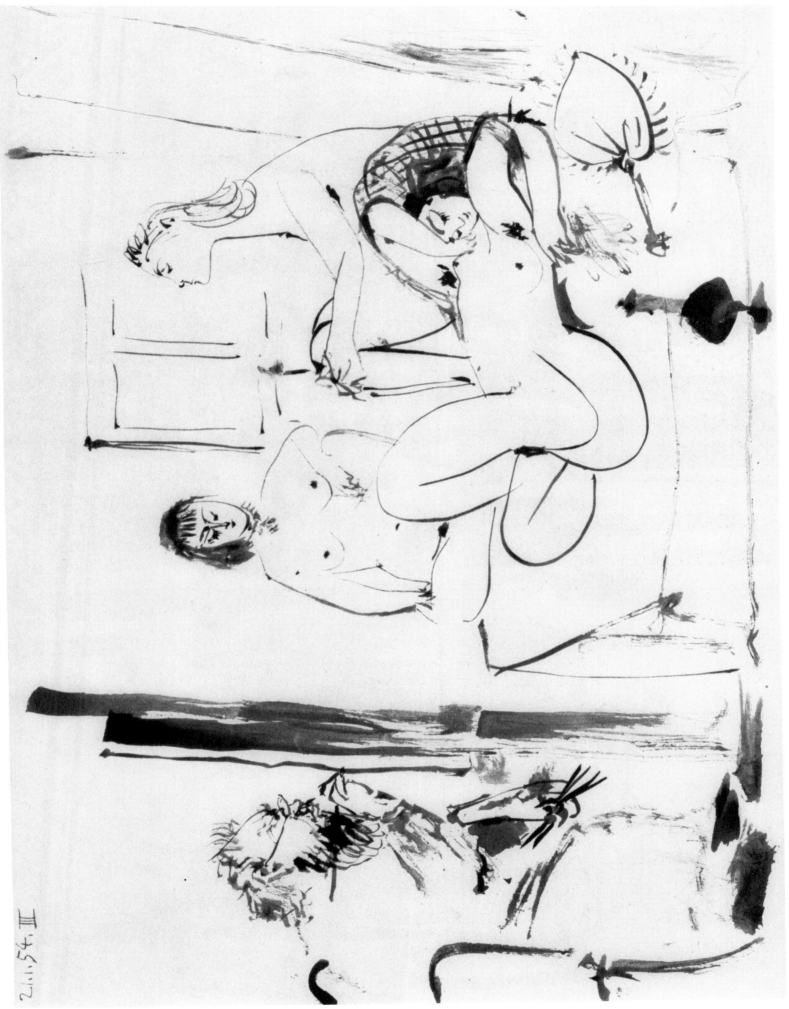

139

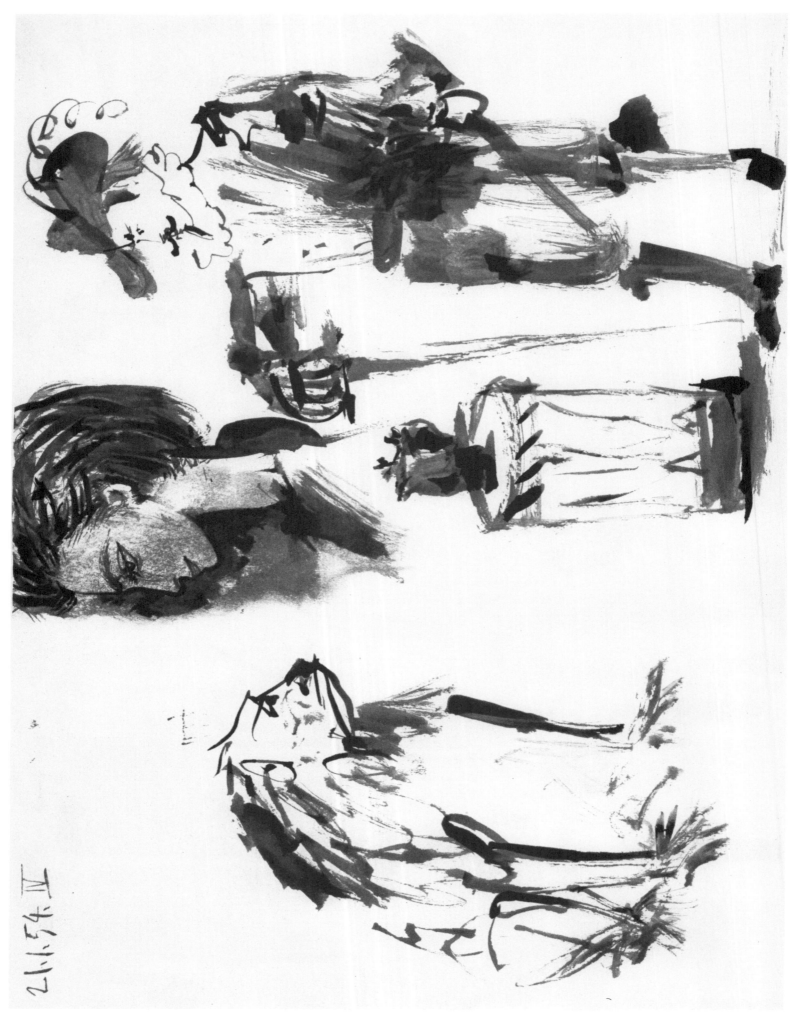

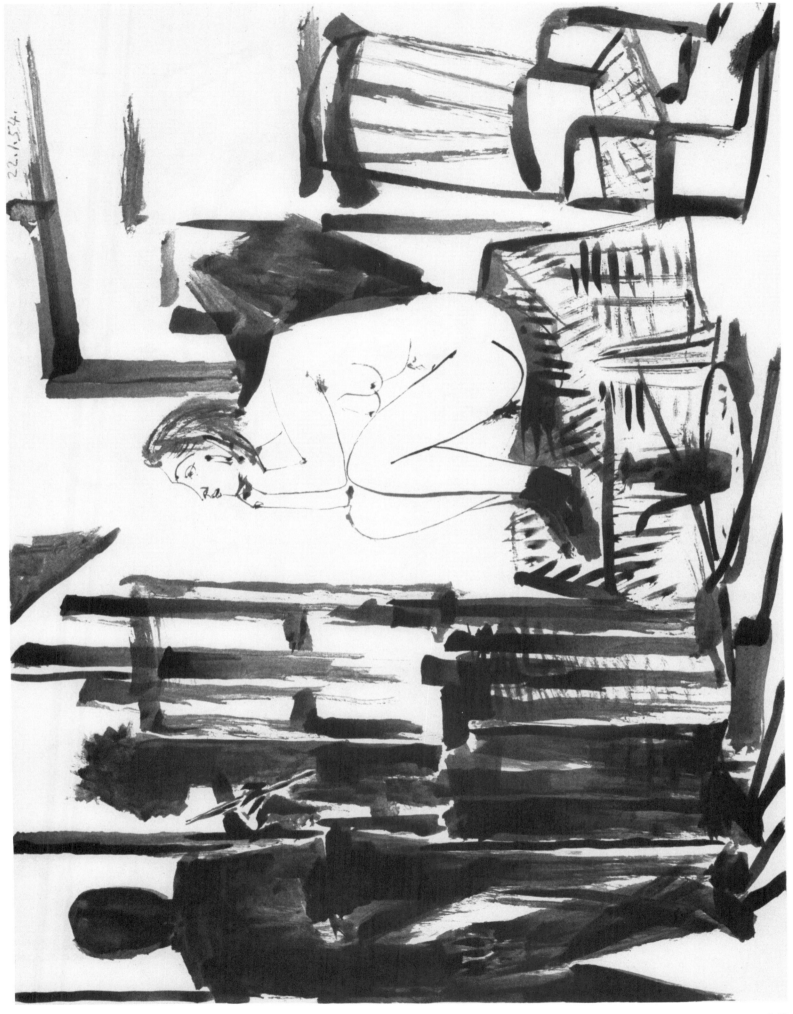

141

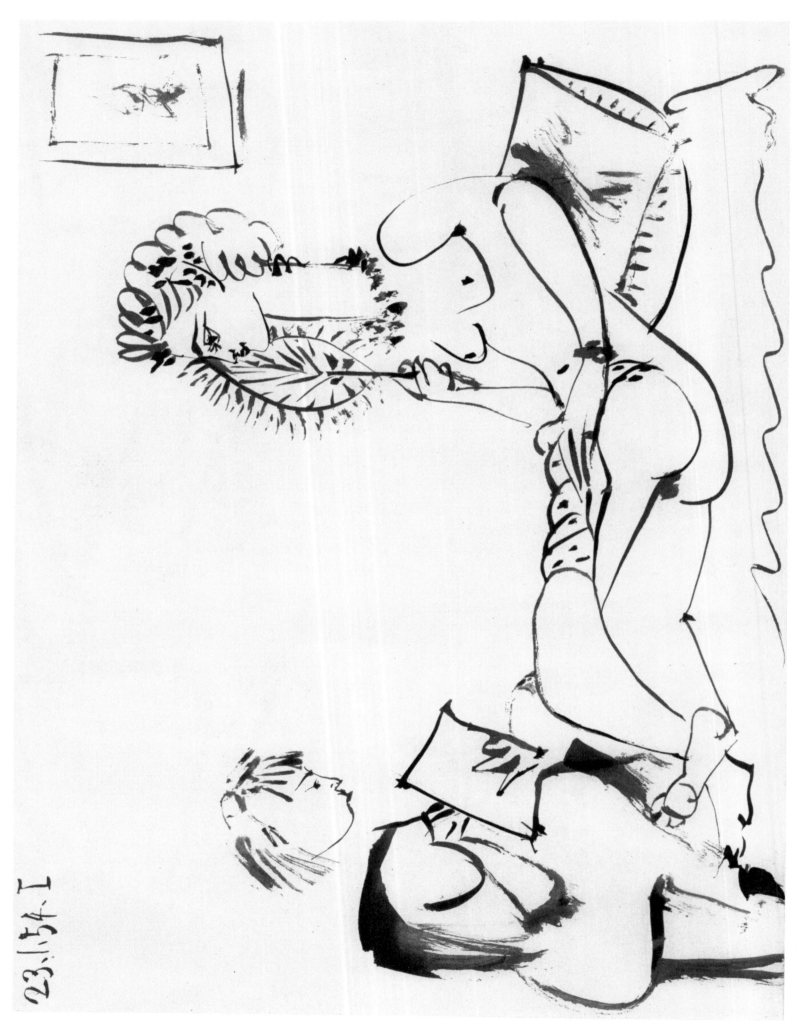

23.1.54.I

142

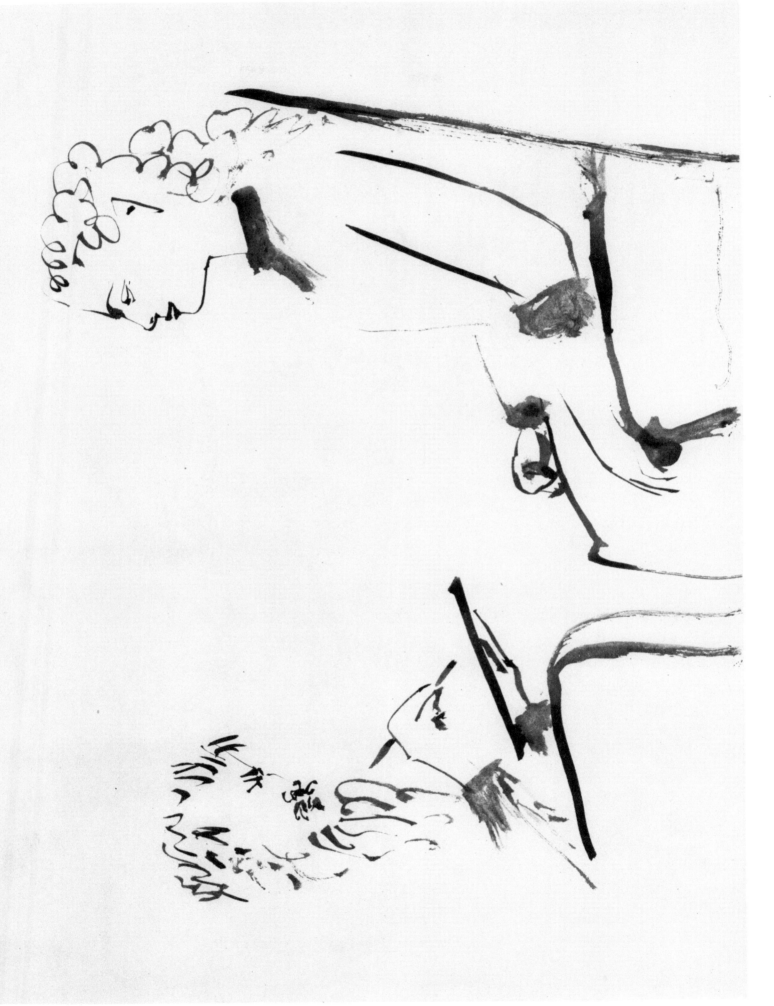

23.1.54.II

143

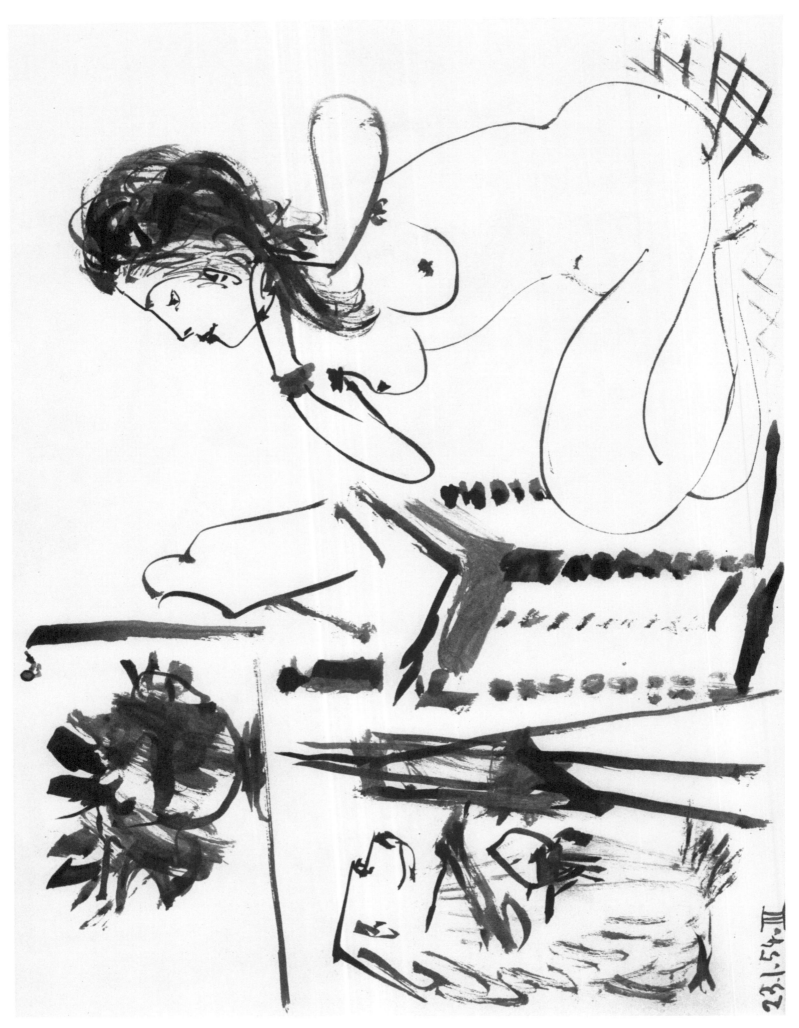

144

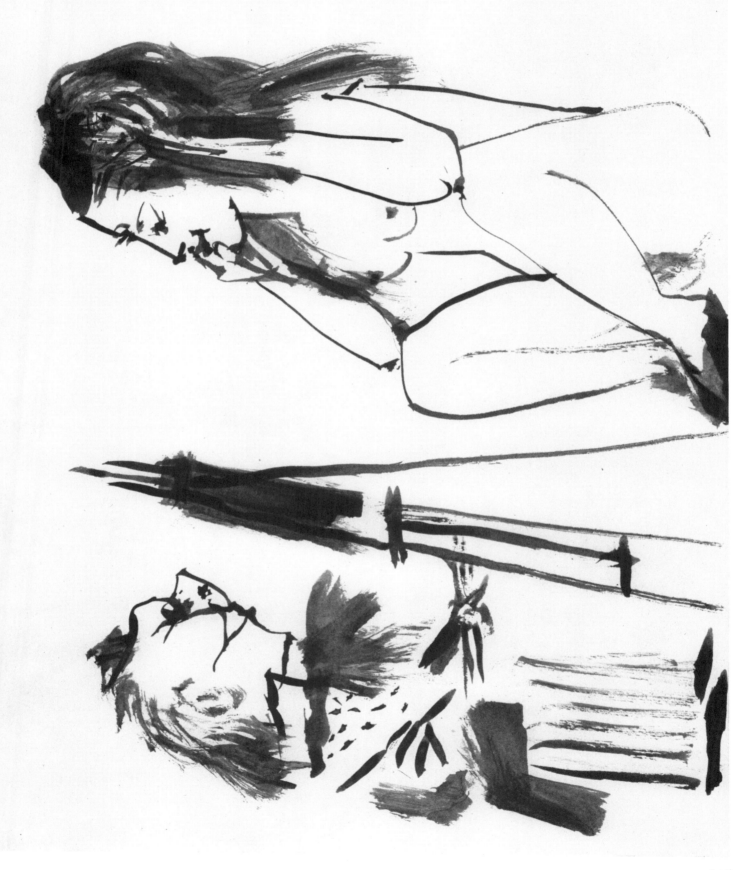

145

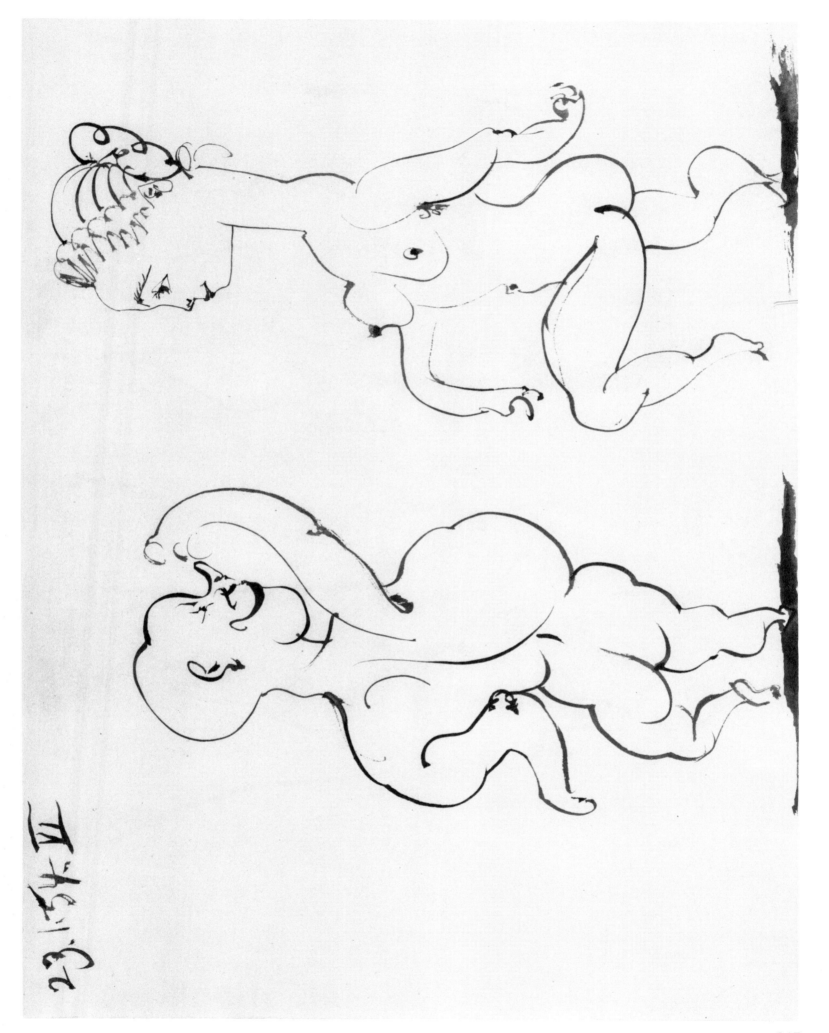

23.54.亚

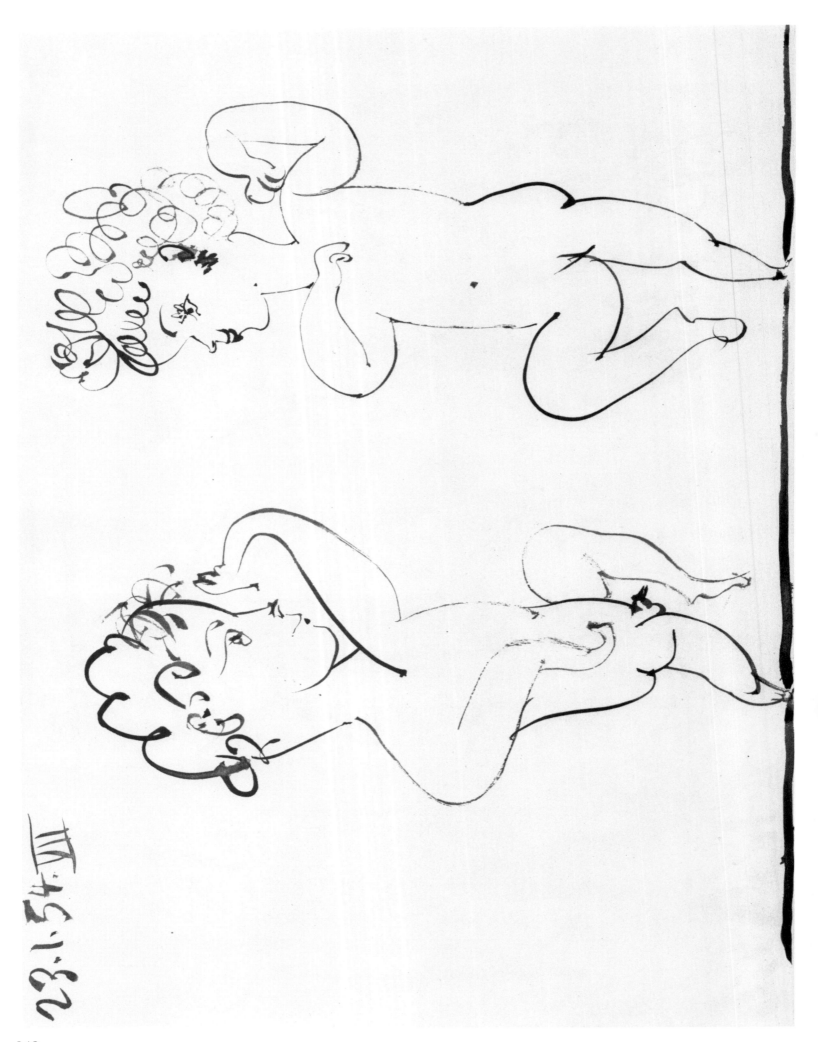

23.1.54.VII

148

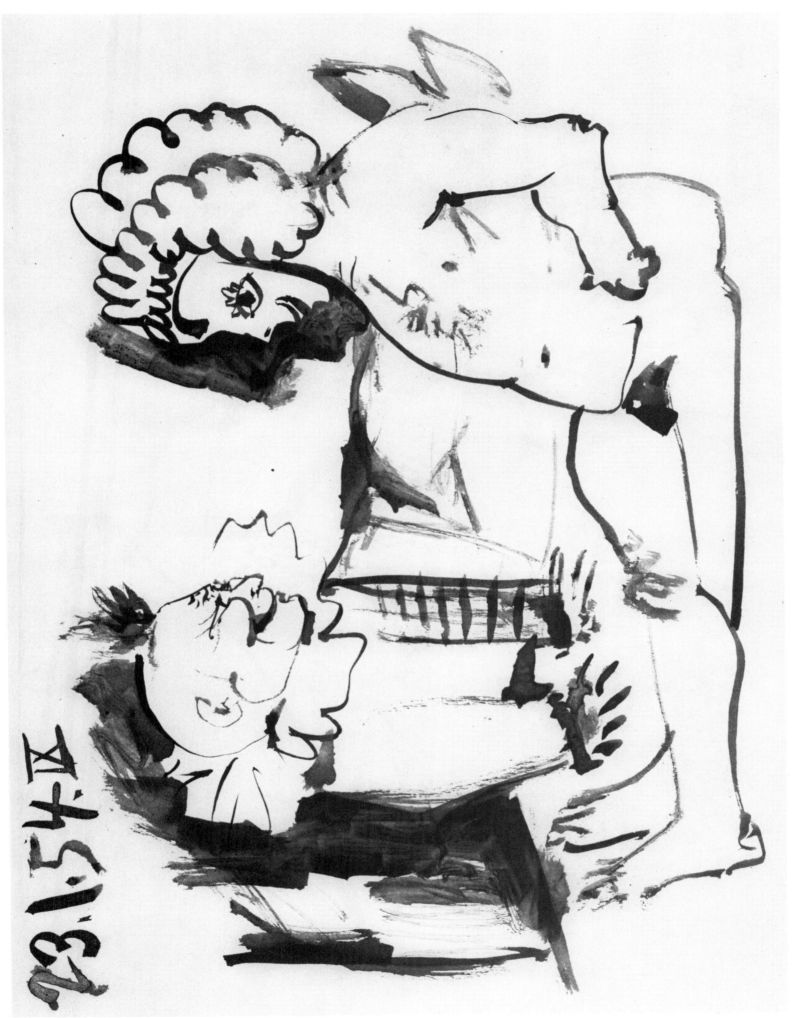

149

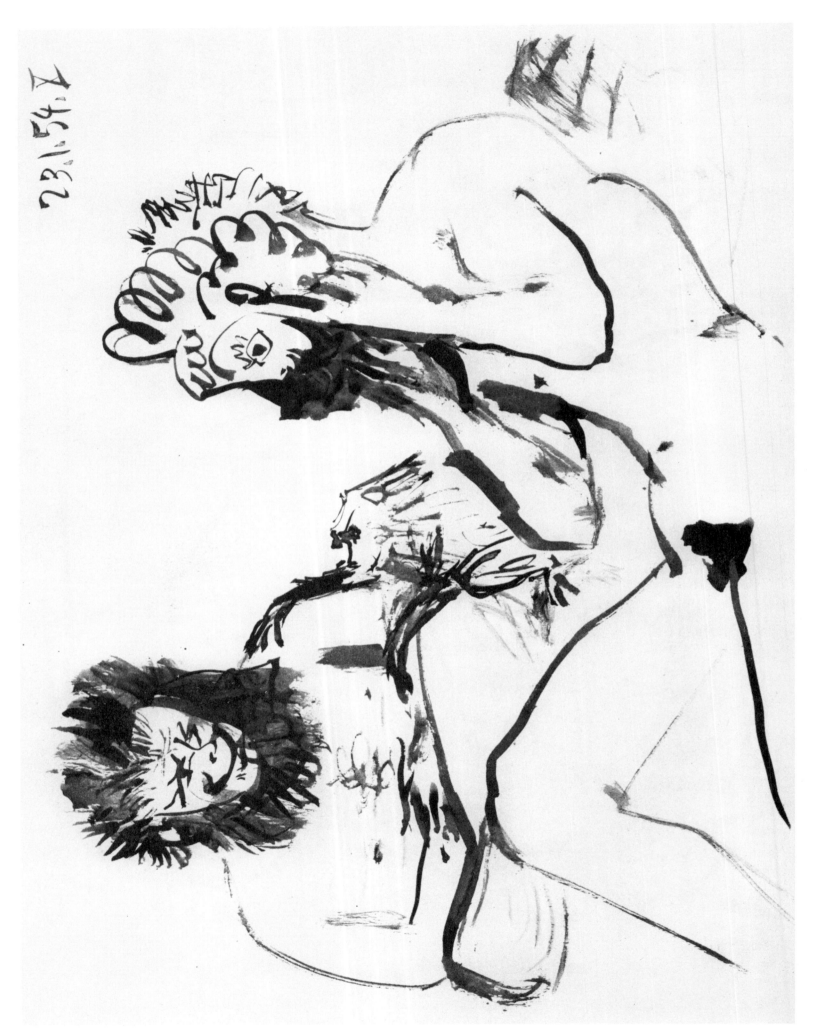

23.6.54.Ⅴ

150

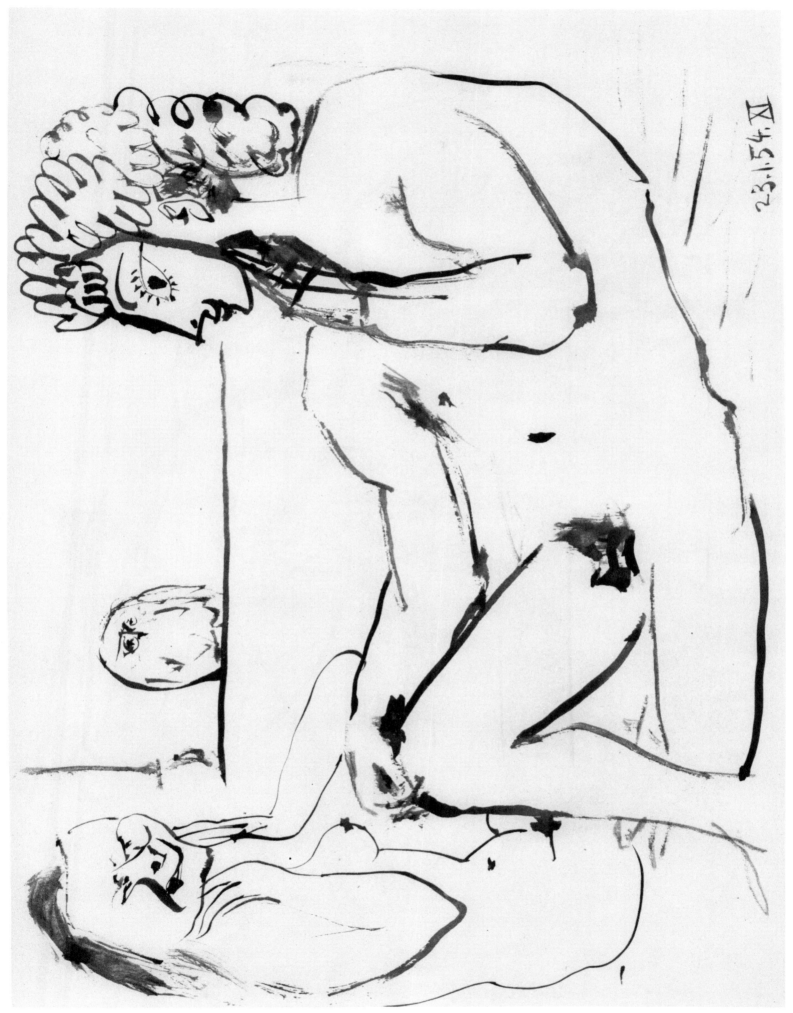

151

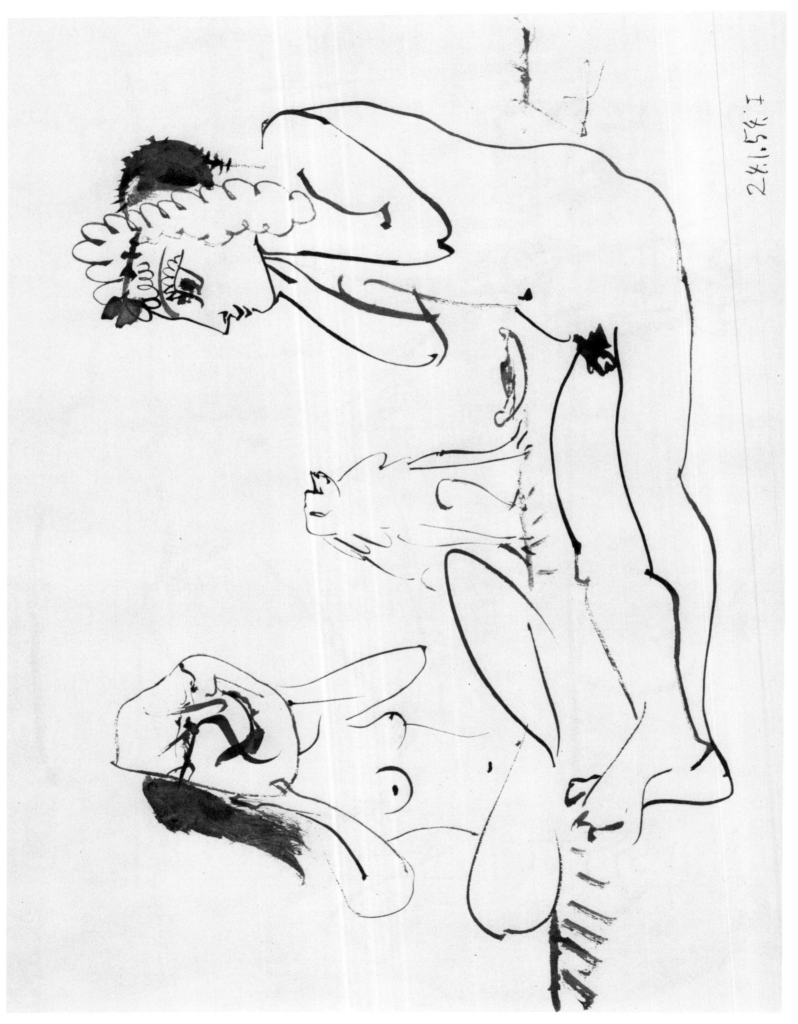

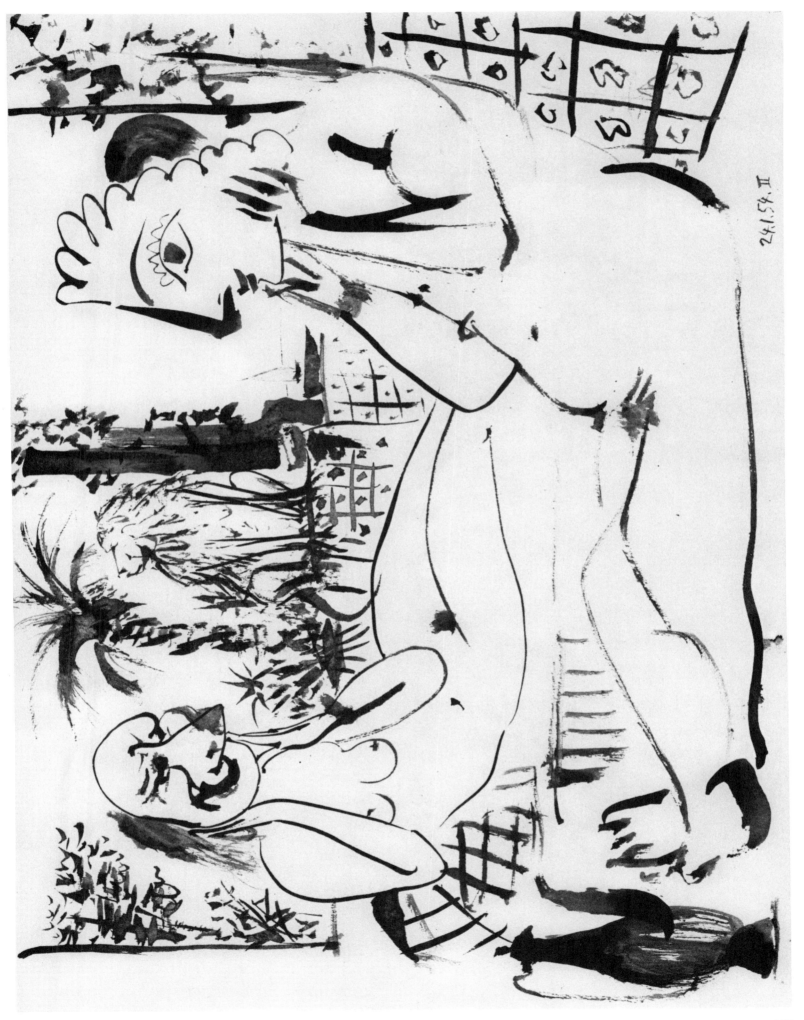

153

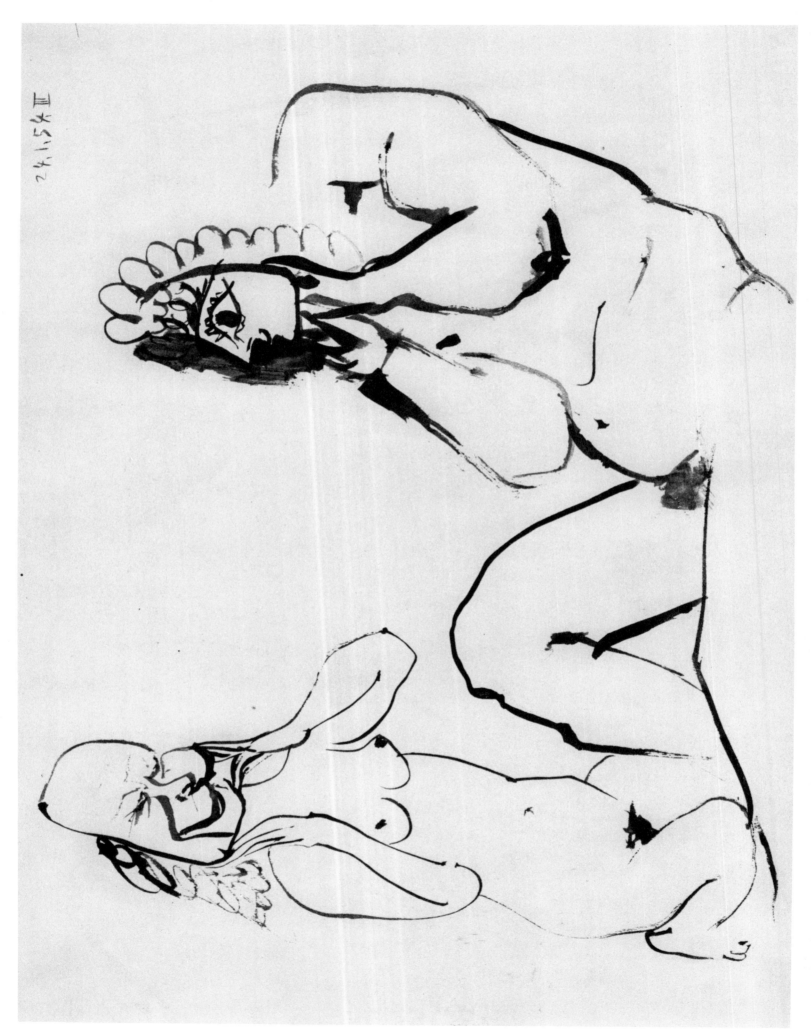

154

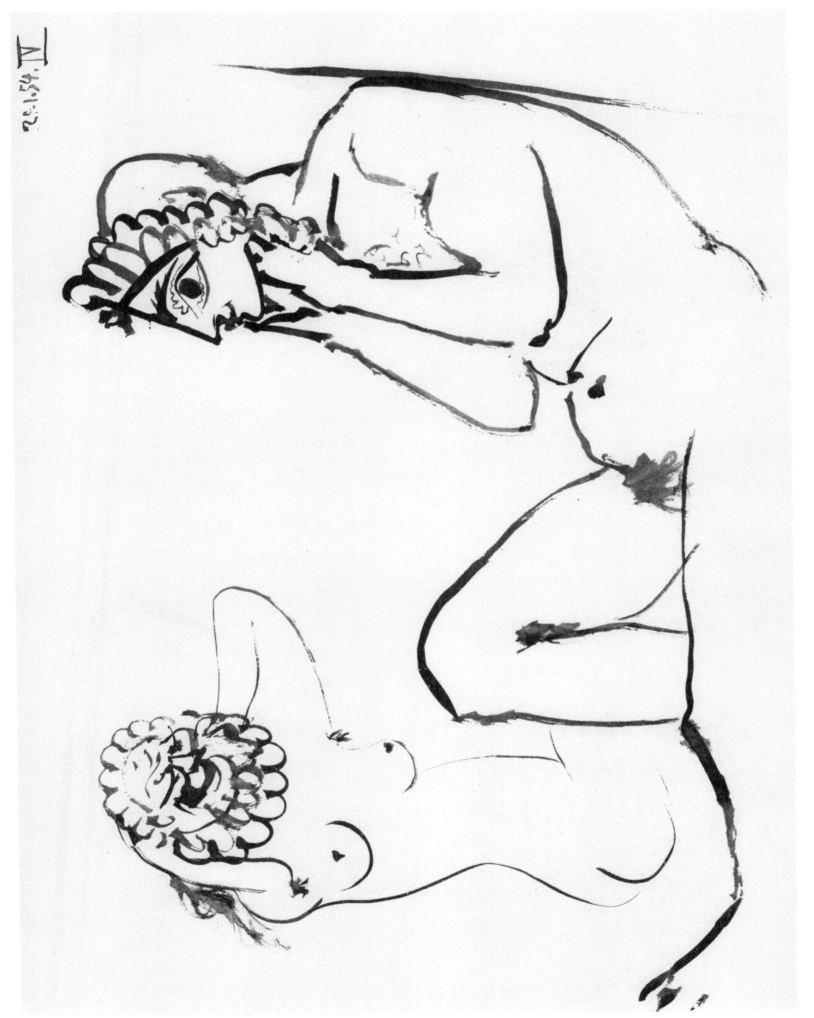

26.1.54.IV

155

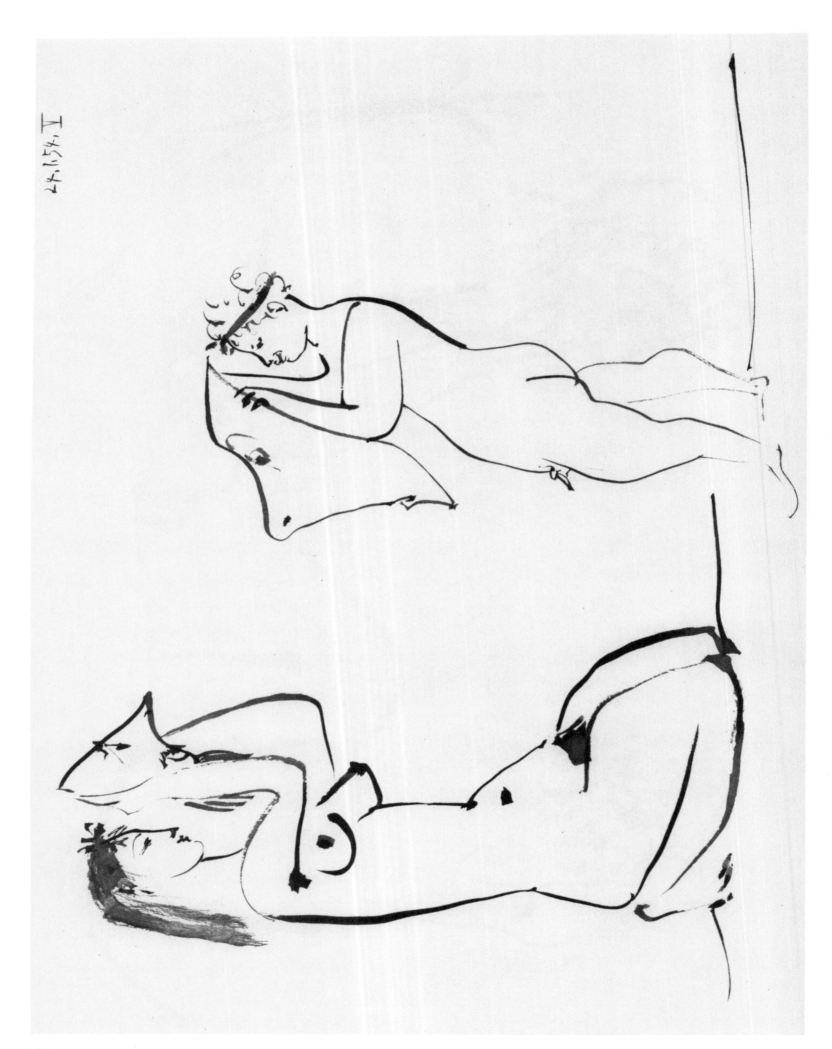

156

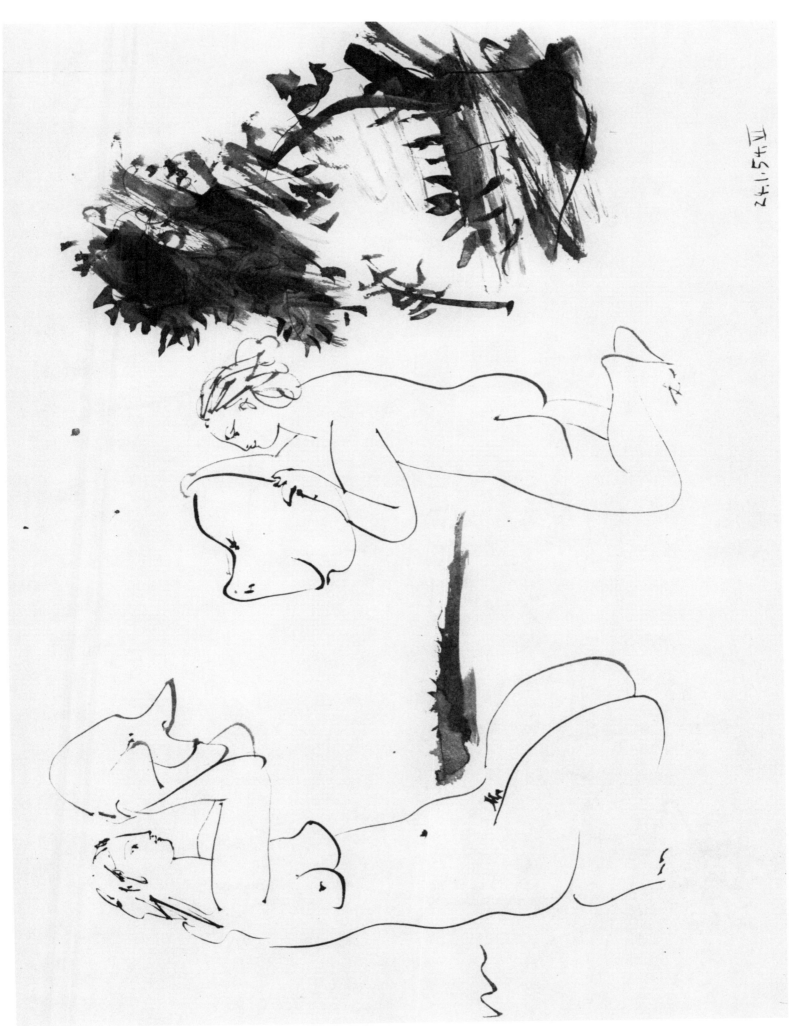

157

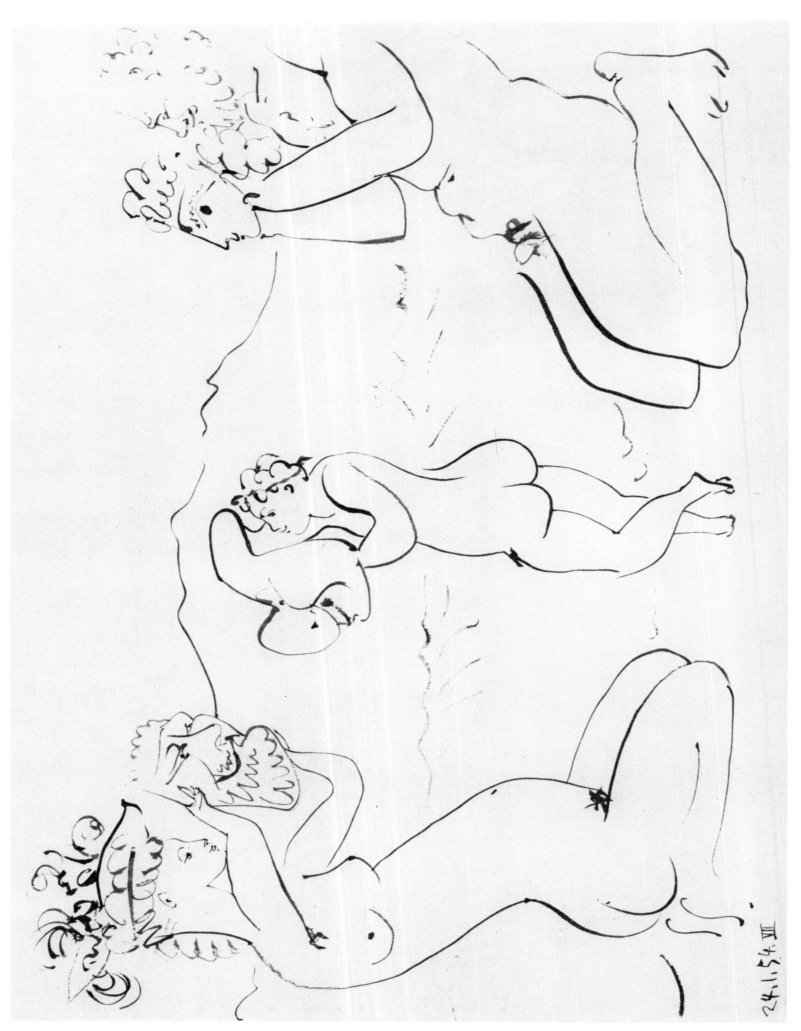

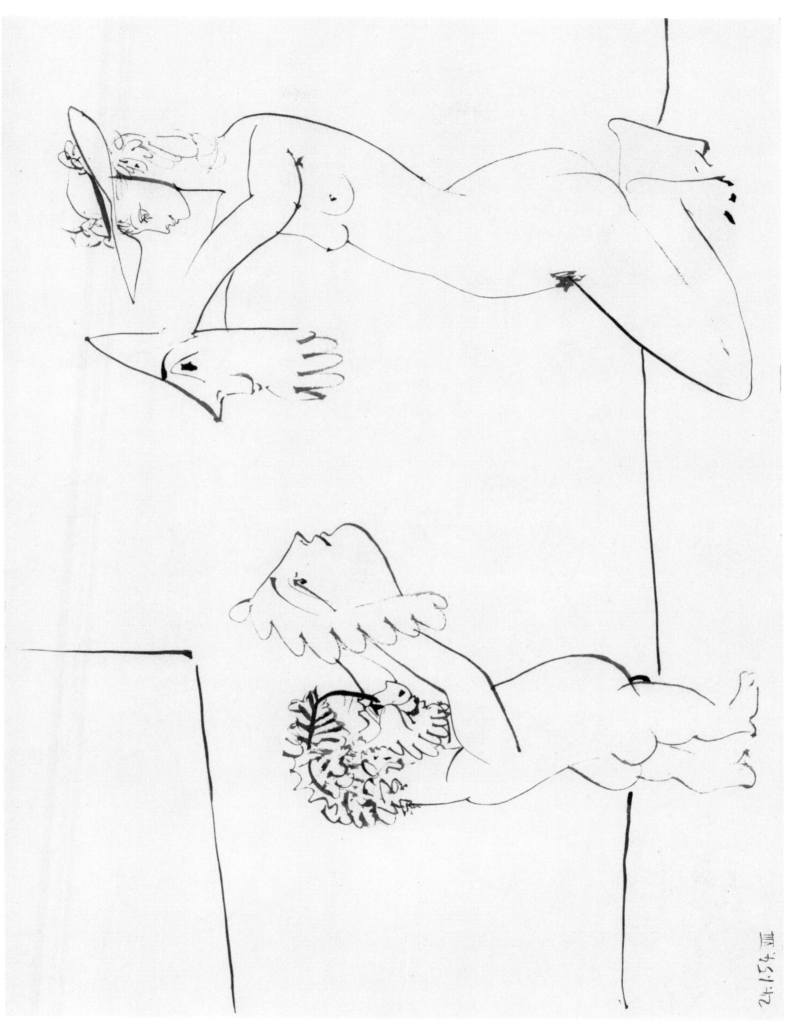

24.1.54. VIII

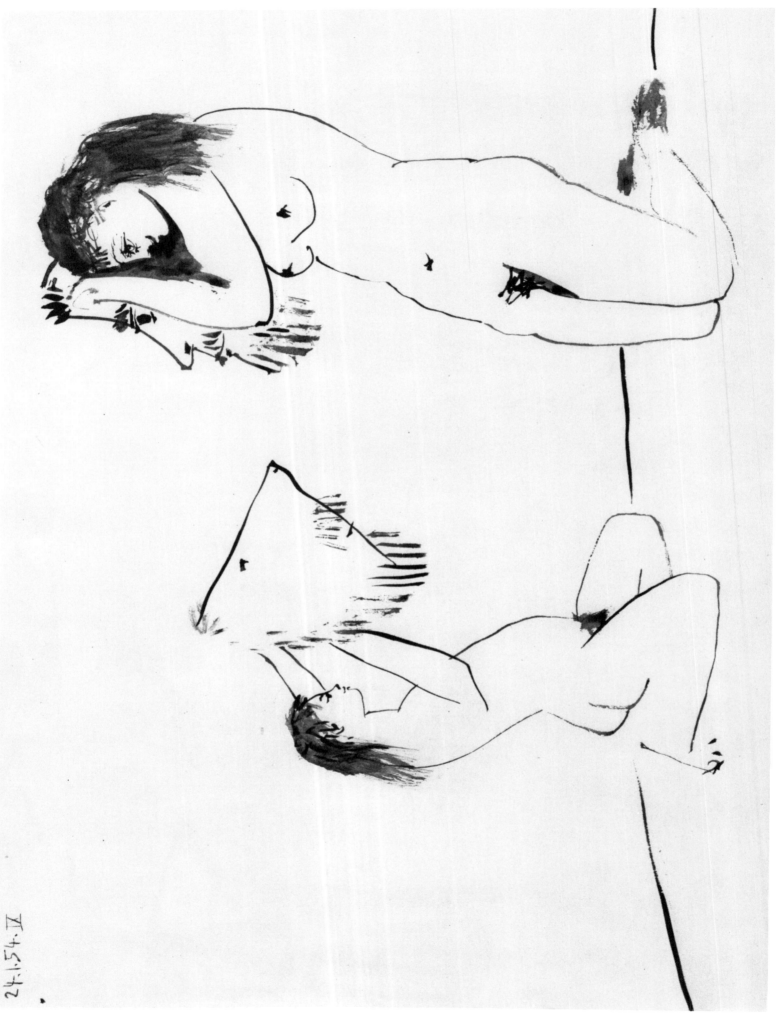

24.1.54.VI

160

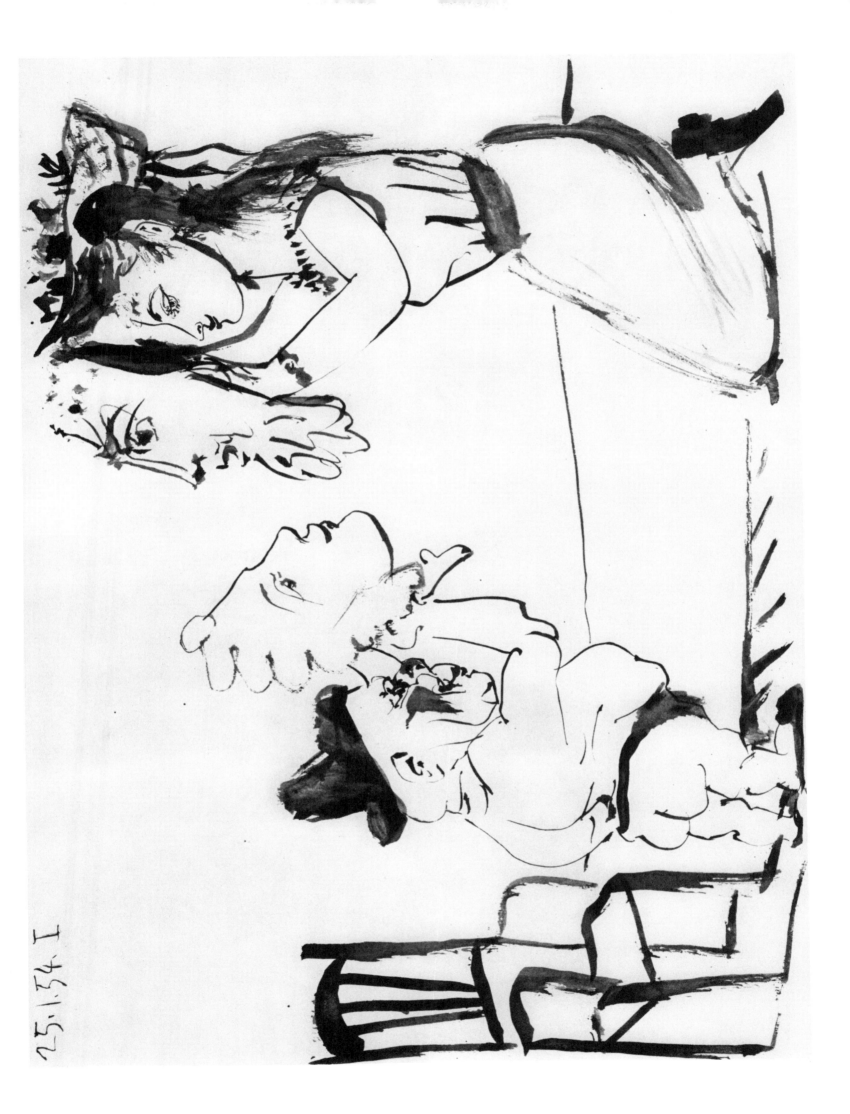

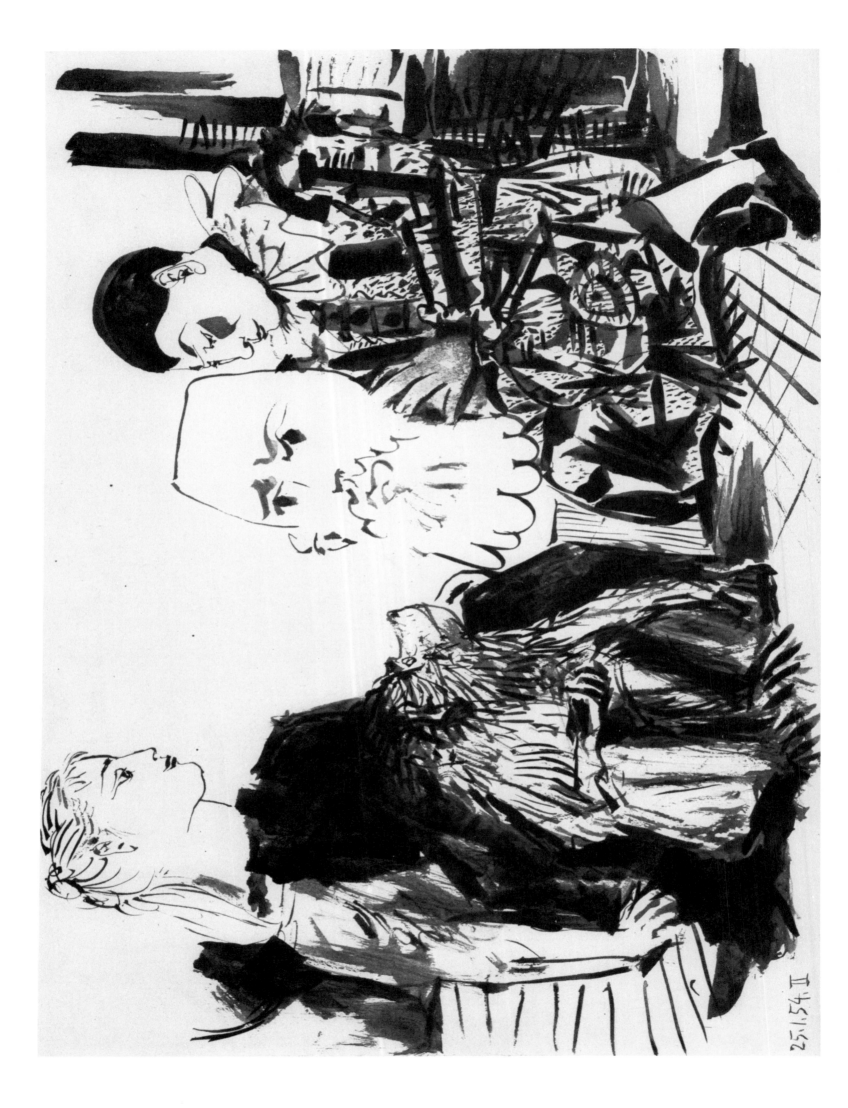

25.1.54. III

163

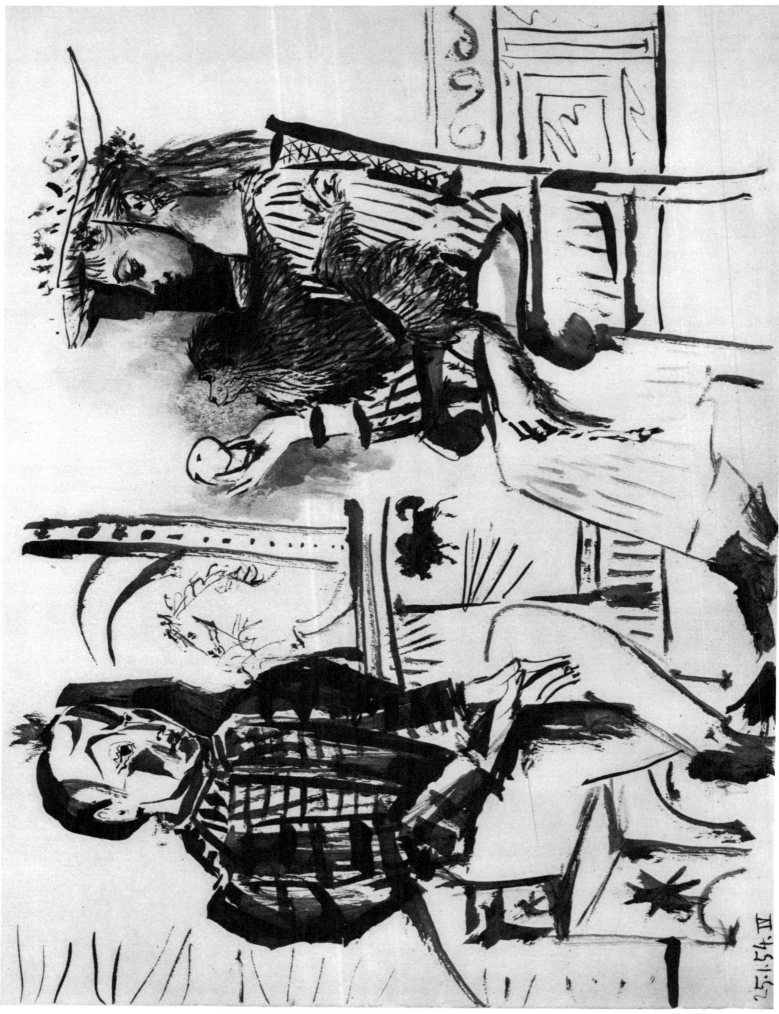

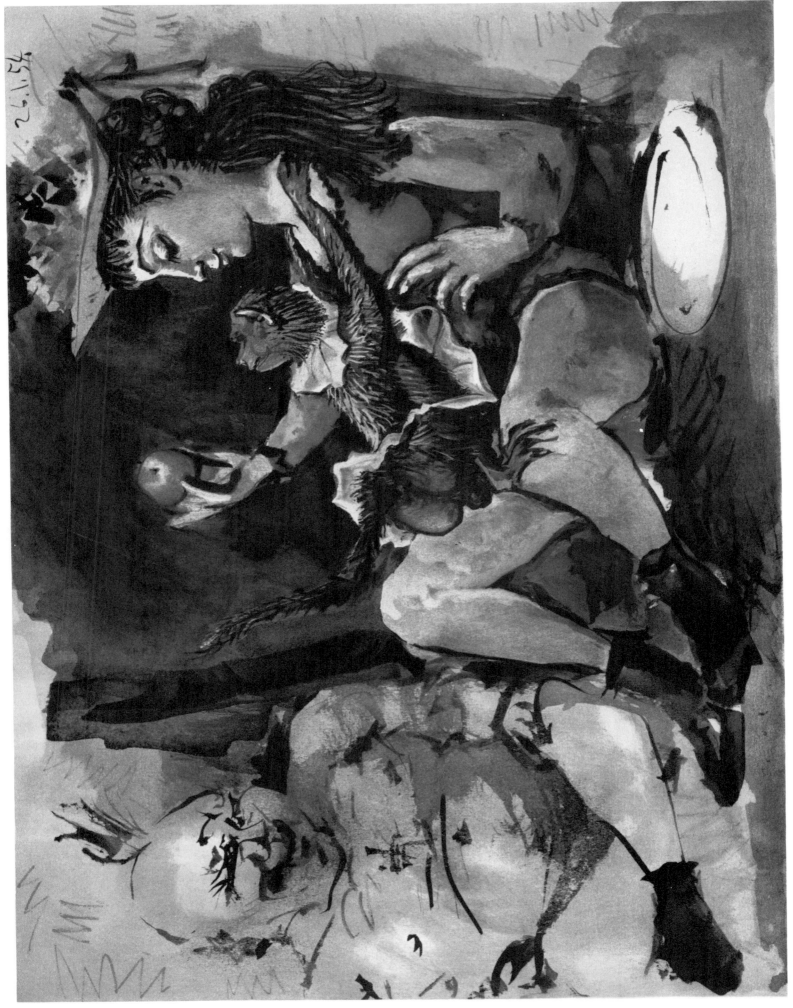

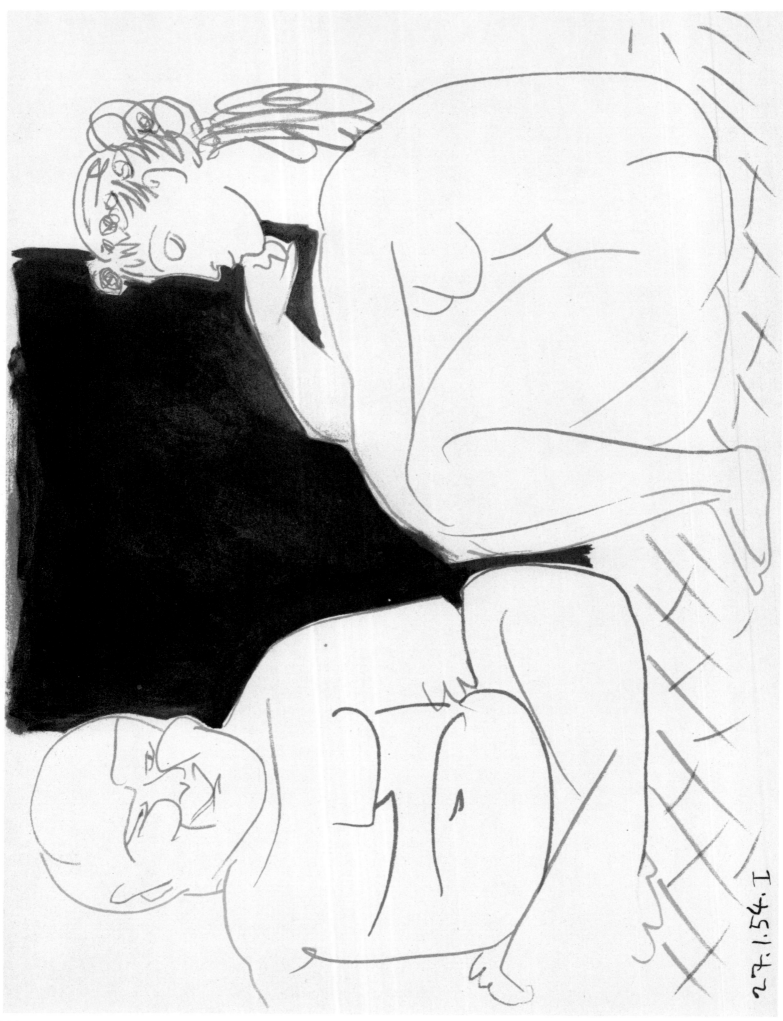

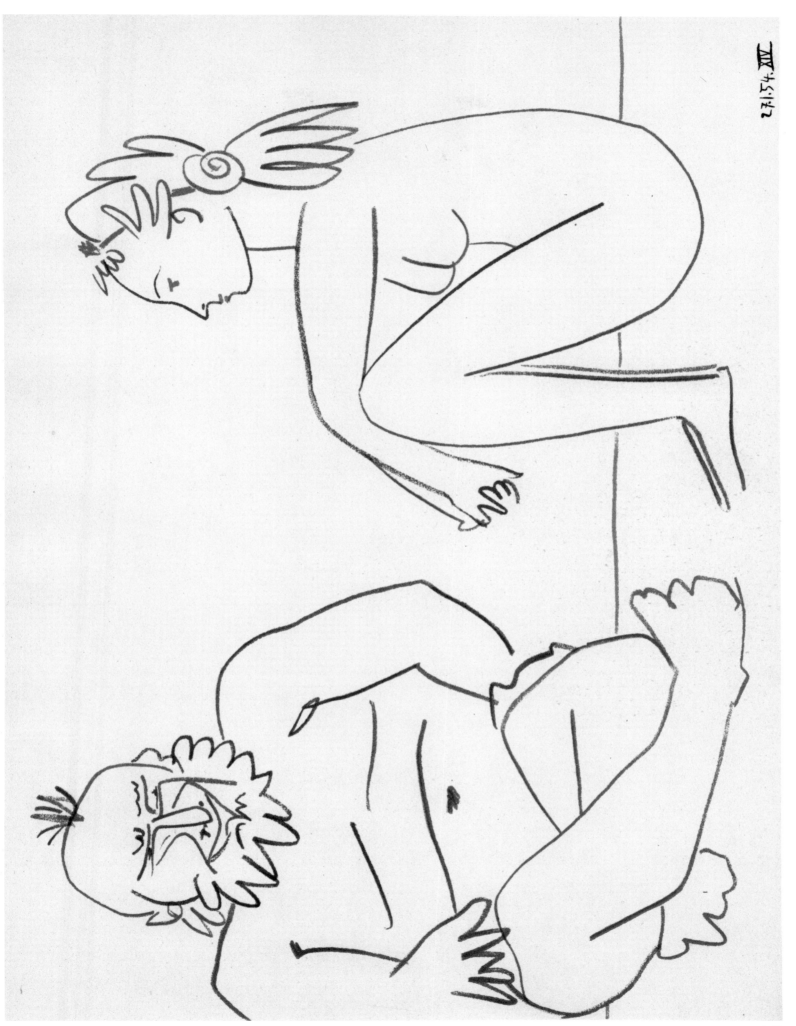

167

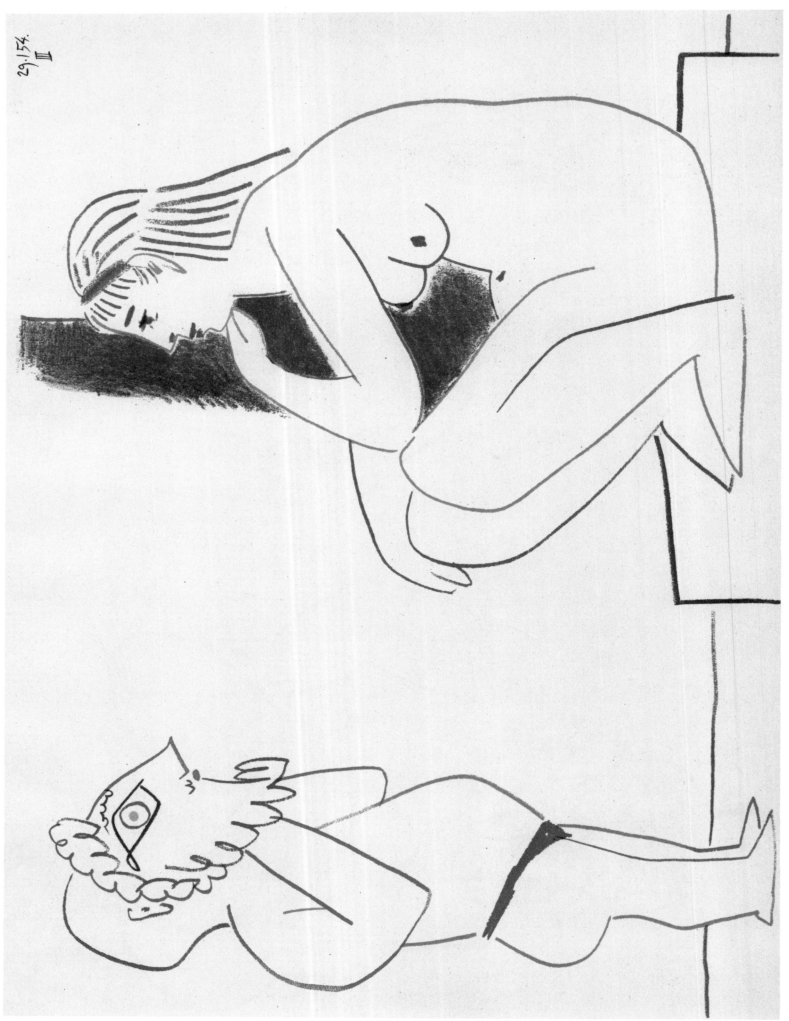

168

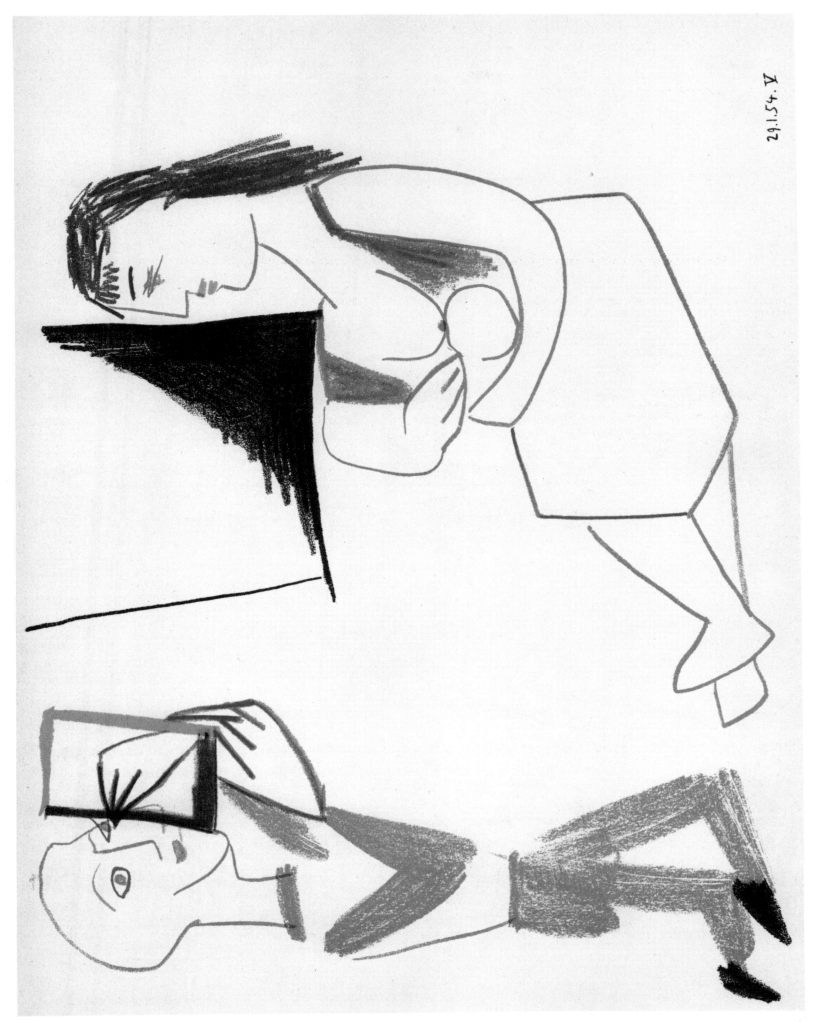

29.1.54. V

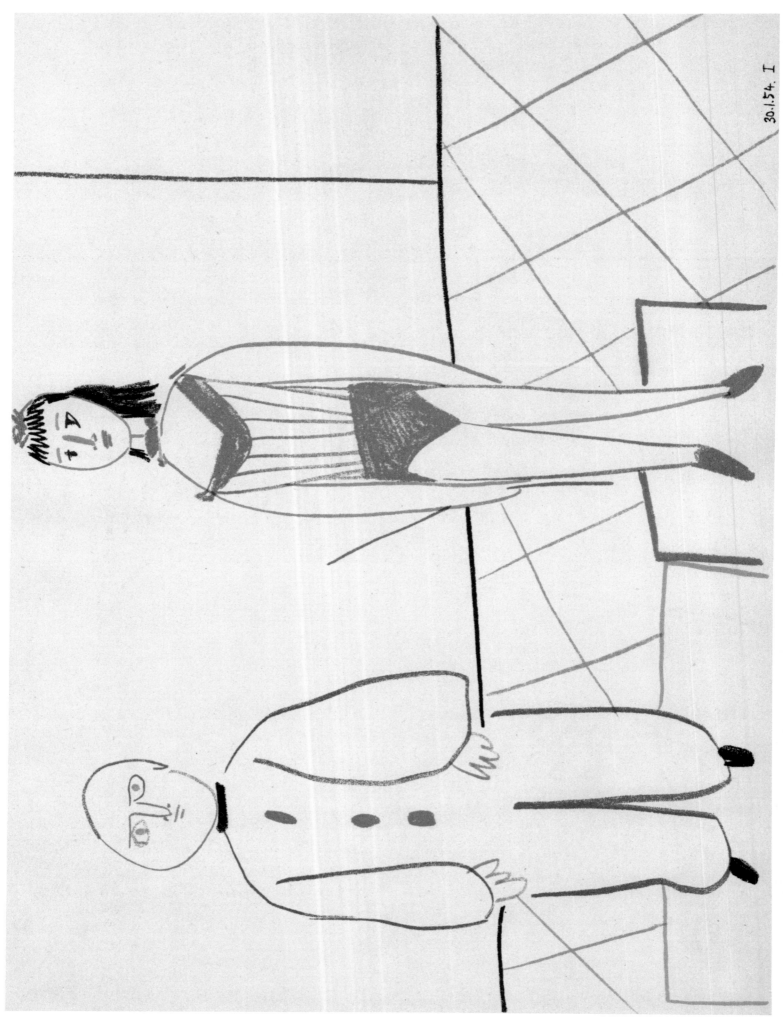

30.1.54. I

170

31.1.54. II

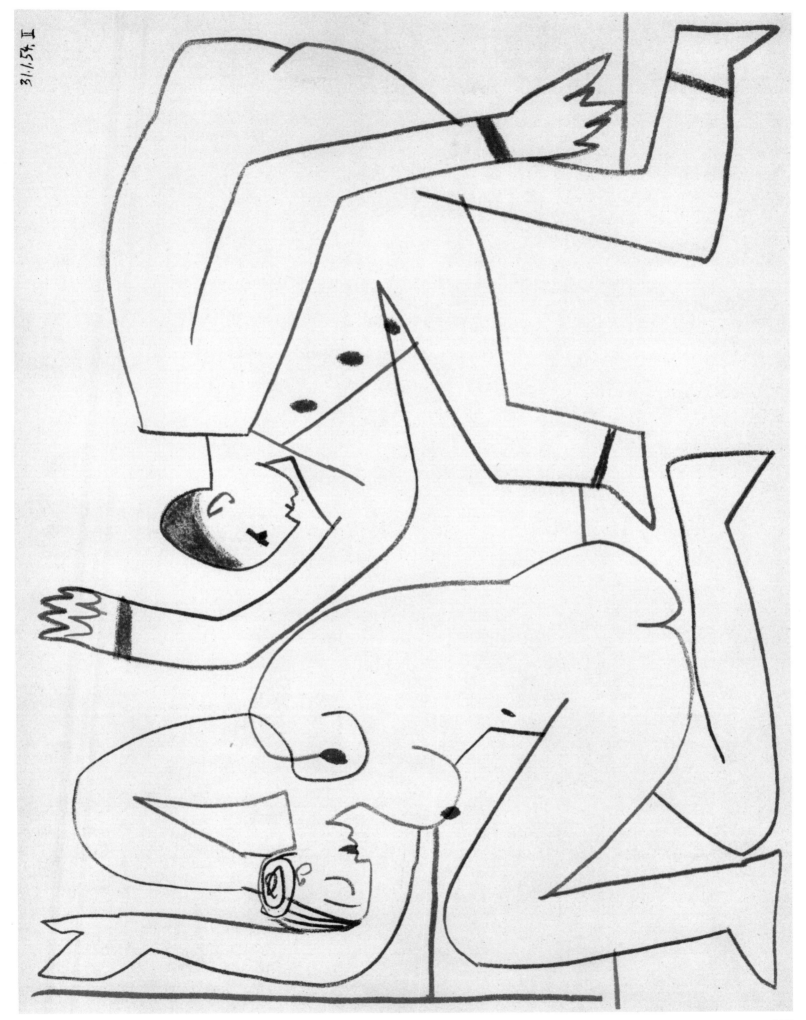

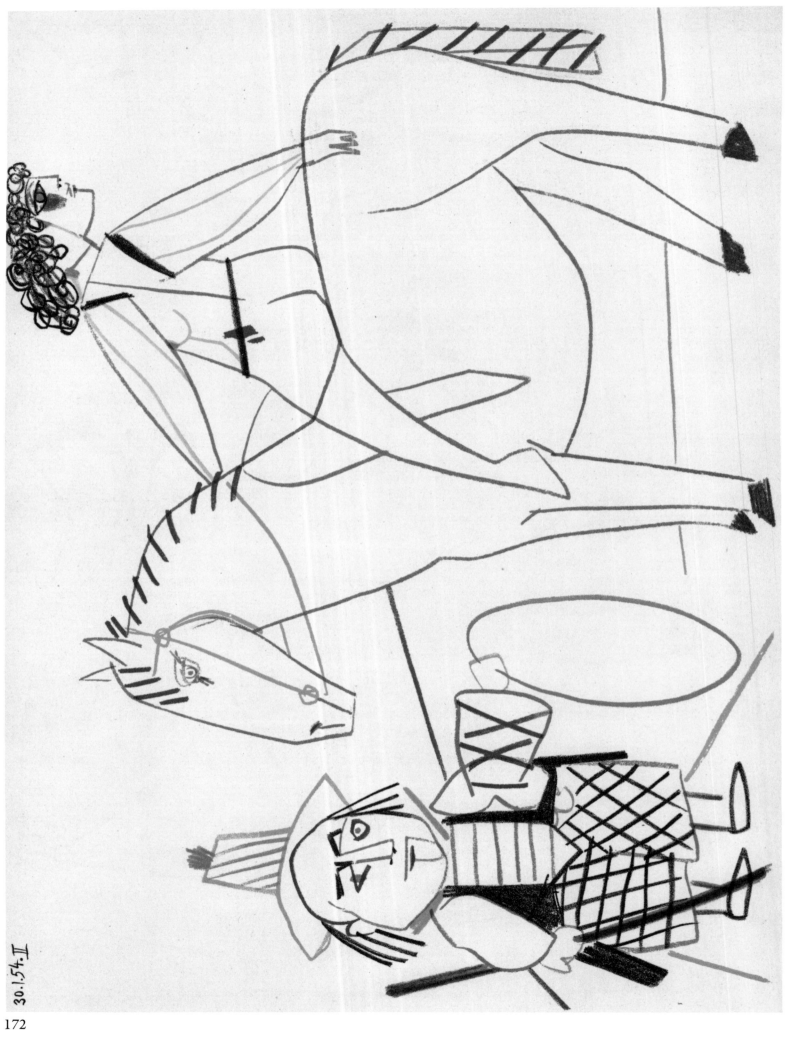

30.1.54.II

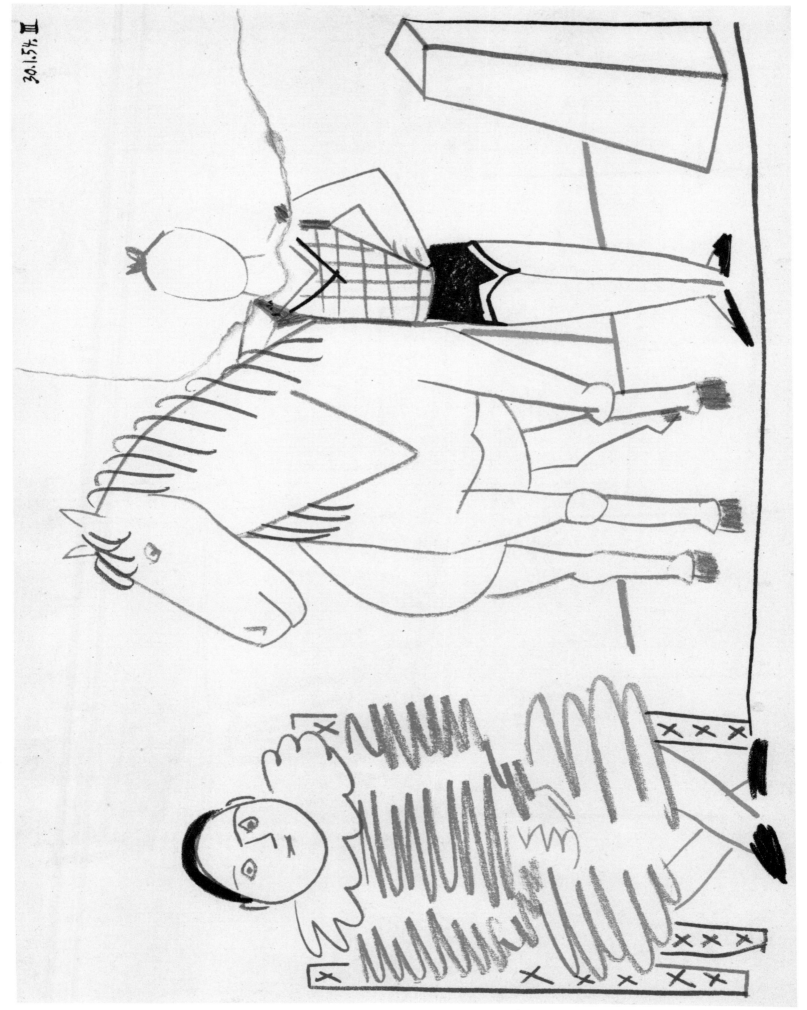

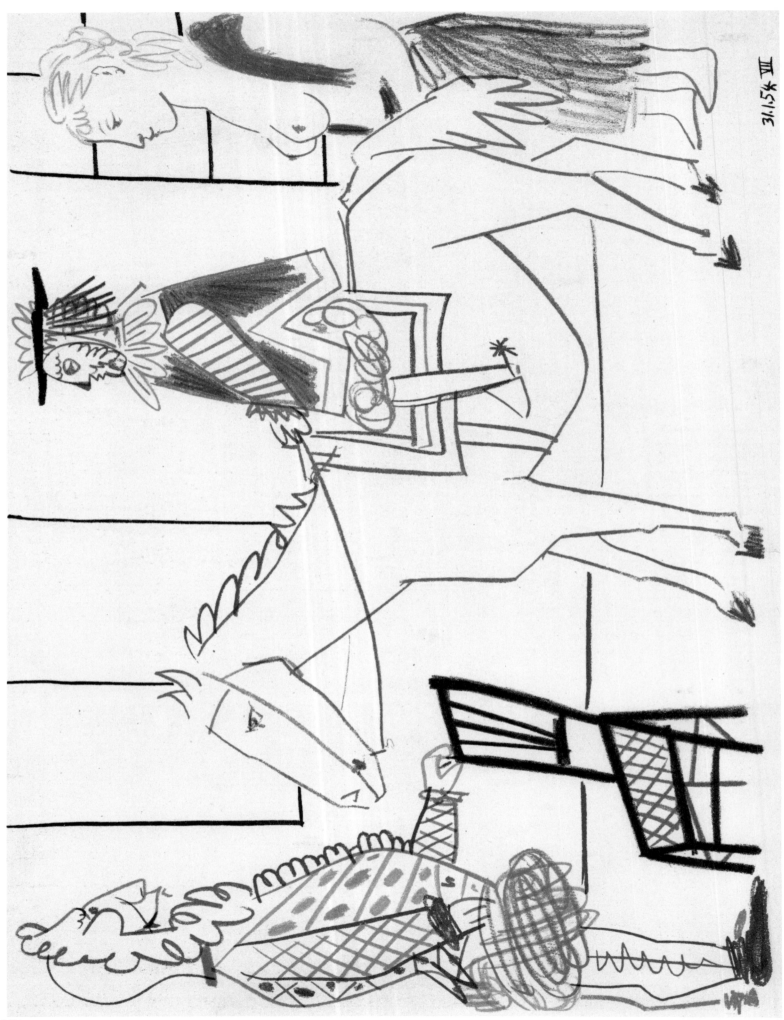

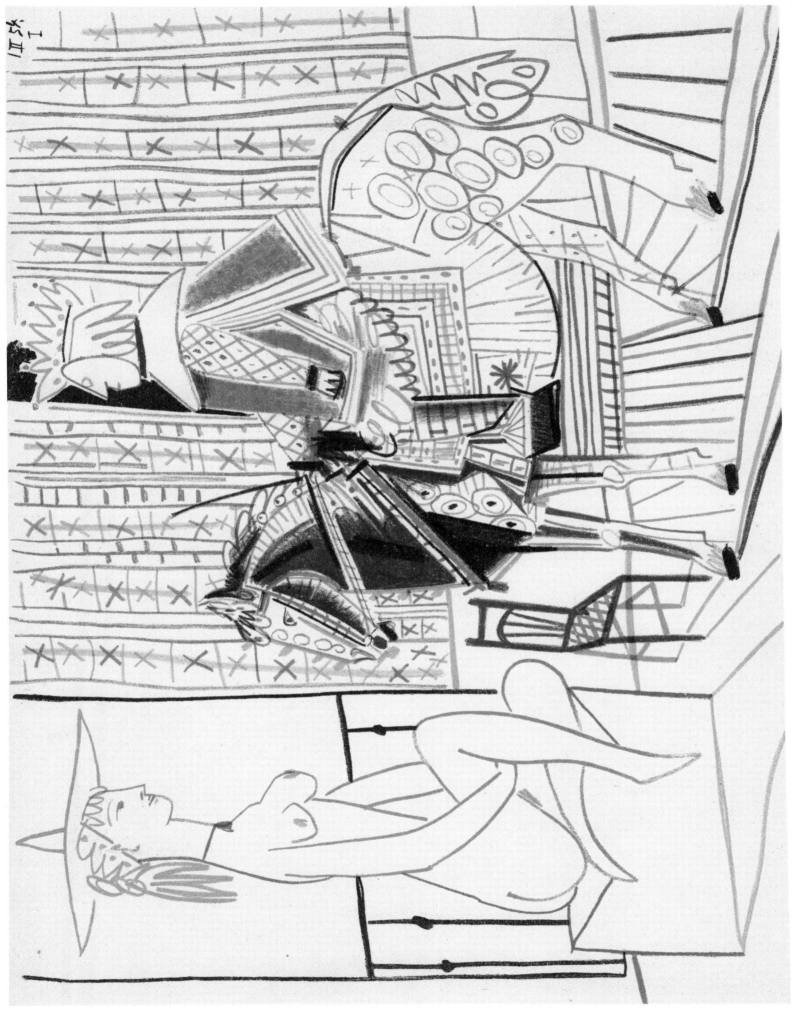

175

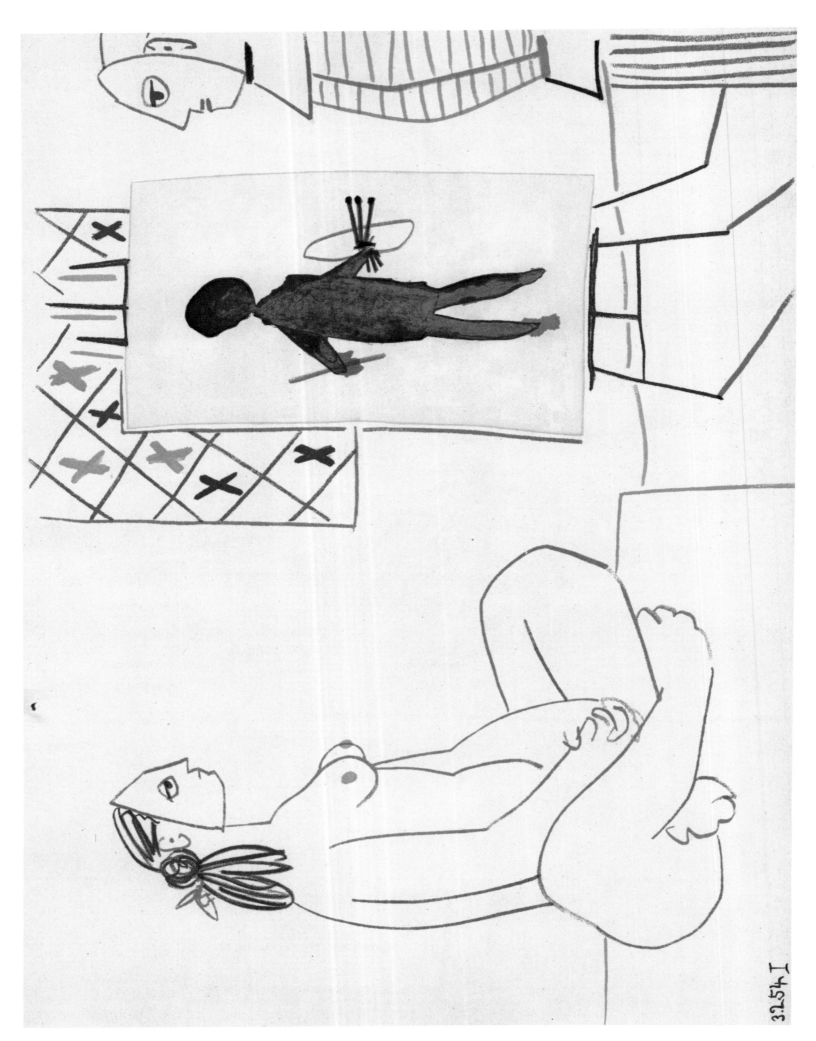

32541 I

176

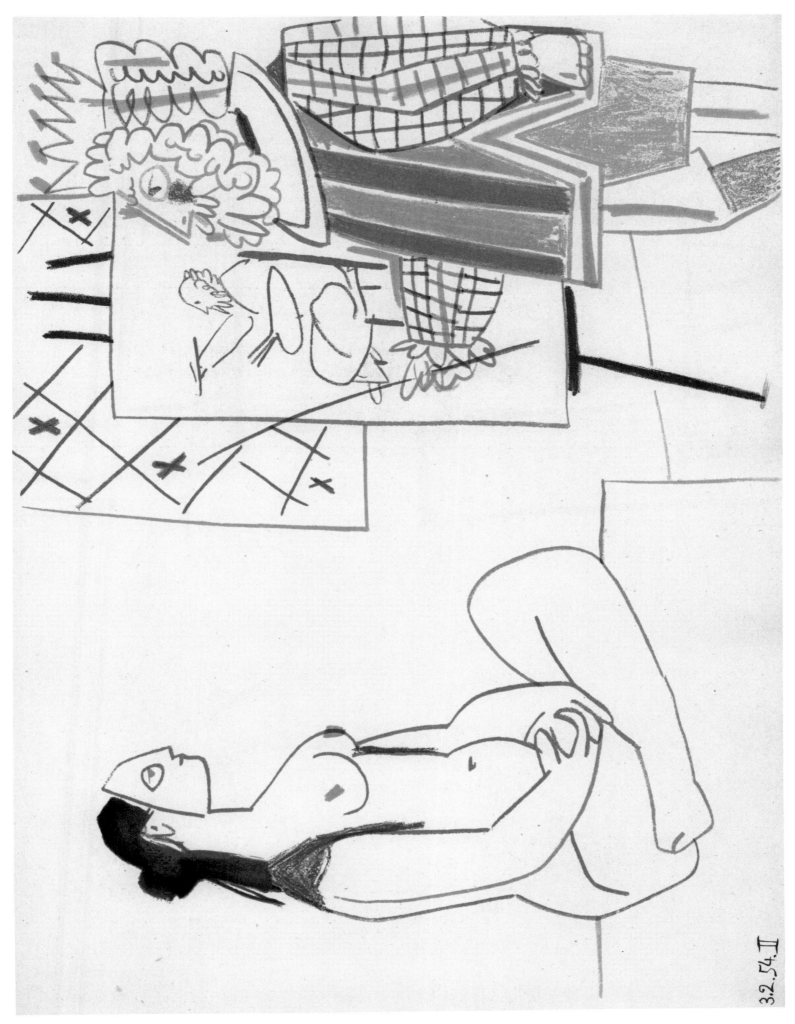

3.2.54.II

177

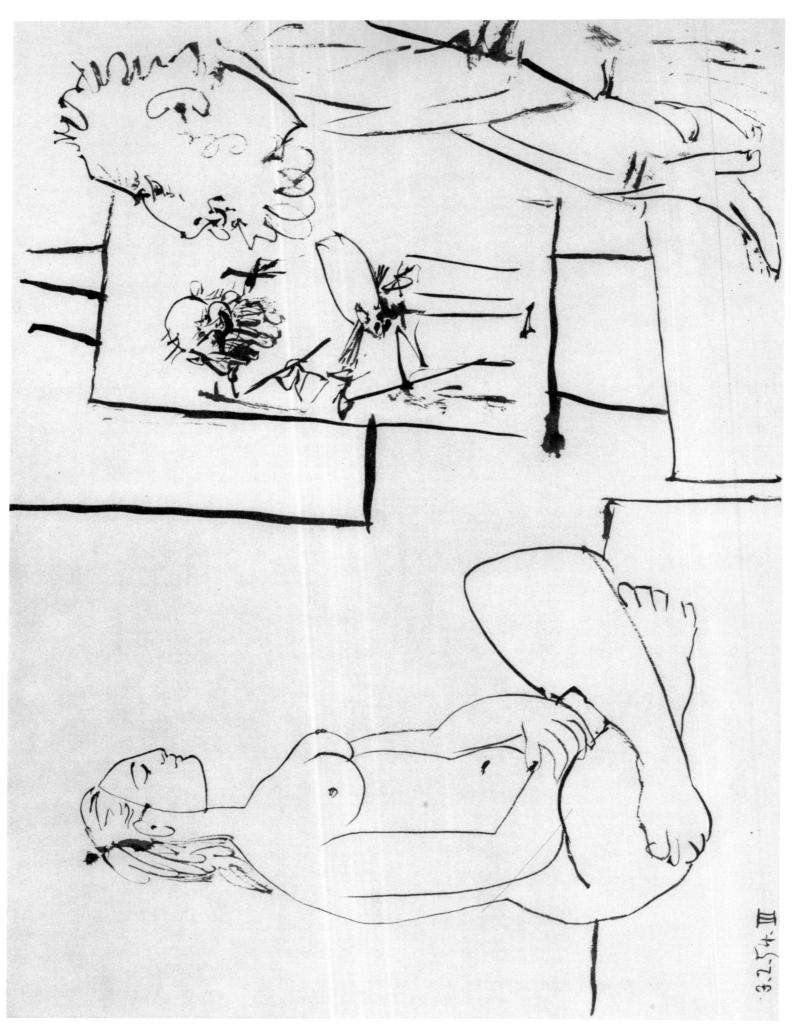